The J. Paul Getty Museum

Handbook of the Collections

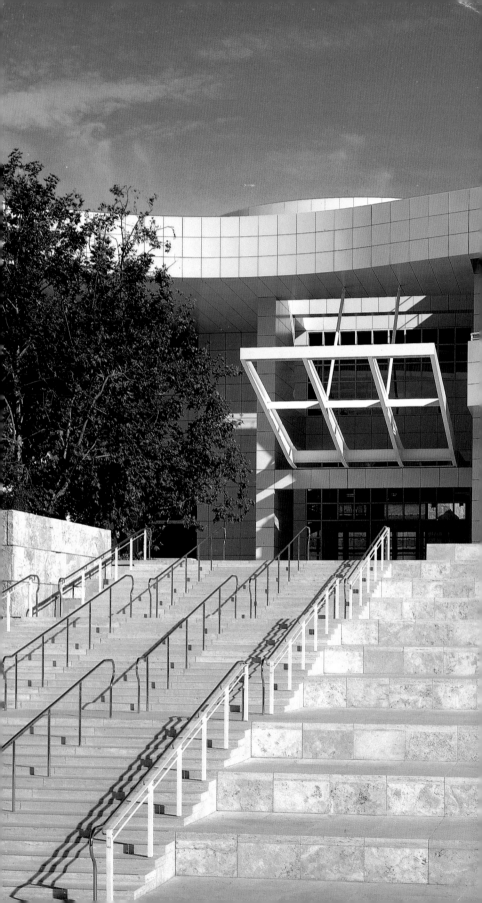

The J. Paul Getty Museum

Handbook of the Collections

LOS ANGELES

© 1997
The J. Paul Getty Museum
1200 Getty Center Drive
Suite 1000
Los Angeles, California
90049-1687

Second printing

Publisher
Christopher Hudson

Managing Editor
Mark Greenberg

Library of Congress
Cataloging-in-Publication
Data

J. Paul Getty Museum
 The J. Paul Getty Museum
 handbook of the collec-
 tions—Rev. ed.
 p. cm.
 Rev. ed. of: The J. Paul
Getty Museum handbook
of the collections. Malibu,
Calif. : The Museum, 1991.
 ISBN 0-89236-482-3 (cloth)
 ISBN 0-89236-483-1 (paper)
 1. Art—California—
Malibu—Catalogs. 2. J. Paul
Getty Museum—Catalogs.
I. J. Paul Getty Museum.
J. Paul Getty Museum hand-
book of the collections.
II. Title.
N582.M25A627 1997
708.194'93—dc 96-29947
 CIP

Printed and bound in Italy

Editor
Mollie Holtman

Production Coordinator
Amy Armstrong

Designer
Jeffrey Cohen

Photographers
Charles V. Passela
Jack Ross
Lou Meluso
Ellen Rosenbery

Typesetter
G&S Typesetters, Inc.
Austin, Texas

Printer
Amilcare Pizzi S.p.A.

On the title page:
Travertine steps lead to the
entrance of the new Getty
Museum. Photo: Tom Bonner

Page vi:
Interior of the eighteenth-
century Italian paintings
galleries, with Giovanni
Battista Pittoni's *Sacrifice of
Polyxena* and Thomas Gains-
borough's *Anne, Countess
of Chesterfield*. Photo: Tom
Bonner

The Collections

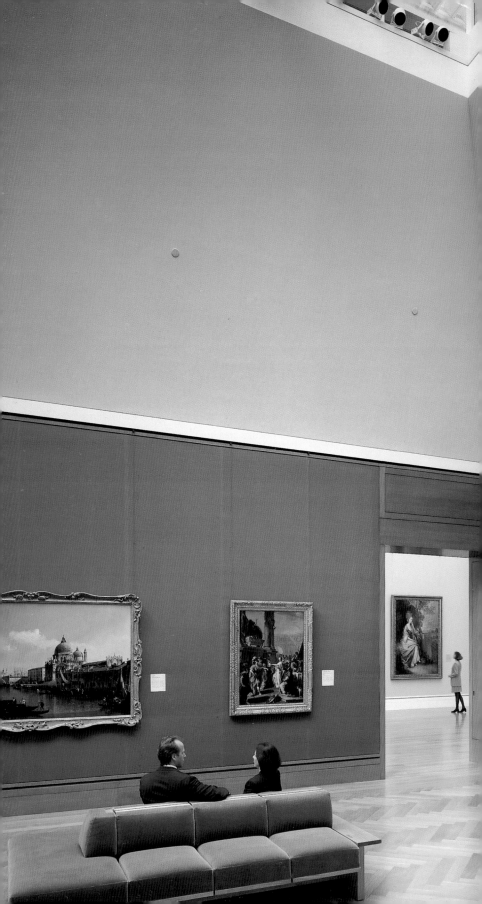

Introduction

Seldom has a Museum changed its face so completely as the Getty Museum will in 1997. As this book is being printed, the Museum is closed for the first time in forty-three years. The collections are being packed in Malibu and moved five miles inland to a brand-new, much larger, much more conspicuous building that will be the core and chief public attraction of the new Getty Center. At the same time architects are finishing plans for the renovations that will convert the Getty Villa into America's only center for comparative archaeology where, in the year 2001, the Museum's antiquities collection will be at the center of programs of conservation, scholarship, and public education.

"If a museum is alive and thriving, it is bound to keep changing and improving," wrote my predecessor Stephen Garrett in a guidebook of 1978. "This is good for our visitors and good for our staff. But it means that guidebooks go quickly out of date." That one did, and so have its successors, including the 1986, 1988, and 1991 editions of the *Handbook of the Collections*. The reason, of course, is the rapid growth of the collection made possible by J. Paul Getty's huge bequest.

The Museum has had opportunities for expansion and improvement that could not have been imagined when it first opened in 1954, or even when the Villa building opened in 1974. Since the early 1980s hundreds of important new works of art have been acquired in the areas of the Museum's three traditional interests, antiquities, French furniture and decorative arts, and European paintings, and thousands more have been acquired to form four new collections.

Classical antiquities, the largest of the Museum's original collections, has been strengthened by the purchase of important groups of Greek vases, Cycladic figures and vessels, Hellenistic metalwork, and sculpture from Magna Graecia. Most recently, one of the finest private collection of Greek and Roman works in existence, that of Lawrence and Barbara Fleischman, has been acquired through donation and purchase.

J. Paul Getty had a particular passion for the exquisitely made furniture and decorative objects of eighteenth-century France. In recent years many more have been added in various periods, especially the Neoclassical. The entire collection now occupies an extensive suite of galleries and paneled rooms, a kind of museum-within-a-museum at the Getty Center.

The Getty's European paintings now include dozens of examples of very great importance, among them a group of Italian works of the Renaissance and many fine seventeenth-century Dutch paintings. There are also French and Spanish works of great distinction and a small but brilliant group of Impressionist and Post-Impressionist pictures. About 140 paintings have joined the collection since 1983.

Entire collections have been formed in the past decade and four new curatorial departments created. The Museum has been buying drawings since 1981; there are now about five hundred examples of remarkably high quality distributed across the history of European art. The collection ranks among the best for its size in the world.

In 1983 the Museum entered the field of illuminated manuscripts with the purchase of the collection of Peter and Irene Ludwig, 144 items that formed the most important group of medieval and Renaissance manuscripts in private hands; since then, more than 90 acquisitions have made the Getty's collection far more diverse and important.

In 1984 the Museum seized another exceptional opportunity and bought a number of the best private holdings of photographs anywhere. Together with thousands of acquisitions made since then, they now form the finest museum collection of photographs in this country. All of the drawings, manuscripts, and photographs are available for study by students and scholars, and a selection of each is on view in changing exhibitions.

The Museum also has been actively buying European sculpture. Statues in bronze and marble of the sixteenth through the nineteenth century can now be seen in a series of ground-floor galleries in the new Museum together with maiolica, glass, goldsmiths' work, *pietre dure*, and Italian furniture.

One of our aims is to satisfy every visitor's curiosity and make a trip to the Getty Museum as much a memorable adventure for the mind as a delight for the senses. We offer information about the collection through many different means: introductory talks, lectures, publications, labels, didactic shows, audioguides, and interactive computer programs. And we offer to families and schools an ambitious program of services. With our greater visibility in Los Angeles and our much-expanded capacity, we will be trying to ensure that those services will be used to the fullest.

The works of art in this *Handbook* were brought to Los Angeles for the joy and enlightenment of the public. May this book give readers who have not yet seen the originals an inducement for visiting the Getty Museum. And for those who have visited, may the book recall the experience and enrich the recollection.

John Walsh, *Director*

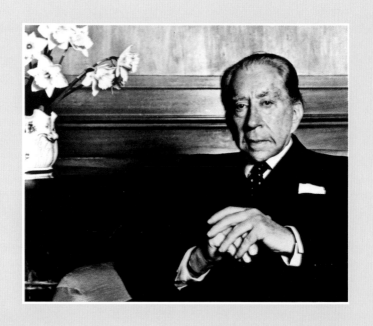

J. Paul Getty and His Legacy

J. Paul Getty combined the lives of oil-field wildcatter, shrewd and spectacularly successful businessman, writer, and member of the international art world. His attitude toward art and collecting was complex. Although he maintained that "fine art is the finest investment," he also felt that "few human activities provide an individual with a greater sense of personal gratification than the assembling of a collection of art objects that appeal to him and that he feels have a true and lasting beauty." When he died on June 6, 1976, at the age of eighty-three, Paul Getty had collected art for more than forty-five years. Collecting was a part of his life that he relished and about which he felt deeply.

J. Paul Getty (fig. 1) was born in 1892 in Minneapolis. His father, George F. Getty, was a successful attorney and already wealthy when he entered the oil business in Oklahoma in 1903. He planned to have Paul, his only child, enter the family business, and so Paul worked summers in the Oklahoma oil fields from the age of sixteen.

After a semester at the University of Southern California and time at the University of California, Berkeley, Getty began to read political science and economics at Oxford University in November 1912. He received his diploma in June 1913 and set off on a *Wanderjahr*. He made the rounds of museums and galleries from Sweden and Russia to Greece and Egypt but later could recall being impressed by only one painting—the *Venus* by Titian in the Uffizi.

FIGURE 1

J. Paul Getty, 1960s. Photo: JPGM Archives

After spending the tense early days of World War I in London with his parents, Getty began a trial year of joint ventures in the Oklahoma oil fields with his father. In 1916 he brought in his first producing oil well, becoming a millionaire at age twenty-three, and he returned to Los Angeles in July 1916 for an extended vacation. When the United States entered the war, he applied to the Army Air Service but was not called. He gradually adopted a pattern of living about seven months of the year in Europe and five months in the United States, where he helped make George F. Getty Incorporated, the family oil firm, increasingly profitable. When his father died in May 1930, Getty became president. Perhaps as a relief from his business responsibilities, he found his interest in art developing. He read voraciously on the subject and visited museums whenever he could.

The United States and Europe were enjoying a period of tremendous prosperity, and great numbers of wealthy collectors—including William Randolph Hearst, the Mellons, and the Rothschilds—bid against each other enthusiastically for anything great that came on the market. Following the panic of 1929 and the Depression, Getty found that the time was right to begin collecting works of art. In March 1931 he purchased his first art object of value—a landscape by the seventeenth-century Dutch painter Jan van Goyen—at auction in Berlin for about $1,100. Two years later he bought ten paintings by the Spanish Impressionist Joaquin Sorolla y Bastida at a New York auction.

Getty often said that he was inspired to collect decorative arts after leasing a penthouse in 1936 from a Mrs. Frederick Guest on Sutton Place South in New York. The apartment was furnished with French and English

FIGURE 2

BERNARD MOLITOR

French, 1755–1833
Rolltop Desk, circa 1785–88
Oak veneered with
mahogany and lacquer; gilt-
bronze mounts; marble top
137 × 181 × 87 cm
(4 ft. 6 in. × 5 ft. 11½ in. ×
2 ft. 10¼ in.)
Los Angeles, J. Paul Getty
Museum 67.DA.69

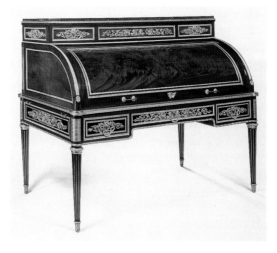

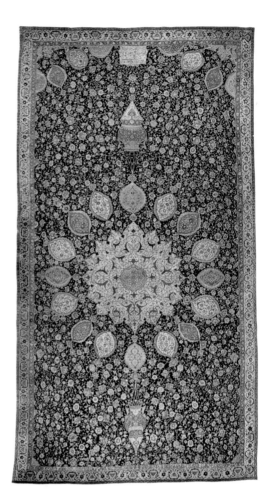

FIGURE 3

ARDABIL CARPET

Persian, Safavid Dynasty,
1540
Silk and wool
729 × 409 cm
(23 ft. 11 in. × 13 ft. 5 in.)
Los Angeles County
Museum of Art 53.50.2,
Gift of J. Paul Getty

eighteenth-century pieces, and Getty responded enthusiastically to living
with them. He acquired in one stroke the beginnings of a significant col-
lection of French eighteenth-century furniture at the Mortimer Schiff
sale in London in June 1938. Fear of impending war kept bidding far below
estimates. Among the purchases were a magnificent Savonnerie carpet,
the famous rolltop desk by Bernard Molitor (fig. 2), a side table with Sèvres
plaques by Martin Carlin, a damask settee and chairs by Jean-Baptiste
Tilliard *fils*, and the Ardabil Carpet (fig. 3), a large sixteenth-century Per-
sian carpet made to adorn the most holy of all the Persian religious shrines,
the mosque of Safi-ud-din.

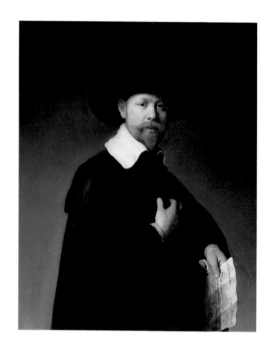

FIGURE 4

Rembrandt
Harmensz.
van Rijn

Dutch, 1606–1669
Portrait of Marten Looten,
1632
Oil on panel
92.7 × 76.2 cm (36½ × 30 in.)
Los Angeles County
Museum of Art 53.50.3,
Gift of J. Paul Getty

In succeeding months Getty bought a large number of paintings, the start of the Museum's collection. He bid anonymously on Rembrandt's *Portrait of Marten Looten* (fig. 4) at the sale of the Anton W. W. Mensing in the Netherlands, then lent the portrait anonymously for exhibit in the Fine Arts Pavilion of the 1939 New York World's Fair. This enabled him "to share his joy in owning the masterpiece with millions of people."

World War II temporarily curtailed Getty's collecting. He threw his energies into expanding and running the Spartan Aircraft Corporation in Tulsa, manufacturing aircraft and training pilots. By 1947 he was back in Europe, living in hotel rooms and negotiating deals with the burgeoning European oil market and for the development of oil fields in North Africa and Arabia. A fully integrated worldwide oil network—producing, transporting, refining, and marketing—soon made Getty's company a strong competitor to the giants of the oil world.

Getty's avocation continued to be art. He visited museums, archaeological sites, and art dealers, recording in his diary works of art that impressed him (and often their prices). In the early 1950s he resumed buying art and began donating works from his collection to various museums, including the Santa Barbara Museum of Art, Oberlin College, and the San Diego Museum of Art. In 1953 he gave the Los Angeles County Museum of Art two of his most prized possessions, the Rembrandt *Portrait*

of Marten Looten and the Ardabil Carpet. Later in 1953, colleagues, notably Norris Bramlett, persuaded him to establish a museum in his own name. The ranch Getty had purchased in Los Angeles in 1945 seemed an ideal location. The trust indenture he executed in late 1953, the only document in which he specified how his money was to be used, authorized the creation of a "museum, gallery of art and library" and stated the purpose of the trust simply as "the diffusion of artistic and general knowledge."

In the early fifties Getty made his first important purchases of antiquities: the life-size marble Lansdowne Herakles (see p. 26), three sculptures from the Earl of Elgin's collection at Broomhall including the Elgin Kore (fig. 5), and the fifth-century-B.C. Cottenham Relief. Greek and Roman sculpture was to be a continuing passion for Getty; the Herakles remained a personal favorite until the end of his life.

FIGURE 5

Sᴛᴀᴛᴜᴇ ᴏꜰ ᴀ
Fᴇᴍᴀʟᴇ Fɪɢᴜʀᴇ

(The Elgin Kore)
Greek, circa 475 B.C.
Gray marble
71 × 28 × 19 cm
(28 × 11 × 7½ in.)
Los Angeles, J. Paul Getty
Museum 70.AA.114

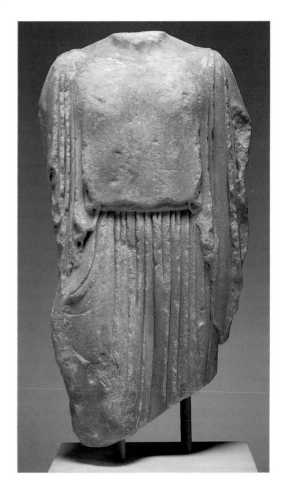

The J. Paul Getty Museum was opened to the public in May 1954 (fig. 6). Although Getty continued to buy works of art for his private residences, the best pieces began to appear in the Museum, which also acquired a small staff. The distinguished art historian Wilhelm R. Valentiner was made director in 1954 and remained for two years. George F. Getty II, Getty's eldest son, became director shortly after Dr. Valentiner and remained until his death in 1973. Getty himself then served as director until he died.

In the mid-fifties Getty tried to build all three of his collections—paintings, decorative arts, and antiquities—with some consistency. He met the famous connoisseur Bernard Berenson and passed much time talking with him and studying art in the library at Villa I Tatti in Settignano, not far from Florence. Under Berenson's influence, Getty began to take an interest in Italian Renaissance painting and to acquire Italian pictures to add to his Dutch and English paintings. His thoughts on art and the art market at this time are expressed in *Collector's Choice*, a book he wrote with Ethel LeVane in 1955. His approach to collecting was a simple one: "I buy the things I like—and I like the things I buy—the true collector's guiding philosophy."

Getty enjoyed research and tried to be certain his acquisitions were thoroughly studied, often employing scholars to determine the provenances and former prices of works of art he was considering and give opinions about them. Competent in six languages—English, French, Spanish, German, Italian, and Latin—Getty had an approach to research that was both wide-ranging and individual. He frequently lamented that he lacked sufficient leisure to follow up all the clues.

In some ways Getty saw himself in the tradition of other ambitious and eclectic collectors, from the Roman emperor Hadrian to his own older contemporary William Randolph Hearst. In his diary Getty compared the architecture and investments represented by Hadrian's Villa and Hearst Castle at San Simeon with his own holdings in art and real estate. He was gratified to own works of art that great connoisseurs of the past had owned and cherished.

In October 1957 an article in *Fortune* magazine listed Getty, until then a virtually unknown businessman, as the richest American. From then on the American public began to use the Getty name as a synonym for wealth. At times Getty was uncomfortable with the attention paid to his personal fortune and tried to deflect it into discussions of the number of jobs his corporations created through reinvestment of profits. In 1957 a gallery was added to the small museum in Malibu, and all the recently purchased antiquities and decorative arts purchases were installed (fig.7).

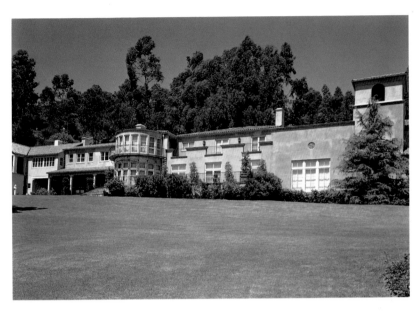

FIGURE 6
The Ranch House, Malibu, California, circa 1950s. Photo: JPGM Archives

FIGURE 7
Antiquities gallery in the Ranch House, circa 1965. Photo: JPGM Archives

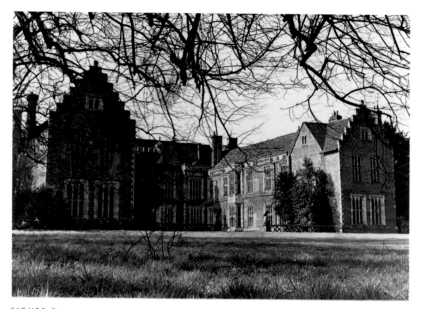

FIGURE 8

Sutton Place, Surrey, England. Photo: JPGM Archives

Much of Getty's attention between 1958 and 1968 was centered on
Sutton Place, a manor house twenty-five miles southwest of London
built in 1521–26 by one of Henry VIII's courtiers. The house was acquired
in 1959 by a subsidiary of the Getty Oil Company to serve as the parent
company's new international headquarters and as Getty's own residence
(fig. 8). He continued to acquire art. One major purchase, made in 1962, was
the Rembrandt *Saint Bartholomew* (see pp. 120–121), in 1962.

By 1967 he had resumed buying at auctions. His interest in the Getty
Museum also revived, and in the coming years he earmarked large sums
for the purchase of works of art, notably the portrait of Agostino Pallavicini
by Anthony van Dyck (see p. 114).

During 1968 Getty decided to expand his Museum. Gradually he
developed the idea of a major art museum that he could leave as a gift to
the people of Los Angeles. "There were other, and for me, overriding
considerations," he wrote. "It was my intent that the collections should be
completely open to the public, free of all charges be they for admission or
even for parking automobiles. Nothing of this sort could be insured
if the museum were under the control of a city, state, or even the Federal
government."

One evening at Sutton Place Getty announced to a group of guests
that he wished to build a separate large building on the ranch property and
that it was to be an accurate re-creation of the Villa dei Papiri in Hercula-

neum. The villa had been one of the largest ever built in the ancient Roman Empire and had possibly been owned by Lucius Calpurnius Piso, father-in-law of Julius Caesar. The villa had stood outside Herculaneum on the Bay of Naples and had been buried along with that city and Pompeii when Mount Vesuvius erupted in A.D. 79. Getty had eagerly pored over the scanty information about the villa's architecture. It would satisfy his desire for a museum building that would itself be a work of art. To this end he eventually invested more than $17 million in a new building and endowed the Museum to meet operating expenses.

Ground was broken in December 1970, and three intense years of work (fig. 9) produced the results that have delighted more than four hundred thousand visitors a year ever since (fig. 10). During construction Getty and the trustees realized that the new building would provide an enormous increase in gallery space. From 1970 to 1974, a large number of works of art were purchased and the professional staff was enlarged. The British architect Stephen Garrett joined the staff to oversee the project; he became Assistant Director, and then, after Getty's death, Director until 1983.

The new J. Paul Getty Museum building opened its doors to the public in January 1974. Greek and Roman art set the tone because of the architecture and gardens, and the entire main floor was devoted to antiquities. Although this part of the collection was of great importance, relative to other museums the French furniture was the finest of the three Getty collections, with paintings remaining the least developed.

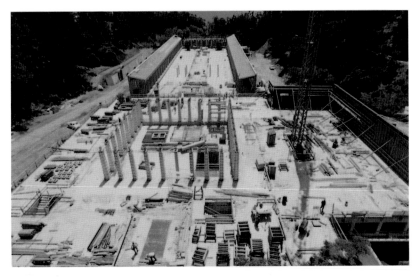

FIGURE 9
Aerial view of the Getty Villa under construction, May 1972. Photo: JPGM Archives

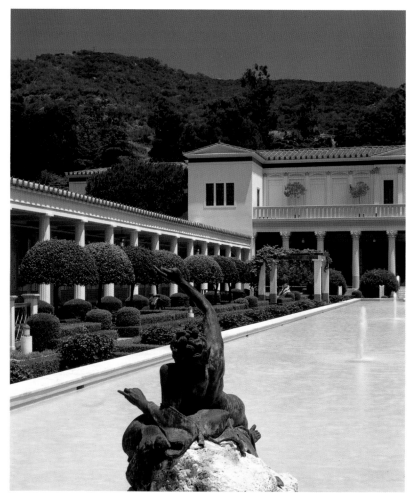

FIGURE 10
View of the Getty Villa Museum from Main Peristyle Garden. Photo: Alexander Vertikoff

At his death in June 1976, Getty bequeathed four million shares of
Getty Oil stock worth about $700 million to his Museum, leaving it to
the trustees' discretion to decide how the legacy should best be used. Al-
though the assets would be tied up in the courts for some time to come, the
collections grew impressively in the first years after he died through the
receipt of Getty's private collection from Sutton Place and some purchases.
Significant acquisitions included the late fourth-century-B.C. Greek bronze
statue of a Victorious Youth (see pp. 32–33), the *Saint Andrew* by Masaccio
(see p. 93), and the Corner Cupboard by Jacques Dubois (see pp. 208–209).

Early in 1981 the trustees appointed Harold M. Williams, Chairman of
the Securities and Exchange Commission during the Carter Administration,

to be President and Chief Executive Officer of the J. Paul Getty Trust. By April 1982, with the receipt of the proceeds of Getty's estate, the Trust already had begun to prepare for its transformation from a small museum into a visual arts institution of international significance. Realizing that the new income represented an unparalleled opportunity to expand upon Getty's initial vision, Williams and the trustees moved to set up other organizations that could operate in tandem with the Getty Museum in furtherance of J. Paul Getty's mandate for "the diffusion of artistic and general knowledge." These were the Getty Center for the History of Art and the Humanities (now Getty Research Institute), a center for advanced scholarship with a library of a million volumes and a photo archive of two million images, along with uncounted numbers of unpublished letters and manuscripts; the Getty Conservation Institute, dedicated to applied science, training, documentation, and field projects throughout the world; the Getty Art History Information Program (now Getty Information Institute), providing greater access to art and humanities information and setting international standards for research and education through the use of computer technology; the Getty Center for Education in the Arts (now Getty Education Institute for the Arts), devoted to advancing the improvement and integration of visual arts education in primary and secondary schools in this country; and the Getty Grant Program, which supports a range of projects and publications across the entire spectrum of the Getty Trust's interests.

Income from Getty's legacy would permit the Museum to expand its collections dramatically, the Trustees realized, and this suggested that a new museum be built somewhere else; the original building in Malibu could then operate as a branch. With the exception of the Conservation Institute, which was housed in Marina del Rey, the new Getty organizations were located at a bank building in Santa Monica, with the offices of the Trust across town in Century City. The trustees envisioned a complex similar to a university campus where all the Getty organizations would be gathered together, a place where the many approaches to art—display, scholarship, conservation, education—could flourish, and where new forms of collaboration would come naturally. A dramatic, 750-acre spur of the Santa Monica Mountains in west Los Angeles was purchased by the Trust in 1983 and plans for a new Getty Center were set in motion. John Walsh, who had been a paintings curator at the Metropolitan Museum of Art and the Museum of Fine Arts, Boston, as well as a university professor, became the Director of the Getty Museum in 1983. In October 1984, after a lengthy selection process, the trustees named Richard Meier of New York the project architect.

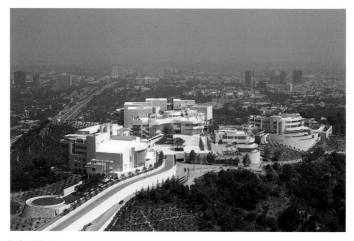

FIGURE 11
An aerial view of the nearly completed Getty Center, looking south.
Photo: Tom Bonner

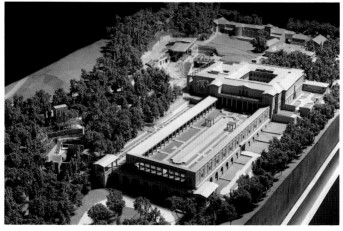

FIGURE 12
A model of the planned renovation of the Villa, prepared by Machado and Silvetti
Associates, Inc.

The new Getty Center, whose construction began in 1989 after six
years of planning, became the largest single-phase building project in the
history of Los Angeles (fig. 11), with more than a thousand people working
on the site. As this revised *Handbook of the Collections* is being printed the
Getty Center is set to open to the public by the end of 1997.

The Museum staff wrote a program that was the basis of Meier's
designs. It called for galleries designed to draw attention to the works of art
and supply excellent light, daylight wherever possible; a peaceful environ-

ment; use of the site and the building plan to induce a receptive frame of mind in visitors; temporary exhibitions galleries of various types and sizes; and a multitude of educational services. The new Getty Center is a world apart from the verdant canyon of the Museum in Malibu. It looks out across all of Los Angeles and the mountains and sea beyond, and it can be seen by hundreds of thousands every day. The Museum will have three times the attendance, more than a million visitors annually. But it is planned to provide the pleasures visitors expect at Malibu, especially the memorable experience of buildings and gardens, courtyards and views. Works of art, however, will be better served. The collection will be housed in galleries that are proportioned to the works and allow a lucid layout. Entire collections that had been shoehorned into confined spaces or else shown only in part, such as furniture, decorative arts, and sculpture, will finally have ample room. And natural daylight, almost entirely absent from the galleries in Malibu, will be abundant, especially for paintings. Much more space is provided for changing exhibitions, not simply of the permanent collections of drawings, manuscripts, and photographs, but also loan shows, for which a special wing has been built. Recognizing that visitors better enjoy and remember works of art for which they are given information, spaces have been provided near the galleries where they can learn about objects and their contexts, either electronically or from live informants.

The Getty collection of Greek and Roman antiquities will be on display temporarily at the Getty Center and, after several years of renovation at the Villa (fig. 12), then will move back to Malibu in the year 2001. The Villa will become an international center for the exhibition, study, conservation, and public education in the field of antiquities and comparative archaeology. The permanent collection will fill both levels of the Museum building, together with temporary exhibitions. Interdisciplinary research, conservation treatment, conservation training, publications, and performances are planned by a consortium of Getty organizations.

For those who work for the Getty Museum and the other programs of the Getty Trust, J. Paul Getty's legacy has brought the professional adventure of a lifetime. For the Museum's visitors it will go on furnishing new surprises, pleasures, and rewards.

N . B .

Getty's own observations as quoted here have been taken from the following books written by or with him: *Collector's Choice* (with Ethel Le Vane), London: W. H. Allen, 1955; *The Joys of Collecting*, New York: Hawthorn Books, 1965; and *As I See It*, Englewood Cliffs: Prentice-Hall, 1976.

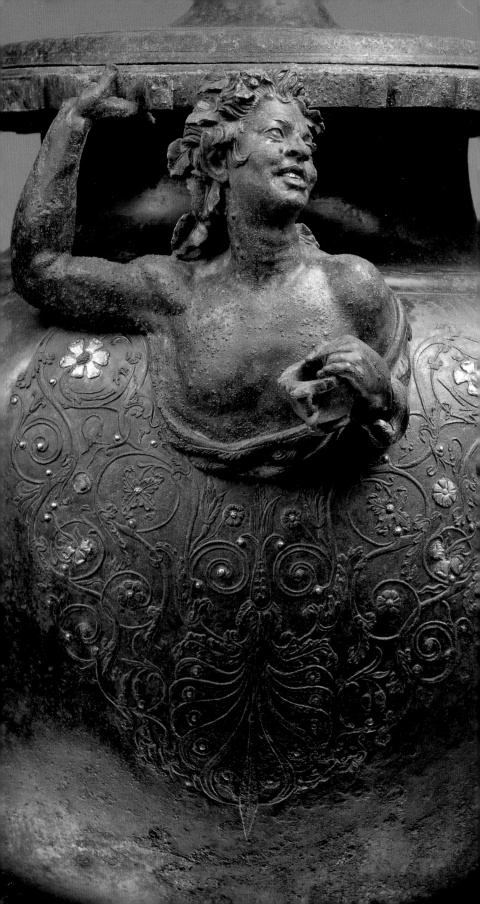

Antiquities

The Museum's antiquities collection began with J. Paul Getty's purchase of a small Classical terracotta sculpture at a Sotheby's auction in London in 1939. The thirty-eight years that passed between that time and Getty's last direct acquisition, a marble head of a Roman youth, witnessed the creation of a collection of ancient Greek and Roman art that was the third most important of its kind in the United States. For many years the collection's greatest strength was in sculpture. It was the heart of the antiquities collection when Getty was alive, and many of the Museum's most interesting examples of ancient sculpture, including the dedicatory group with a portrait of Alexander the Great (see p. 23) and the Tarentine terracotta group of a seated poet and sirens (see p. 43), were acquired under Getty's personal direction.

In the years since his death, the collection has continued to grow. Several major acquisitions of Greek sculpture have been made, including the Victorious Youth (see pp. 32–33) and the brilliantly painted group composed of two griffins attacking a fallen doe (see p. 20). Other additions have included a number of Cycladic marble sculptures of the Aegean Bronze Age (see pp. 17–18) and the Cult Statue of a Goddess from the Classical period (see pp. 20–21).

Important acquisitions have also been made in other areas; the collection of vases has grown to be the department's strongest holding. Included are such masterpieces as the large drinking cup painted by Onesimos, the drinking cup painted by Douris, and the Chalcidian amphora by the Inscription Painter (see pp. 46–48). Other noteworthy acquisitions have been made in the areas of Roman bronze sculpture, Greek and Roman gems, and such luxury wares as Hellenistic silver and Roman glass. The most recent and substantial acquisition has been the important collection of Lawrence and Barbara Fleischman, consisting of some three hundred objects made in a variety of media and ranging in date from the Bronze Age to Late Antiquity. Outstanding for their rarity and excellent state of preservation are the Cycladic Head of an Idol (see p. 17) and the bronze Lebes (see p. 33). While the scope of the Museum's collection has been extended to include fine examples of Egyptian portrait painting and cast bronzes from Northern Europe, its focus has been and will continue to be art of the Classical period.

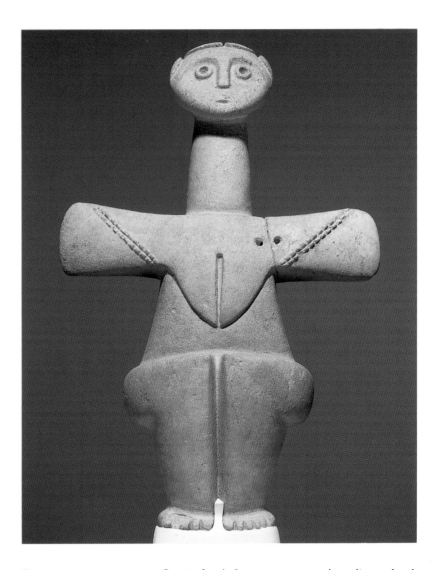

FERTILITY GODDESS

Cypriot, 3000 – 2500 B.C.
Limestone
42.4 × 27.7 cm
(16½ × 10¹³⁄₁₆ in.)
83.AA.38

Cypriot female figurines are among the earliest sculpted objects of artistic importance from the Aegean and eastern Mediterranean areas. Since they usually range in height from only about an inch to just over a foot, the Museum's statuette is one of the largest known. With head raised, arms extended, and legs drawn up, this figure appears to be squatting, perhaps giving birth. The phallic character of the head and neck is intentional, and the configuration of the breasts implies female genitalia. The holes drilled in the figure's left shoulder and arm are part of an ancient repair: the broken arm was fastened on by a cord threaded through the holes. Such careful treatment proves that this statuette was prized by its ancient owner.

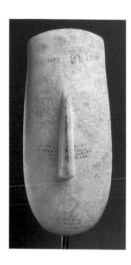

Head of an Idol of the Early Spedos Type

Early Cycladic,
2600–2500 B.C.
Island marble with
polychromy
22.8 × 8.9 cm (9 × 3½ in.)
96.AA.27

Although this head from a Cycladic idol is rare in that it is almost life-size, its features follow the abstract simplicity that is typical of Cycladic statues. This piece is also important in that it preserves much of the colorful detailing that most likely decorated all Cycladic sculpture: a fringe of hair across the brow, dotted tattooing on the cheekbones, and a stripe along the bridge of the nose. These finely carved and modern-looking statuettes were created in the Bronze Age (circa 3000–1100 B.C.) and have been found throughout the eastern Mediterranean. They represent the earliest form of art created by the Greeks.

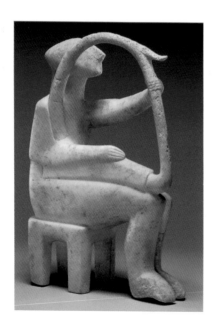

Harpist

Early Cycladic II,
circa 2500 B.C.
Island marble
35.8 × 9.5 cm (14 × 3¹¹⁄₁₆ in.)
85.AA.103

Men are infrequently represented in Cycladic art. When they do appear, they are often musicians who play the harp or a wind instrument. This seated harpist is the sole male Cycladic figurine in the Museum's collection, and one of only ten harpists known today. He sits on a four-legged stool, his left hand encircling the frame of his instrument and his right hand resting on its sound box. The original purpose of the figure is unknown. Such figures may have been created as protective idols that accompanied their owners to the grave.

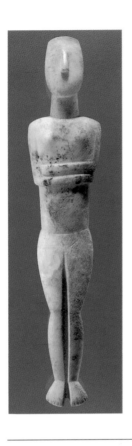

FEMALE FIGURE OF THE LATE SPEDOS TYPE

Attributed to the
Steiner Master
Early Cycladic II,
2500 – 2400 B.C.
Island marble
H: 59.9 cm (23⅞ in.)
88.AA.80

Discovered on the Greek islands known as the Cycla-
des, female idols of this kind have been found in
both burial sites and sanctuaries, although their exact
purpose remains unknown. This piece belongs to
the best-known and most numerous figure type, those
reclining with folded arms. The details of the human
body are reduced to a minimum, and the figure is a
flattened, schematic representation that approaches
pure abstraction. Incision delineates the arms from the
body, separates the thighs, and defines the abdomen
and pubic triangle. Many idols originally were enhanced
with brightly colored pigments that accentuated ana-
tomical features and decorative markings.

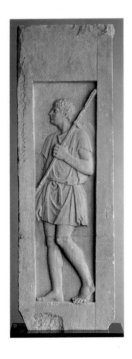

SLAB WITH RELIEF OF A YOUNG HUNTER

Greek (Macedonia),
350 – 300 B.C.
Marble
143.1 × 42.7 cm
(56⅛ × 16¹¹⁄₁₆ in.)
96.AA.48

A young hunter is shown in relief with his spears
propped on his shoulder. Slung from the weapons is an
indistinct object, possibly a traveling hat or a net bag
for holding the day's catch. Since the relief was origi-
nally painted, colored details would have helped to
identify the item. The architectural molding preserved
at the top right edge of the slab confirms that it formed
the right-hand wall of a three-sided funerary shrine
(naiskos). The figure of the hunter would have looked
toward an image of the deceased on the back wall.

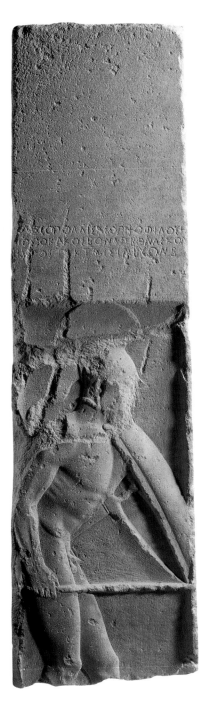

GRAVE STELE
OF THE HOPLITE
POLLIS

Greek (probably from
Megara), circa 480 B.C.
Marble
149.8 × 44.5 cm
58⁷⁄₁₆ × 17⅛ in.)
90.AA.129

The style of this figure displays inno-
vations in the rendering of human
anatomy and perspective made during
the Early Classical period (480 – 450
B.C.). The body is defined with confident,
sharp contours, the surfaces of the
musculature are accurately carved with
subtly modeled anatomical details, the
profile pose is nearly correctly rendered,
and the warrior appears as if he were
about to move. His angled shield is
sculpted to show its deep interior curve.
Made to mark the grave of a Greek foot
soldier (hoplite) named Pollis, this stele
probably stood in or near the Greek
city-state of Megara, midway between
Athens and Corinth. The three-line
inscription written in Megarian script
above the figure of Pollis reads: "I speak,
Pollis, the beloved son of Asopitos,
having not died a coward [but fighting]
in the line of battle." The nude Pollis
is armed with a spear in his right hand,
a round shield on his left arm, a sword
at his left side, and a helmet. This
monument to a brave warrior was made
around the time that the Greeks
were fighting the Persians in 480 B.C.

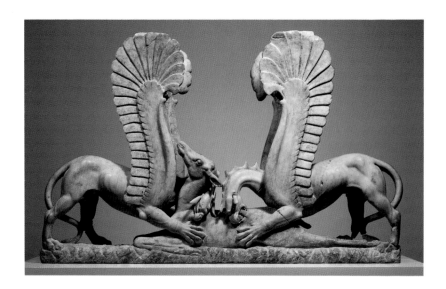

SCULPTURAL GROUP OF TWO GRIFFINS ATTACKING A FALLEN DOE

Greek (South Italy), late
fourth century B.C.
Marble with polychromy
95 × 148 cm (37¼₆ × 57¼ in.)
85.AA.106

The surviving pigments on this sculptural group provide a vivid reminder that all ancient marbles were once brightly painted. In a remarkable feat of sculpting, the artist has captured the notion of dangerous beauty by juxtaposing the lithe, sinuous forms of the griffins with the brutality of their attack on the ill-fated doe. The symmetrical, upright, sickle-shaped wings were functionally necessary, for the channels carved between the wings indicate that the piece served as a support, probably for a ceremonial table.

CULT STATUE OF A GODDESS, PERHAPS APHRODITE

Greek (South Italy),
425 – 400 B.C.
Limestone and Parian
marble with polychromy
H: 220 cm (85¹³⁄₁₆ in.)
88.AA.76

The over-life-size proportions, quality of execution, and the fact that the figure is finished on all sides suggest that this statue was made as a cult image, or sacred representation of the deity, intended to stand within a temple. The voluptuous proportions of the figure and the carefully articulated suggestion of breezes moving the drapery make it most likely that the subject is Aphrodite, the goddess of love and sexuality. It is sculpted from an unusual combination of materials: fine limestone is used for the draped body and Parian marble is used for the head, preserved arm, and foot. Although this statue is surely a product of the Greek colonies of South Italy and Sicily, it nevertheless strongly reflects the style of late Classical sculpture from Athens.

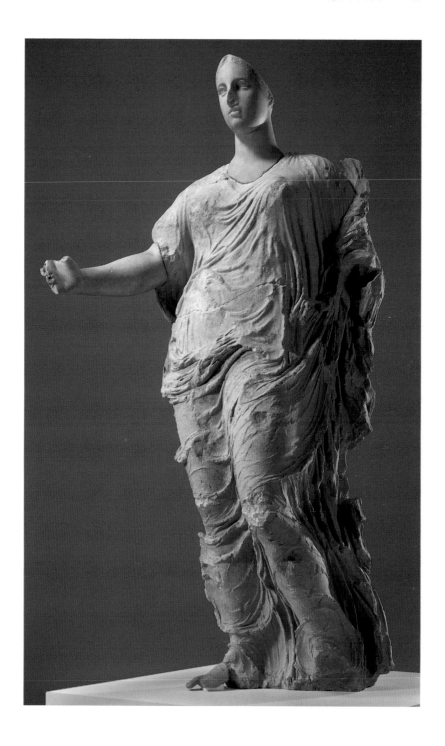

LEKANIS

Greek (South Italy),
late fourth century B.C.
Marble with polychromy
H: 30.8 cm (12 in.);
DIAM: 60 cm (23¾ in.)
85.AA.107

The decoration on the interior of this unique ceremonial basin provides a sense of the original appearance of Greek wall painting. Rendered in vivid polychromy, Thetis and two Nereids ride to the left, one on a spirited sea horse (*hippocampos*), the other two on sea monsters (*kete*). Each carries a piece of armor for Thetis' son Achilles, the greatest Greek hero in the Trojan War. When the lekanis was filled with water, the illusion that the Nereids were riding over the sea would have been complete. The basin was probably used for a foot-washing ritual.

PORTRAIT OF A
BEARDED MAN

Greek, Hellenistic,
160–150 B.C.
Marble
40.7 × 25 cm (16¹/₁₆ × 9⅞ in.)
91.AA.14

Although the size and individualized features indicate that this head is a portrait of an important man, the lack of a diadem signifies that he was not a king at the time it was carved. Stylistically the head relates closely to the figures of gods and goddesses fighting giants on the Great Altar of Zeus at Pergamon, a city on the western coast of Turkey, and to other Pergamene portraits. The subject may have been a high-ranking member of the powerful Attalid dynasty that ruled Pergamon during the Hellenistic period (323–31 B.C.), possibly Attalos II. The head was once part of a draped standing sculpture; traces of a mantle remain on the back of the neck. The head was damaged in antiquity and has survived as two large fragments.

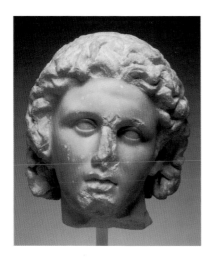

PORTRAIT OF ALEXANDER THE GREAT

Greek, circa 320 B.C.
Marble
H: 28 cm (10¹⁵⁄₁₆ in.)
73.AA.27

Identifiable by the manelike, swept-back hair and the deep-set, upturned eyes, this head is undoubtedly a portrait of Alexander the Great (356–323 B.C.). This portrait type of the youthful conqueror of the Persian Empire and India was created by Lysippos, the only sculptor Alexander allowed to portray him during his short life. It combines elements of Alexander's actual appearance with features of ideal representations of gods and heroes. The head belongs to a statue that probably was part of a commemorative monument composed of several figures, including Alexander's favorite companion, Hephaistion.

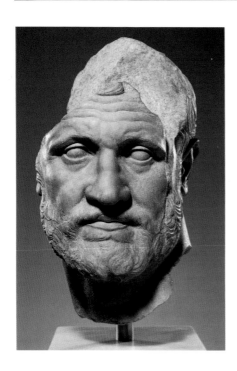

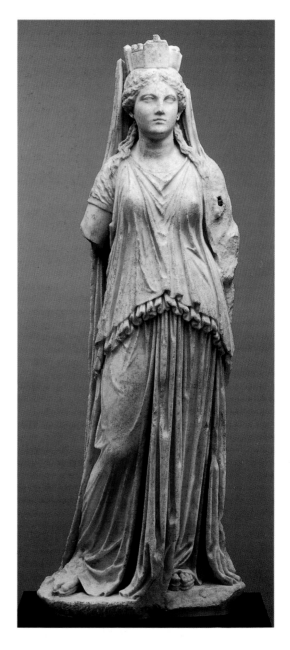

STATUE OF
TYCHE

Greek, Hellenistic,
150 – 100 B.C.
Island marble
H: 84.5 cm (33¼ in.)
96.AA.49

Tyche, the personification of a specific city and, more generally, the goddess of good fortune, is identified by her turreted mural crown. During the Hellenistic period (323 – 31 B.C.), when many cities were being founded by Alexander the Great's successors, large statues of Tyche were commissioned to ensure safety and prosperity. Smaller statues of Tyche, such as this one, were most likely adaptations of the life-size or colossal public representations. This statue was originally adorned with real earrings and a necklace, secured through holes in her ears and veil. Other details would have been added with paint.

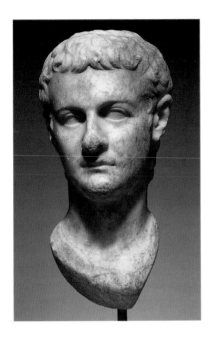

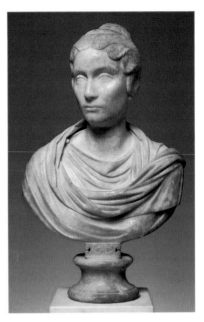

PORTRAIT OF CALIGULA

Roman, early first
century (A.D. 37–41)
Marble
H: 43 cm (16¾ in.)
72.AA.155

Gaius Julius Caesar Germanicus, the
third Emperor of Rome (r. A.D. 37–41),
spent his early childhood in a Roman
army camp in Germany. Since his par-
ents dressed him in a military costume
that included *caligae*, the footgear of
a soldier, the legionnaires gave him
the nickname Caligula, or Little Boots.
He became Emperor of Rome at the
age of twenty-five but was assassinated
within four years because his reign
had turned despotic and his behavior,
cruelly erratic. Because of his unpopu-
larity, most portraits of Caligula were
destroyed after his death. This surviv-
ing likeness reflects late Julio-Claudian
classicism, a style popular during
the reign of Claudius (r. A.D. 41–58),
Caligula's successor.

PORTRAIT BUST OF A ROMAN LADY

Roman, A.D. 150–160
Carrara marble
H: 67.5 cm (26⁹⁄₁₆ in.)
83.AA.44

The features of this elegant lady convey
a placid yet intriguing character.
Although her face is unlined, she is no
longer young; one detects the confi-
dent self-assurance of a Roman matron
secure in her status. Her elaborate
coiffure is in the fashion of Faustina the
Elder, wife of Emperor Antoninus
Pius (r. A.D. 138–161), and the high pol-
ish also dates the piece to the Antonine
period. This bust provides a fine example
of the unique achievement of the Roman
portrait sculptors.

LANSDOWNE
HERAKLES

Roman copy after a Greek
original of 375 – 350 B.C.
by the Polykleitan school,
circa A.D. 125
Pentelic marble
H: 193.5 cm (76⁳⁄₁₆ in.)
70.AA.109

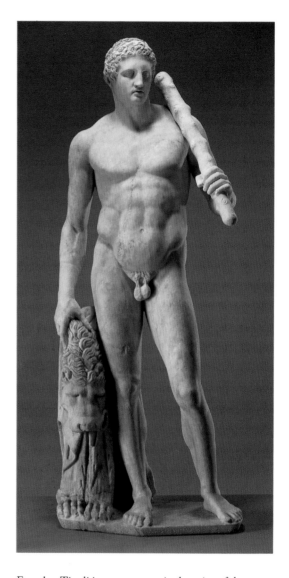

Found at Tivoli in 1790 or 1791 in the ruins of the
villa of the emperor Hadrian (r. A.D. 117 – 138) and un-
til 1951 in the collection of the marquess of Lansdowne,
the Lansdowne Herakles was one of J. Paul Getty's
favorite pieces. The young Herakles is shown larger
than life-size, carrying the club with which he slew the
Nemean lion and holding its skin. As an exemplar
of human achievement and the subject of philosophical
discussion, he was an appropriate model for a Roman
emperor.

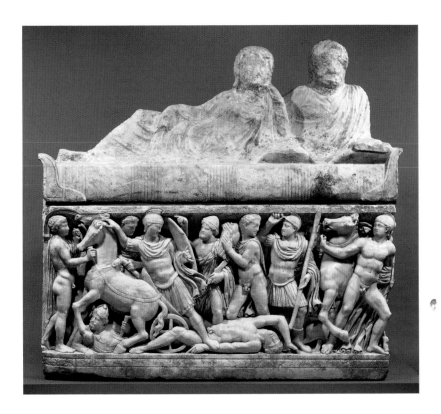

SARCOPHAGUS
WITH LID

Roman (Athens), late
second–early third
century A.D.
Pentelic marble
Box: 134 × 147 × 249 cm
(53 × 58 × 98 in.)
Lid: 100 × 95 × 218 cm
(39⅛ × 37⅜ × 86 in.)
95.AA.80

Carved in high relief on three sides of the box are
scenes from the legend of Achilles, the Greek hero of
the Trojan War and a central figure in Homer's *Iliad*.
On the right end, Achilles is discovered by Odysseus
hiding among the daughters of King Lykomedes
on the island of Skyros to avoid joining the Greeks at
Troy. On the left end, Achilles arms for battle with
Odysseus and a spear carrier (*doryphoros*) looking on.
The armor he dons is new, recently received from
his mother, the Nereid Thetis. The result of Achilles'
confrontation with the great Trojan hero Hektor is
shown on the front, as Achilles mounts his chariot to
drag Hektor's body around the walls of the city. On
the back of the sarcophagus the shallower relief scene
of Lapiths fighting Centaurs may also be understood
as a reference to Achilles, who was educated by the
Centaur Cheiron. On the lid two figures recline on an
elaborate couch. Their heads were left in an unfin-
ished state so that the portraits of the deceased could
be carved after the piece was purchased.

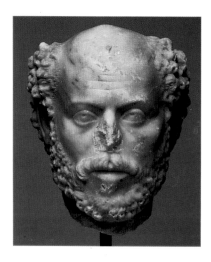

PORTRAIT OF
A BALDING MAN

Roman (Asia Minor),
circa A.D. 240
Proconessian marble
H: 25.5 cm (10 in.)
85.AA.112

This beautifully carved and well-pre-
served portrait head depicts a balding,
elderly man. The individualized features
suggest that he may have been a person
of some importance, perhaps a magis-
trate or an educated man. The fact that
the striking blue-gray marble from
which the portrait is carved comes from
the area around the island of Marmara
in modern-day Turkey may indicate that
the subject was a Roman citizen of Asia
Minor. The unknown artist skillfully
utilized the contrasting techniques of
deep drill work and high polish to differ-
entiate between the textures of the sub-
ject's smooth skin and tightly curled hair.

STATUETTE OF A
SEATED LION

Greek (Lakonia),
mid-sixth century B.C.
Bronze
9.3 × 5 × 13.3 cm
(3⅝ × 1¹⁵⁄₁₆ × 5¼ in.)
96.AB.76

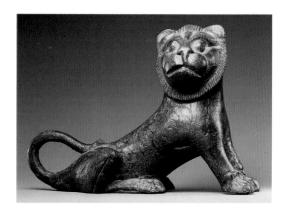

Serving a decorative or dedicatory function, this hollow-
cast bronze statuette of a lion is seated in an alert pose,
emphasized by its upright ears, arched eyebrows, and
bulging eyes. Like other representations of lions manu-
factured in Lakonia, the region around the ancient
city of Sparta in southern Greece, this one has an incised
mane and mild demeanor.

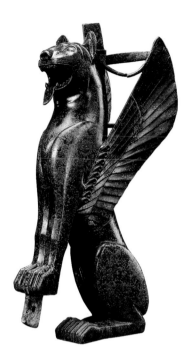

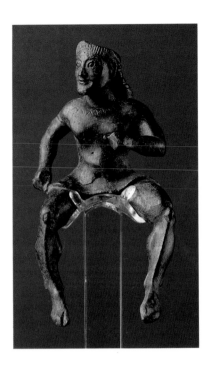

FURNITURE
SUPPORT
REPRESENTING A
WINGED FELINE

Tartessian, 700 – 575 B.C.
Bronze with gilding
H: 61 cm (24 in.)
79.AB.140

Although winged felines were popular
in Greek, Phoenician, and Assyrian art,
this creature's articulated wings and
curved brow point to an origin in
Tartessos, the Phoenician colony on
the southwest coast of the Iberian penin-
sula. The beast was cast in two separate
pieces that are joined with rivets just
below the wings. The thin bronze rods
between the head and wings could
be design features, but more likely they
are part of the bronze mold's internal
system of tubes, which facilitated the
flow of the molten metal. The pierced
projections behind the head and below
the front paws of the winged creature
indicate that it was attached to a larger
structure, such as a wooden throne.

STATUETTE OF
A RIDER

Greek (Corinth),
circa 550 B.C.
Bronze
H: 8.5 cm (3⁵⁄₁₆ in.)
96.AB.45

Filled with youthful exuberance, this
small figure once sat astride a large
horse, his muscular legs tensely clinging
to the sides of the mount. The top of
his head is flattened, suggesting that he
originally wore a hat. He may be one of
the Dioskouroi, the twin sons of Zeus,
who were renowned horsemen. A simi-
lar bronze was found at the sanctuary
of Zeus in Dodona, in northern Greece.
The object most likely served as a
votive offering, which would have been
dedicated at a sanctuary.

STATUETTE OF A FALLEN YOUTH

Greek, 480–460 B.C.
Bronze with copper inlays
7.3 × 13.5 cm (2⅞ × 5¼ in.)
86.AB.530

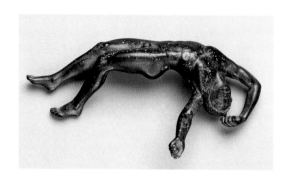

The closed eyes, prostrate pose, and twisted torso of this figure suggest that he is likely dead. He may be a fallen warrior holding his weapons (now missing) who was part of a group composition, perhaps showing figures in a landscape. The beautifully articulated details of this figure are the work of a master craftsman. Copper inlays were used for curls of the hair and the nipples. These inlays, now lost or altered by oxidation and burial, once created a rich contrast with the golden tones of the figure's polished bronze flesh.

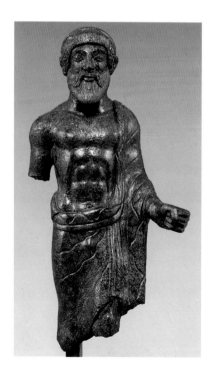

STATUETTE OF A BEARDED MAN

Etruscan (Piombino),
circa 480 B.C.
Bronze
H: 17.2 cm (6¹¹⁄₁₆ in.)
55.AB.12

Said to have been found in Piombino, this figure is a fine example of Early Classical Etruscan statuary. The rigid frontality of its pose and the advanced left leg are vestiges of the earlier Archaic style, but the more naturalistic treatment of the torso and face are new. The figure wears a *tebenna*, the Etruscan precursor of the Roman toga. Perhaps the now-missing object he held in his clenched left hand was a scepter, justifying his frequent identification as Tinia, the Etruscan equivalent of the king of the Greek gods, Zeus.

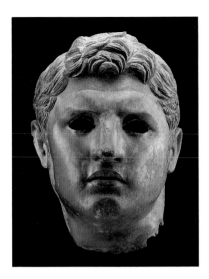

Portrait of a Man

Roman (Asia Minor),
first century B.C.
Bronze
H: 29.5 cm (11½ in.)
73.AB.8

This head, which once had realistic inlaid eyes and lips inlaid with copper, was part of a full-length statue probably depicting either a prince or ruler. The image is a powerful and vigorous one, befitting a man who was a leader during the Hellenistic period (323 – 30 B.C.). It shows the idealized features characteristic of portraits of men whose rule was legitimized by courage and will, rather than by divine or royal status.

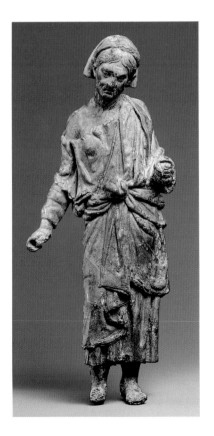

Statuette of an Old Woman

Greek, Late Hellenistic,
first century B.C.
Bronze
H: 12.6 cm (4¹⁵⁄₁₆ in.)
96.AB.175

Although the objects once held in her hands are now missing, the pose of this frail old woman suggests that she is spinning wool. She would have held a distaff with raw wool in her left hand and twisted the thread away from her body with her right hand. She tilts her head downward, following the movement of the thread. Her clothing is reflective of the humble attire worn by women engaged in domestic and agricultural tasks. Representing people of varying ages and status in a variety of poses was of great interest during the Hellenistic period (323 – 30 B.C.).

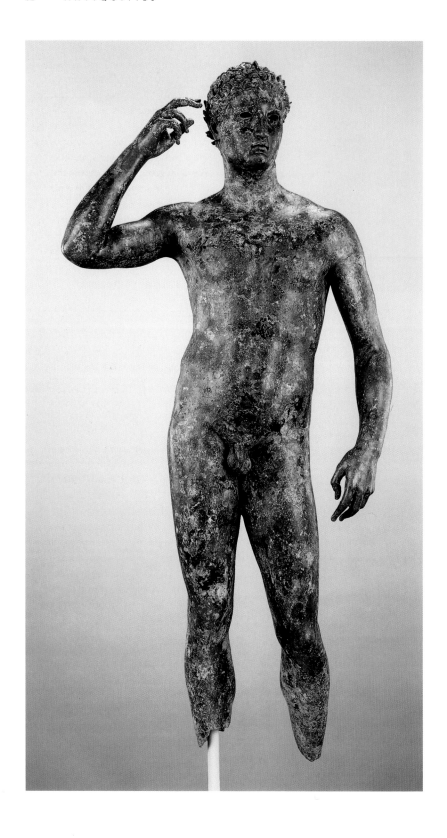

STATUE OF A
VICTORIOUS
YOUTH

Greek, 325 – 300 B.C.
Bronze with copper inlays
H: 151.5 cm (59⅝ in.)
77.AB.30

Few monumental Greek bronze sculptures have sur-
vived. Among them, this representation of a victorious
young man is one of the finest examples from the last
decades of the fourth century. Standing confidently, the
subject raises his right hand beside his head, on which
he has just placed the olive wreath of victory. Each city
or sanctuary that hosted competitions awarded wreaths
made from a specific plant to their winners, and the
olive wreath was the prize given to the victor in the
most prestigious of all of these contests, at Olympia.
This sculpture most likely was dedicated there.

The artist is unknown, but the figure's open stance,
the small size of the head relative to the body, and
the slight torsion of the pose strongly reflect the inno-
vations of Lysippos, the fourth-century-B.C. sculptor
who specialized in cast-bronze figures.

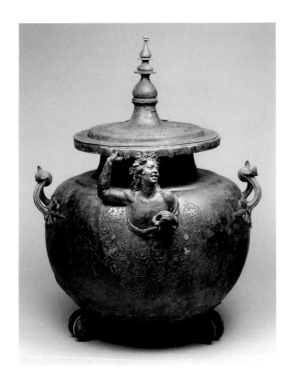

LEBES

Greek, Late Hellenistic,
50 – 1 B.C.
Bronze with silver inlays
H: 58 cm (22¹³⁄₁₆ in.)
96.AC.51

Adorning the front of
this cauldron, or *lebes*, is
a half-length figure of
a young satyr, a member
of the retinue of Dio-
nysos, the god of wine.
The handsome rustic
snaps his fingers and
bares his teeth in a wild,
impudent grin; his eyes
and teeth are silvered.
This figure and the large
grape leaf below the
handle in the back imply
that the object functioned
in some aspect of the
Dionysiac cult, possibly
for serving wine. The
good condition of this
piece suggests that it may
have been placed in a
tomb, either as an urn or
a funerary offering.

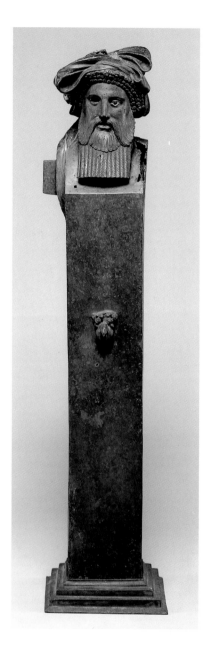

HERM OF
DIONYSOS

Attributed to the
Workshop of Boethos
Greek, Late Hellenistic,
100 – 50 B.C.
Bronze with ivory inlay
H: 103.5 cm (40⅛ in.);
W (base): 23.5 cm (9¼₆ in.)
79.AB.138

In Greece and Rome, a sculpture called
a herm was a rectangular pillar sur-
mounted by a head, often of Hermes, the
god of travelers, commerce, and thieves.
Herms stood at crossroads to protect
travelers and at the entrances of homes
to keep evil away. The Getty herm is
unusual in featuring a bearded, turbaned
image of Dionysos, the god of wine
and the theater. In common with other
large-scale Greek bronzes, the head
had inlaid ivory eyes with the iris and
pupil added in colored stone. One ivory
eye remains, and the bronze eyelashes
are also visible. This herm is very
similar to one that was discovered with
other Greek bronze sculptures in an
ancient shipwreck off Mahdia on the
coast of Tunisia. The two herms appear
to be two different versions of a single
original model. The Mahdia herm
was signed by the sculptor Boethos
of Kalchedon, whose works were highly
prized by Roman collectors of Greek art.

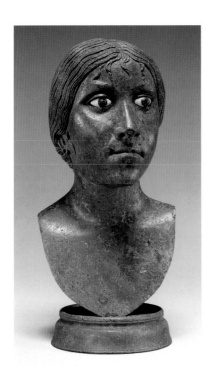

MINIATURE PORTRAIT BUST OF A YOUNG WOMAN

Roman, late first century B.C.
Bronze with glass-paste inlays
H: 16.5 cm (6⁷⁄₁₆ in.)
84.AB.59

Remarkably detailed and well preserved, this small bust of a Roman lady attests to the sensitivity of the craftsman responsible for its manufacture. After casting, the head was engraved with many details, in particular with the braided and knotted hairstyle popular during the reign of Augustus (31 B.C.–A.D. 14). The earrings are missing; but the inlaid eyes of glass paste, which do not usually survive from antiquity, are preserved and add to the head's strikingly realistic impression.

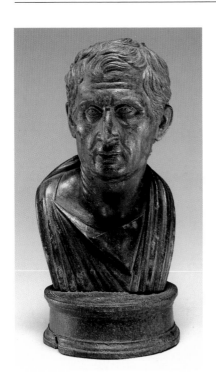

PORTRAIT BUST OF MENANDER

Roman, early
first century A.D.
Bronze
H: 17 cm (6⅝ in.)
72.AB.108

The faint inscription (MENANΔPO() on the round base of this bust identifies this man as the Greek playwright Menander (342/41–291/90 B.C.). His comic plays were famous in his own time, and later they were adapted by Latin authors such as Plautus and Terence for Roman audiences. Although many replicas of this portrait type exist, this bust is one of two known versions inscribed with Menander's name, confirming the identity of this popular image.

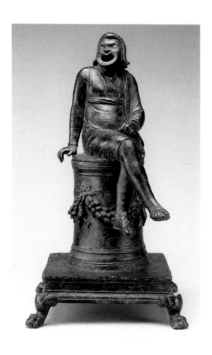

THYMIATERION

Roman, first half of
the first century A.D.
Bronze with silver inlays
H: 23.3 cm (9⅛ in.)
87.AC.143

This incense burner features an actor
who wears the clothing and mask associ-
ated with productions of Greek New
Comedy. The mask's wide open mouth
was appropriate for comic effect and the
amplification of speech. The figure is
hollow, however, and the altar on which
he sits is pierced underneath for venti-
lation. As the incense smoldered inside
the altar, the perfumed smoke would
emerge through the actor's open mouth.

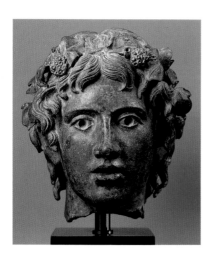

HEAD OF THE
YOUNG DIONYSOS

Roman, A.D. 1 – 50
Bronze with silver inlays
H: 21.6 cm (8½ in.)
96.AB.52

The twisted vine wreath covered with
leaves and berries indicates that this
life-size head is that of Dionysos, the
god of wine, represented here as a beau-
tiful youth. The pupils and irises of
his eyes would have been inlaid in glass
or stone making him appear very life-
like. Despite these missing elements,
the dreamy expression still verges on the
erotic, with an intent to transfix recep-
tive viewers. Based upon similar statues
of a youthful Dionysos, this head
was once part of a full-length figure that
might have served as a lamp or tray
bearer.

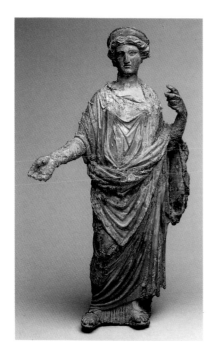 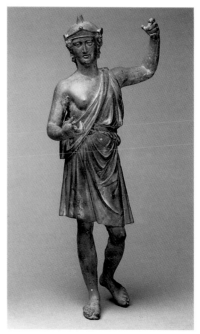

STATUETTE OF CERES OR JUNO

Roman, A.D. 40 – 68
Bronze
H: 32 cm (12½ in.)
84.AB.670

Clad in a long tunic and mantle, this figure is identified as a deity by her diadem. Her original attributes are missing, but the positioning of her hands suggests that she held an offering dish (*patera*) in her right one and a scepter or spear in her left. While various Roman goddesses are represented with these attributes on coins of the period, this figure is probably either Ceres (the Greek Demeter) or Juno (the Greek Hera). A large, square hole in the back of the statuette indicates that it was once fastened to another object, perhaps a chariot or a piece of furniture.

STATUETTE OF ROMA OR VIRTUS

Roman, A.D. 40 – 68
Bronze
H: 33.1 cm (12¹⁵⁄₁₆ in.)
84.AB.671

The impact of Greek classicism on Roman Imperial art is evident in this fine statuette of a female deity. The figurine once held objects that established her identity. She might represent Roma, the personification of the city and empire of Rome, or Virtus, the embodiment of valor. Common to both are the helmet, spear, and short chiton, or dress, that leaves the right breast bared. The distinguishing attribute would have been held in her right hand: a winged Victory if Roma or a sword if Virtus. This figure may have been part of a group that included the bronze Statuette of Ceres or Juno (see previous entry) and the Togate Magistrates (see p. 38).

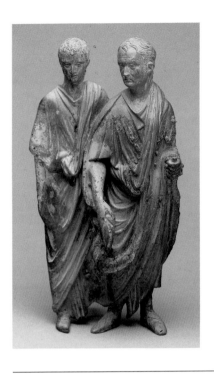

RELIEF WITH TWO TOGATE MAGISTRATES

Roman, A.D. 40–68
Bronze
26 × 13.8 cm (10⅛ × 5⅜ in.)
85.AB.109

The togas worn by these men identify them as members of the upper classes. The older wears the shoes of a senator and holds a scroll in his left hand, indicating that he is either a priest or a local official. The shoe of the younger man is that of a knight. These figures are hollow on the back and, along with the Museum's statuettes of Roma or Virtus and Ceres or Juno (see p. 37), probably formed part of the decoration of a ceremonial chariot or a large piece of furniture.

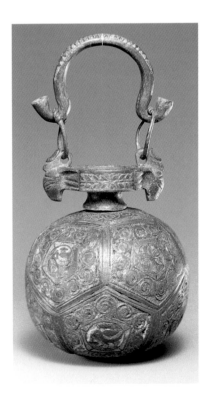

ARYBALLOS

Roman (Gaul), A.D. 70–100
Bronze with red and blue champlevé enamel
H: 10.5 cm (4⅛ in.)
96.AC.190

The round shape and flaring mouth of this aryballos recall the features of terracotta oil containers made in ancient Greece. Two large rings, which pass through elephant-head lugs on either side of the rim, fit over the ends of the handle. Enamel inlays ornament the five-sided panels that decorate the body. Within these panels are curling tendrils enframing smaller pentagons that contain either the image of a bird or a rosette. The use of enamel is typical of vessels produced in the northern part of the Roman province of Gaul.

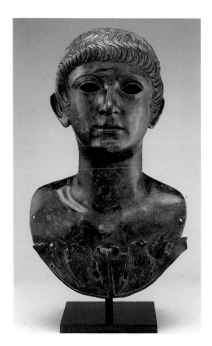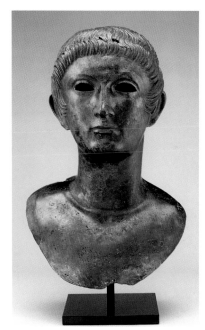

Pair of Portrait Busts

Roman (Gaul), A.D. 60–70
Bronze
H(.1): 40.6 cm (15¹³/₁₆ in.);
H(.2): 40 cm (15⅝ in.)
89.AB.67.1–.2

These two hollow-cast busts were made from the same mold, and only minor differences in appearance distinguish them from one another. Their empty eye sockets were originally inlaid with realistic eyes crafted from colored materials. Their distinctive hairstyle with the wave across the forehead was common in the reign of the Roman emperor Nero (A.D. 54–68). Long, separately made strands of hair were once attached to the backs of their heads, a hairstyle associated with boys who served as sacrificial attendants for various Roman cults (*camilli*) or were special attendants (*tirones*) in an imperial youth organization known as the *Iuventus* (Latin for "the youth" or "young men"). The intended purpose of the *Iuventus* was to prepare aristocratic young men of Rome and its provinces for military service and later for governmental posts. Under Nero it also formed an imperial honor guard. The style of the busts suggests that they were created in Gaul, where they would most likely have been displayed in a local shrine of the *Iuventus*.

STATUETTE OF MARS / COBANNUS

Roman (Gaul),
A.D. 125 – 175
Bronze
H: 76 cm (29 ¹⁵/₁₆ in.)
96.AB.54

The Latin inscription on its base identifies this figure as Cobannus, a local Gallic god identified with Mars, the Roman god of war: "Sacred to the venerable god Cobannus, Lucius Maccius Aeternus, *duumvir,* [dedicated this] in accordance with a vow." In style, the sculpture is a distinctly Gallo-Roman creation. Instead of the customary image of Mars as a mature, bearded man, the god appears here as an idealized youth who wears a contemporary Roman legionary helmet. His costume—a long-sleeved tunic and long leggings worn under a Greek-style cloak—is typical of northern provincial dress. The dedicator of this statue, Lucius Maccius Aeternus, was a *duumvir*, one of the two chief magistrates of a Roman colony.

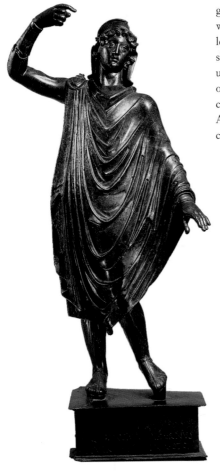

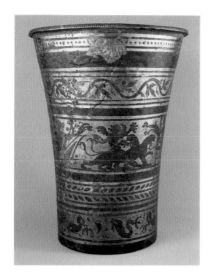

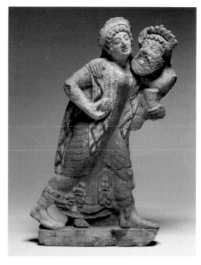

SITULA

Roman (probably Asia
Minor), A.D. 220–320
Bronze with tin plating
H: 33.5 cm (13 3⁄16 in.);
DIAM (rim): 27.2 cm
(10 11⁄16 in.)
96.AC.55

This elegant slender vessel once had a
swinging handle and served as a situla,
or bucket. Its shape goes back to that of
the Greek *kalathos*, a tall flaring basket.
These types of baskets had many uses,
but were especially associated with wool
working and the harvest. On the main
frieze of this container is a lively Diony-
siac procession, particularly appropriate
if this were used in conjunction with the
grape harvest. The god of wine reclines
on a chariot that is drawn by felines.
Riding the felines is Eros, who holds up
bunches of grapes. In front of Dionysos,
a nude young satyr, one of Dionysos'
retinue, runs on tiptoe. Behind Dionysos'
chariot is a dancing maenad, a goat-
legged Pan, and old Silenos, also mem-
bers of Dionysos' circle.

ANTEFIX IN THE FORM OF A MAENAD AND SILENOS DANCING

South Etruscan, early
fifth century B.C.
Terracotta
H: 54.6 cm (21 1⁄2 in.)
96.AD.33

Once decorating the edge of a roof
of an Etruscan temple or civic building,
this figural group was made from a
mold. The maenad, who holds castanets
(*krotola*) in her right hand, seems to
turn her head away from the amorous
Silenos, who eagerly embraces her. He
holds a drinking horn in his left hand,
which adds a sense of revelry. The
original pigments are exceptionally
well preserved and serve as a reminder
that most ancient sculpture and much
of the architecture was brightly painted.

PAIR OF ALTARS

Greek (probably Taranto),
400 – 375 B.C.
Terracotta
41.8 × 31.5 cm
(16⁵⁄₁₆ × 12⁵⁄₁₆ in.)
86.AD.598.1 – .2

The imagery on these two altars forms one composi-
tion. On the right altar, Aphrodite, the goddess of love
and sexuality, and her lover Adonis, associated with
vegetation and fertility, sit side-by-side in a rocky
landscape. Adonis puts his right arm around the god-
dess. Two women attend them, one standing and
carrying a drum, the other seated in a pose associated
with mourning. On the left altar, three women dance
toward the lovers; two carry musical instruments, a
drum and a xylophone. These scenes emphasize the
sadness and joy of the myth of Adonis who, like a plant,
was fated to die and be reborn each year. Probably
made for a private shrine, these small altars were used
for the burning of offerings or incense.

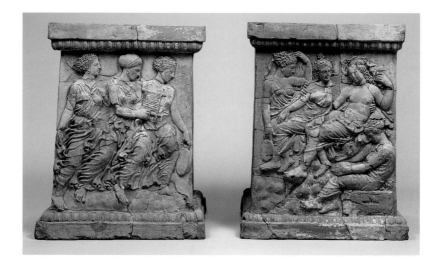

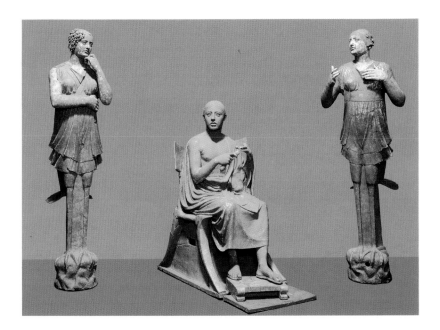

Seated Poet and Sirens

Greek (probably Taranto),
circa 310 B.C.
Terracotta with polychromy
Poet H: 104 cm (40⁹⁄₁₆ in.);
Sirens H: 140 cm (54⅞ in.)
76.AD.11

Once brightly painted, this trio of large clay figures
has often been identified as Orpheus and the Sirens.
Orpheus was a mythical singer, or poet, who survived
a journey to the realm of the dead, and sirens were
monstrous bird-women known for their sweet and
seductive song, which enraptured and drew sailors to
their deaths. Here, the seated man is singing, as shown
by his open mouth and the object in his right hand,
which is the handle of the pick (*plektron*) used to strike
the strings of a harp (*kithara*). His instrument, now
entirely missing, once rested in the hollow on his lap.

Because he is singing and playing the harp, the
seated figure has been identified as Orpheus; his attire,
however, does not match what is found in many con-
temporary representations of the poet. On fourth-
century-B.C. Apulian vases Orpheus is usually shown in
an elaborately embroidered oriental costume—a long,
flowing robe with a short, capelike chlamys around the
shoulders—and a soft Phrygian cap. Since sirens, as
figures who mourn the dead and help fulfill the promise
of life after death, are often found in a funerary con-
text, the seated man may be a simple mortal, depicted
as a poet.

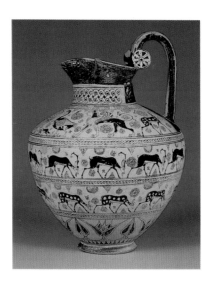

OINOCHOE

East Greek (Rhodes),
circa 625 B.C.
Terracotta
H: 35.7 cm (14 in.);
DIAM (body): 26.5 cm
(10⁷⁄₁₆ in.)
81.AE.83

This trefoil *oinochoe*, or pitcher with a
three-lobed spout, is decorated in a
black-on-white style of vase painting
characteristic of the Orientalizing
period of the seventh century B.C. This
particular type of painting first appeared
on Greek ceramics made in Asia Minor.
The Rhodian variety is painted in the
Wild Goat style, named after its most
common motif. Borrowed from the arts
of the ancient Near East, the decorative
elements of the style remained largely
unchanged for nearly a century. Here the
figural subjects are exclusively animals,
real and imaginary, with floral and geo-
metric patterns used as filler ornaments
and framing borders.

ARYBALLOS

Greek (Corinth), first quarter
of sixth century B.C.
Terracotta
H: 11.2 cm (4⅜ in.);
DIAM: 11.7 cm (4⁹⁄₁₆ in.)
92.AE.4

A rare example of narrative art produced
in the city of Corinth, this oil container
depicts Herakles battling the serpentine
Hydra. He thrusts his sword toward
the Hydra's weaving heads in an attempt
to chop them off but is bitten on the
shoulder by one of them. Behind Herak-
les stands Athena, his patron goddess.
To the right, Herakles' nephew Iolaos
helps to defeat the monster. The names
of Athena, Herakles, and Iolaos are
all written on the vase in the Corinthian
alphabet.

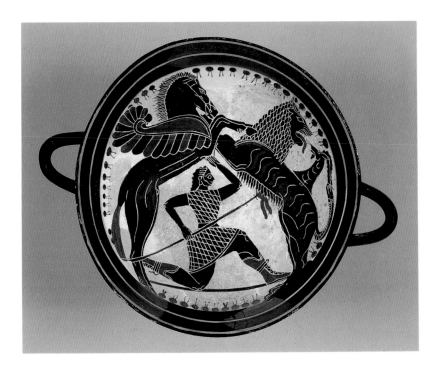

BLACK-FIGURED KYLIX

Attributed to the
Boread Painter
Greek (Sparta),
570 – 565 B.C.
Terracotta
H: 12 cm (4¹¹/₁₆ in.);
DIAM: 14 cm (5½ in.)
85.AE.121

In the relatively brief period during which vase painting
flourished in Sparta, the Boread Painter emerged as
one of the more innovative and accomplished Lakonian
craftsmen. Although creating balanced compositions
presented a challenge for ancient vase painters, here
the Boread Painter grouped his figures in a triangular
arrangement, successfully filling the circular frame
in the interior of the cup. The Corinthian hero Bellero-
phon attacks the mythical Chimaera, a fire-breathing
lion with a goat's head on its back and a snake as its tail.
As the hero thrusts his spear into the belly of the mon-
ster with his right hand, he restrains his winged steed,
Pegasos, with his left.

BLACK-FIGURED NECK-AMPHORA

Attributed to the
Inscription Painter
Greek, "Chalcidian" (Rhegion,
South Italy), circa 540 B.C.
Terracotta
H: 39.6 cm (15⅝ in.);
DIAM: 24.9 cm (9¹³/₁₆ in.)
96.AE.1

A scene from Homer's *Iliad* decorates
this storage vessel. During the Trojan
War, King Rhesos of Thrace and twelve
of his men came to assist the Trojans.
Arriving too late at night to enter Troy,
the exhausted Thracians camped in
the fields outside the city, hanging their
elaborate armor in the surrounding
shrubbery. As they slept, the Greek
heroes Odysseus and Diomedes killed
them in order to steal their immortal
horses. On one side of the vase, Dio-
medes is about to slay Rhesos, while
on the opposite side, Odysseus murders
another Thracian. Named for the
Euboean dialect used in the inscriptions,
"Chalcidian" pottery was probably
made in Rhegion in southern Italy,
a colony of the Greek city of Chalcis.

BLACK-FIGURED HYDRIA

Attributed to the
Eagle Painter
Caeretan (Etruria),
circa 525 B.C.
Terracotta
H: 44.6 cm (17⅝ in.);
DIAM: 33.4 cm (13 in.)
83.AE.346

The Labors of Herakles were popular
as subjects in sixth-century-B.C. vase
painting. However, although the
Museum has two examples (see p. 44),
the slaying of the many-headed Hydra
of Lerna was not a very common repre-
sentation. To kill the vicious sea monster
the hero had to cut off each head and
cauterize the neck so that new heads
could not grow back. Here Herakles'
nephew Iolaos assists him. This vase was
likely made in Italy by an artist who
learned his craft in Ionia. He had as much
interest in the ornamental motifs as in
the human subjects.

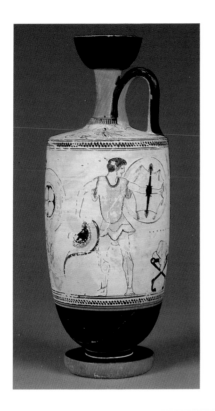

WHITE-GROUND LEKYTHOS

Attributed to Douris
(as painter)
Greek (Athens),
about 500 B.C.
Terracotta
H: 33.5 cm (13⅛ in.);
DIAM: 12.6 cm (4⁵⁄₁₆ in.)
84.AE.770

In a calm, evenly disposed composition around the body of the vase, two young Athenian aristocrats arm themselves in the presence of a boy and a woman. Dressed in a short chiton, one of the youths puts on his greaves, while the other holds his helmet and shield. In the field between the figures is a *kalos* inscription praising the beauty of two youths, Nikodromos and Panaitios.

RED-FIGURED KYLIX

Attributed to the
Brygos Painter
Greek (Athens),
490–480 B.C.
Terracotta
H: 11.2 cm (4⅜ in.);
DIAM: 31.4 cm (12¼ in.)
85.AE.19, 86.AE.286, and
89.AE.58

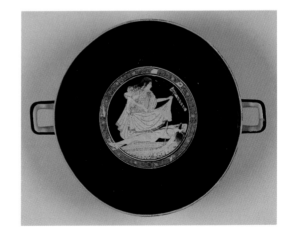

Ajax, the greatest of the Greek heroes at Troy after Achilles, rescued the latter's body from the midst of battle. Angered and humiliated at losing Achilles' armor to Odysseus by vote of their comrades (depicted on side B of the exterior), Ajax decided on revenge but then took his own life instead. Here the painter has depicted the tragic results, as Tekmessa shrouds the body of Ajax, her lover, who lies fallen on his weapon.

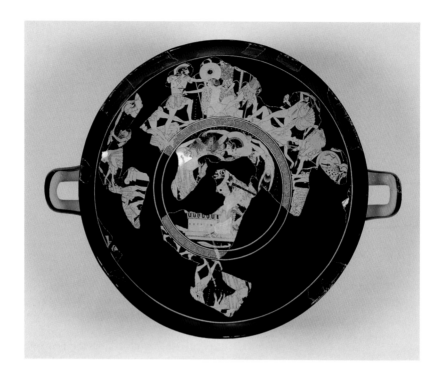

RED-FIGURED KYLIX

Attributed to Onesimos
(as painter); signed by
Euphronios (as potter)
Greek (Athens),
500 – 490 B.C.
Terracotta
H: 19 cm (7⅜ in.);
DIAM: 46.6 cm (19⁵⁄₁₆ in.)
83.AE.362, 84.AE.80,
85.AE.385, and 86.AE.737.1

Remarkable for both its potting and its decoration, this fragmentary late Archaic kylix represents Attic red-figure vase painting at its best. The scenes depicted inside and out are episodes from the Trojan War, a subject appropriate in its grandeur to the monumental proportions of the drinking cup and the elaborate figural compositions. Inside, both the tondo and the surrounding zone are filled with scenes from the Sack of Troy. Especially dramatic is the representation of Neoptolemos' attack on the aged king of Troy, Priam, who has taken refuge on the altar of Zeus Herkaios. The warrior's weapon is the body of Priam's grandson, Astyanax. The artist has provided an accurate and literate illustration of the final episodes from the ancient epic *Iliupersis*, the story of the destruction of the legendary city by the Greeks. The exceptional size and decoration of this vessel suggest that it was made as a dedicatory offering rather than for human use. This is confirmed by the Etruscan inscription underneath the foot dedicating the vase to Herakles.

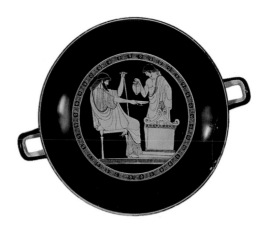

RED-FIGURED KYLIX

Signed by Douris
(as painter); attributed
to Python (as potter)
Greek (Athens), circa 480 B.C.
Terracotta
H: 13.3 cm (5 ⁷⁄₁₆ in.);
DIAM: 32.4 cm (12 ⅝ in.)
84.AE.569

In the interior tondo a stately bearded figure, perhaps Kekrops, a legendary king of Athens, sits before an altar holding a kylix that a youthful attendant fills with wine from an *oinochoe*, or pitcher. On one side of the exterior, the goddess Eos pursues Kephalos as Kekrops and Pandion (both identified by inscription), another mythological king of Athens, and a third king, perhaps Erechtheus, look on. On the other side Zeus seizes the Trojan prince Ganymede.

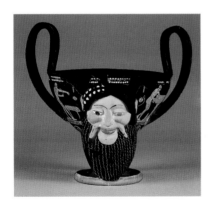

RED-FIGURED KANTHAROS WITH MASKS

Attributed to the Foundry
Painter (as painter) and to
Euphronios (as potter)
Greek (Athens), circa 480 B.C.
Terracotta
H (handles): 21.1 cm (8 ¼ in.);
DIAM (bowl): 17.4 cm (6 ¹³⁄₁₆ in.)
85.AE.263, 88.AE.150, and
96.AE.335.4 – .5, .9

Restored from a number of fragments, this cup has two fully modeled masks attached on either side. One is the face of Dionysos, the god of wine, the other, the face of a satyr. Both are appropriate decorations for a cup used for wine. The bowl is decorated with painted figures of youthful athletes, each standing on a short meander band.

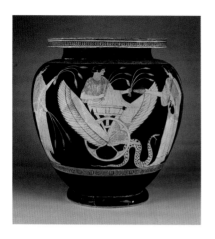

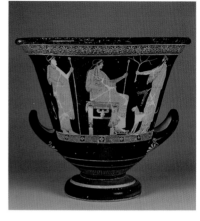

RED-FIGURED
DINOS

Attributed to the
Syleus Painter
Greek (Athens), circa 470 B.C.
Terracotta
H: 36.8 cm (14⅜ cm);
DIAM: 35.7 cm (14 in.)
89.AE.73

Most of the names of the figures depicted
on this vessel used for mixing wine and
water are identified by inscriptions. On
the front, the beautifully rendered figure
of Triptolemos is ready to depart in his
fabulous winged chariot to spread the
knowledge of grain cultivation across
the world. Behind him, Demeter, the
goddess of vegetation and fertility, holds
stalks of grain. Facing Triptolemos is
Kore, the daughter of Demeter, who
offers a departure libation. Additional
figures encircle the vase, including
Hades, god of the Underworld; his
wife Thea; Eleusis, a personification of
the city; Hippothoon and Kalamites,
Eponymous heroes of Eleusis; and an
unidentified man.

RED-FIGURED
CALYX-KRATER

Signed by Syriskos
(otherwise known as the
Copenhagen painter)
Greek (Athens), 470–460 B.C.
Terracotta
H: 43 cm (16¼ in.);
DIAM: 54 cm (21 1/16 in.)
92.AE.6

Both sides of this deep vessel, which was
used for mixing wine and water, depict
unusual mythological scenes. The names
of all the figures are written beside them.
On the front, the goddess Ge Pantaleia
(all-giving Earth) sits on a throne be-
tween her son, Okeanos (Ocean), on the
left, and the god of wine, Dionysos, on
the right. Barely visible over the handle
behind Dionysos is the signature of
Syriskos. This name means "the Little
Syrian," suggesting that he was a for-
eigner working in Athens.

A unique scene is depicted on the
back side of the krater. Themis, the
Greek goddess of justice, is flanked by
Balos (Belos), the son of Poseidon
and Libya, and his maternal grandfather
Ephaphos, the son of Zeus and Io.
The price of the vase, one Greek stater,
is written under its foot. This amount
approximates two day's wages for an
Athenian soldier.

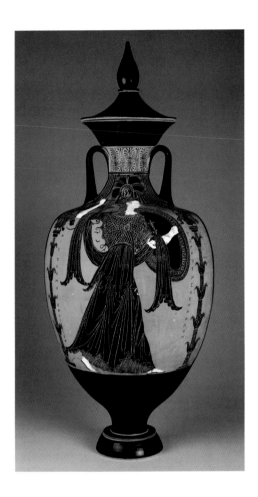

**PANATHENAIC
PRIZE AMPHORA
AND LID**

Attributed to the Painter
of the Wedding Procession
(as painter); signed by
Nikodemos (as potter)
Greek (Athens), 363 – 362 B.C.
Terracotta
H (with lid): 89.5 cm (35 in.)
93.AE.55

Vases of this type were given as prizes for contests
held every four years during the Panathenaic festival
in Athens. Athena, the patron goddess of Athens,
was always placed on the front. The date of this vase
is determined by the presence of the two bordering
figures of Nike, the goddess of victory, standing atop
akanthos columns, which were unique to the year
363/362 B.C. The letters alongside the column behind
Athena spell out the maker of the vase, Nikodemos,
while those alongside the column in front of her iden-
tify the vase as an award.

The reverses of panathenaic amphorae were deco-
rated with images of the contest for which the vase was
awarded. Nike prepares to crown the victorious youth,
a boxer, who has a very long ribbon of leather in his
left hand. When wrapped around the athlete's hand and
wrist, this was his boxing glove. On the left stands his
defeated opponent folding a leather thong in his hands.
The bearded man on the right is the judge of the event.

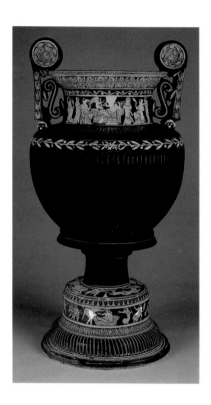

RED-FIGURED DINOID VOLUTE-KRATER AND STAND

Attributed to the
Meleager Painter
Greek (Athens), 390 – 380 B.C.
Terracotta
H: 70.6 cm (27½ in.);
DIAM (krater): 40.6 cm (15¹³⁄₁₆ in.)
87.AE.93

The ribbed black body of this elabo-
rately decorated vase intentionally
imitates metal vessels. The krater is or-
namented with heads of Ethiopians at
the handles' bases, gilded female heads
in the handles' volutes, and floral and
figural decoration on the neck and base.
On the front of the neck is a scene fea-
turing Adonis lying on a couch between
his rival lovers, Aphrodite and Perse-
phone. Echoing the scene on the neck,
the stand shows a reclining Dionysos
attended by Eros and accompanied by
satyrs, maenads, and the gods Hephais-
tos and Apollo. Scenes of mythical and
real combat decorate the shoulder of
the stand, which was cut down in antiq-
uity and has been restored on the basis
of ancient parallels.

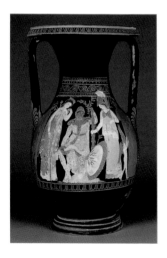

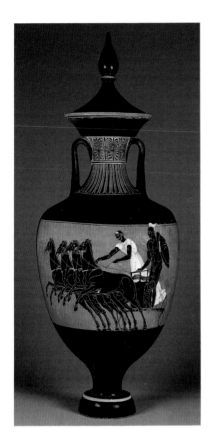

PANATHENAIC PRIZE AMPHORA AND LID

Attributed to the
Marsyas Painter
Greek (Athens), 340 – 339 B.C.
Terracotta
H (with lid): 99.5 cm
(38¹³⁄₁₆ in.)
79.AE.147

This storage vessel belongs to a special class of vases that first came into use about 560 B.C. They were given as prizes to the victors in the Panathenaic games held in Athens every four years. The athletic and artistic competitions honored Athena, the patron goddess of the city. The vases held oil pressed from olives gathered from the sacred groves of Athena, and were always decorated using the black-figure painting technique. The striding figure of Athena adorned one side of these amphorae, and an image of a competition, most probably the one for which the prize was awarded, appeared on the other side. Here a driver and an armored figure (*apobates*) ride in a four-horse chariot. The *apobates* jumped on and off the chariot as it raced against other teams.

RED-FIGURED PELIKE OF KERCH STYLE

Attributed to the circle of
the Marsyas Painter
Greek (Athens), 330 – 320
B.C.
Terracotta
H: 48.3 cm (18⅞ in.);
DIAM (body): 27.2 cm
(10¹³⁄₁₆ in.)
83.AE.10

Vases in the Kerch style take their name from an area on the Black Sea where numerous examples have been found. The style is characterized by an elaborate and often flamboyant use of polychromy, gilding, and relief work to augment the simple red-on-black scheme of earlier Attic vases. The scene represented on the front of the vase is the Judgment of Paris, the young prince of Troy who had to choose the most beautiful of three goddesses: Hera, Athena, or Aphrodite. Paris sits surrounded by the three deities with the messenger god, Hermes, at the far left. The unrelated scene on the back depicts two amazons fighting a Greek warrior.

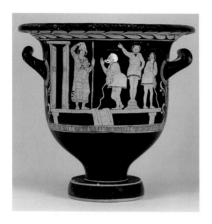

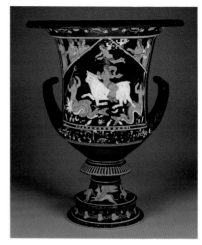

RED-FIGURED BELL-KRATER

Name Vase of the
Choregos Painter
Greek (Apulia, South Italy),
circa 380 B.C.
Terracotta
H: 37 cm (14⁹⁄₁₆ in.);
DIAM (mouth): 45 cm (17¾ in.)
96.AE.29

An unidentified theatrical scene is repre-
sented on the front of this vessel, which
was used to mix wine and water. The
name of each of the four players is in-
scribed above his head, beginning from
the left: Aigisthos, Choregos (a financial
backer), Pyrrhias, and another Chore-
gos. Because the figures are costumed
and stand on an actual stage they appear
to be performing parts in a play, possi-
bly a comic version of the preparations
for a stage production. One theory is
that Aigisthos, who wears tragic dress,
stands for Tragedy. Pyrrhias then rep-
resents Comedy, in the characteristic
pose of a declaimer. The remaining two
actors in masks and padded comic dress
argue over which one they will ulti-
mately back. The reverse side shows a
genre scene: a woman sits attended by
a servant who fans her as she receives a
young male visitor.

RED-FIGURED CALYX-KRATER

Signed by Asteas (as painter)
Greek (Paestum, South Italy),
circa 340 B.C.
Terracotta
H: 71.2 cm (27¼ in.);
DIAM: 59.6 cm (23¼ in.)
81.AE.78

This impressive krater is the largest
of eleven known vases signed by Asteas,
one of only two artists from the city
of Paestum who signed his works.
Standing on an elaborately modeled and
decorated foot, the vase carries the
unique Paestan representation of one of
the most popular myths in antiquity: the
love of Zeus for the mortal girl Europa.
Framed in a unique pentagonal panel,
the white bull into which Zeus trans-
formed himself carries Europa across
the sea. Pothos, the personification of
passionate longing, flies overhead.
Various gods, including Aphrodite and
Eros, watch the scene from the upper
corners like an audience. The theatrical
aspect of the composition follows a
Sicilian tradition. On the back is depicted
a procession of the god of wine, Diony-
sos, and his retinue.

RED-FIGURED LOUTROPHOROS

Attributed to the Painter of
Louvre MNB 1148
Greek (Apulia, South Italy),
late fourth century B.C.
Terracotta
H: 90 cm (35⅛ in.);
DIAM (mouth): 26 cm (10⅛ in.)
86.AE.680

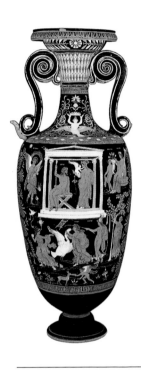

In one of his guises adopted while seducing mortals,
Zeus appears here as a white swan leaping into Leda's
embrace, while Hypnos, a personification of sleep,
showers them with drowsiness. To the right and left are
Leda's companions. In the Ionic building above are
Zeus and Aphrodite with Eros on her arm. Zeus may be
asking for Aphrodite's help in seducing Leda and using
Eros to plead his case. The division of the decoration
into two levels may be inspired by theatrical perfor-
mances, which in antiquity often took place on different
stories of the stage building. Other mythological
figures—Astrape, a personification of lightning; Eni-
autos, the personification of the calendar year; and
Eleusis, a personification of an important sanctuary—
are not clearly connected to the story.

SKYPHOS AND FLASK

Roman, 25 B.C.–A.D. 25
Cameo glass (white on blue)
Skyphos H: 10.5 cm (4⅛ in.);
Flask H: 7.6 cm (3 in.)
84.AE.85, 85.AF.84

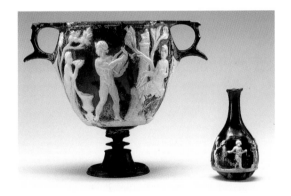

Cameo glass vessels exhibit the great skill of the arti-
sans responsible for their manufacture and carved
decoration. The skyphos is decorated with Dionysiac
imagery: satyrs flanked by female figures. Its foot
is a modern reconstruction. The imagery on the flask
includes Erotes, a striding pharaoh, an obelisk,
and an altar surmounted by the Egyptian god Thoth.

WREATH

Greek, late fourth
century B.C.
Gold, with blue and green
glass-paste inlays and glass
beads
DIAM: 30 cm (11 11/16 in.)
93.AM.30

An abundance of stemmed flowers is attached to a
circlet fashioned as two twigs that hinge at the front by
means of a "Herakles," or square, knot. The myrtle
flowers, many comprised of numerous minuscule com-
ponents, are fashioned out of thin sheet gold. Some of
the delicate petals are inlaid with blue and green glass
paste and some of the flowers have small blue glass
beads attached to the tips of their stamens, adding strik-
ing color accents to an already dazzling display of gold.
Most of the known surviving wreaths are much simpler
in design. Such elaborate wreaths may have actually
been worn in ceremonies, as they often show evidence
of repair. Customarily, they were buried with the dead
along with other precious offerings.

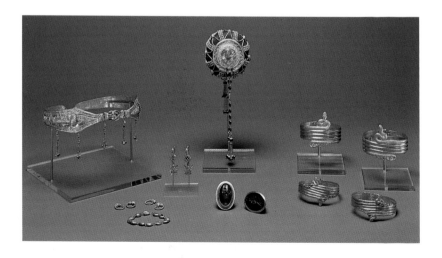

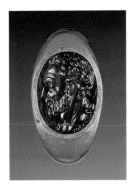

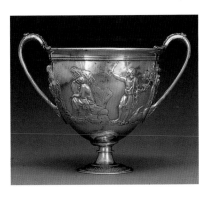

Ring Stone with a Portrait of Demosthenes

Signed by Apelles
(as a gem cutter)
Roman, first century B.C.
Carnelian and Gold
Gem: 1.9 × 1.5 cm (¾ × ⅝ in.)
90.AN.13

This gem is engraved with a portrait of Demosthenes (384–322 B.C.), the city of Athens' most famous orator. It is signed *Apellou*, the genitive of Apelles. The placement of the name surely indicates that it is the signature of the artist, and the style and motif, along with the shape of the gem and ring, suggest a date of the late first century B.C., a time when fine, signed works were in vogue.

Two-Handled Cup

Roman, first century A.D.
Silver
H: 12.5 cm (4⅞ in.);
DIAM: 16.3 cm (6⁷⁄₁₆ in.)
96.AM.57

Encircling this drinking cup is a scene that may be derived from Homer's *Odyssey*. Odysseus was instructed by the sorceress Circe to travel to the Underworld to consult the ghost of the blind seer Teiresias, the only one who could tell the hero when he would return home. Here Odysseus holds aloft his sword and averts his eyes, having slain a ram to summon the ghost. Teiresias sits in the center on a rocky outcrop, gazing sightlessly upward. On the other side five male figures (probably philosophers) converse.

Ensemble of Jewelry

Greek (possibly Alexandria), Hellenistic, 220 – 100 B.C.
Gold with various inlaid and attached stones, including garnet, carnelian, pearl, and glass paste
92.AM.8.1 – .9

This spectacular collection of gold jewelry was surely the prized possession of a Greek woman of high social rank. The style of the pieces and the techniques used indicate that they were probably made in Alexandria, Egypt, by Greek goldsmiths during the reign of the Ptolemies, the rulers of Egypt descended from Ptolemy I Soter, one of the Macedonian generals of Alexander the Great. Signs of ancient repair show that the jewelry was not made specifically for the tomb as funerary offerings, but actually worn. Included are a hair net, a diadem, armlets, bracelets, earrings, and rings.

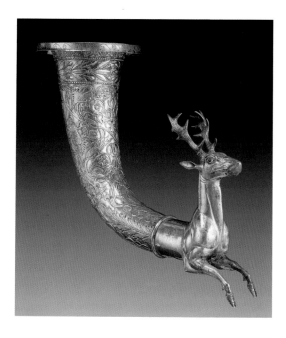

PLATE SHOWING A PHILOSOPHICAL DEBATE BETWEEN PTOLEMY AND HERMES TRISMEGISTOS

Late Antique,
sixth century A.D.
Silver
45 × 28 cm (17⁹⁄₁₆ × 10⅞ in.)
83.AM.342

An unidentified man is enthroned at the top of this plate. Below, a bearded man, designated by a Greek inscription as Ptolemaeus, is seated on the left; behind him stands a woman designated as Skepsis. Facing them is a man named as Hermes, but the inscription relating to the woman with him is lost. The subject seems to be allegorical, perhaps of the philosophical dispute between Science and Mythology. If this is the case, Ptolemy, the founder of the Alexandrian school of scientific thought, is seen here in debate with Hermes Trismegistos, the exponent of traditional human wisdom as embodied in myth.

RHYTON

Eastern Greek (Seleucid
Empire), Late Hellenistic,
late first century B.C.
or early first century A.D.
Gilt silver with glass paste
and stone inlays
H: 26.5 cm (10⅛ in.);
DIAM (rim): 12.7 cm (4¹⁵/₁₆ in.)
86.AM.753

This gilt silver rhyton is one of the most elaborately
decorated drinking horns to survive from antiquity.
Relief floral patterns cover the entire surface of the
curving horn, which terminates in the forequarters of
an antlered stag. Executed with exceptional attention
to anatomical detail—particularly apparent in the
veins running down the creature's snout—the stag is
shown in flight. The preserved inlaid eyes of glass
paste, with the whites clearly visible, heighten the ex-
pression of fear and alertness conveyed by the stag's
raised head. Though the vessel surely was produced in
a workshop on the eastern fringes of the Hellenistic
world, the closest parallels for the ornamental designs
are found among the late Hellenistic decorative arts
created under the Seleucid rulers who inherited the
eastern part of Alexander the Great's sprawling empire.

Preserved on the belly of the animal is an inscription
in Aramaic letters, possibly Persian, which dedicates
this rhyton to the goddess Artemis.

MUMMY PORTRAIT
OF A WOMAN

Attributed to the
Isidora Master
Romano-Egyptian (Fayum),
A.D. 100–125
Encaustic and gilt on a
wooden panel wrapped
in linen
Panel: 33.6 × 17.2 cm
(13⅛ × 6¾ in.)
81.AP.42

Painted portraits such as this one were
usually executed from life on a square
wooden panel, then reshaped after the
subject's death and incorporated into the
linen wrappings of his or her mummy.

The near-perfect condition of this
panel is the result of burial conditions.
At the same time, the liveliness, direct-
ness, and individuality of the represen-
tation support the hypothesis that this
lady sat for her portrait sometime before
her death. Her hairstyle and jewelry
help to date the painting to the early
second century A.D.

Manuscripts

At the J. Paul Getty Museum the art of the Middle Ages is represented primarily by illuminated manuscripts, books written and decorated entirely by hand. In 1983 the trustees of the Museum began the collection with the purchase of the holdings of Dr. Peter and Irene Ludwig of Aachen, Germany. The Ludwig manuscripts represent the history of the art of book illumination from the ninth to the sixteenth century. In order to provide as complete and balanced a representation as possible, about sixty further acquisitions have been made since 1984, including codices and cuttings or groups of leaves from individual books.

Over the course of the Middle Ages manuscripts became the most important means of recording not only scripture and liturgy but also history, literature, law, philosophy, and science, both ancient and medieval. Certain books, mainly religious service books in the early period, came to be decorated with gold, silver, and colors and with elaborate initials, framed paintings (called miniatures), and other decoration.

The Ludwig collection includes masterpieces of Ottonian, Byzantine, Romanesque, Gothic, International style, and Renaissance illumination made in Germany, France, Belgium, Italy, England, Spain, Poland, and the eastern Mediterranean. Among the highlights are three Ottonian manuscripts: the Helmarshausen Gospels, from Romanesque northern Germany (see p. 65); an English Gothic Apocalypse (see p. 70); two Byzantine Gospel books; and a trove of Flemish manuscripts from the fifteenth and sixteenth centuries. Subsequent additions to the Flemish holdings include *The Visions of Tondal*, attributed to Simon Marmion and commissioned by Margaret of York, Duchess of Burgundy (see p. 85), and *The Model Book of Calligraphy* that Joris Hoefnagel illuminated for Emperor Rudolf II (see p. 89). The Ludwigs' focus on German and Central European illumination has been enhanced by the purchase of an Ottonian Gospel lectionary from Reichenau or Saint Gall (see p. 62), two full-page miniatures from a Gothic psalter from Würzburg, and a copy of Rudolf von Ems's *World Chronicle* from Bavaria (see p. 77). The modest holdings in late medieval French manuscripts have been amplified by illuminations by the Boucicaut Master (see p. 78), Jean Fouquet (see p. 81), and Jean Bourdichon, among others.

The manuscripts are exhibited on a rotating basis year-round.

GOSPEL LECTIONARY

German (Reichenau
or Saint Gall), late
tenth century
Vellum, 212 leaves
27.7 × 19.1 cm (10 15/16 × 7 7/16 in.)
Ms. 16; 85.MD.317
Illustration: Decorated
Initials *IN* (fol. 4v)

The beginning of each Gospel passage in this manu-
script is highlighted by an elaborate initial entwined
with gold and silver vines. Such decorated letters are
characteristic of the monastic scriptoria at Reichenau
and Saint Gall, where many of the finest manuscripts
produced in the Ottonian Empire—named for the
dynasty founded in 936 by Otto I of Saxony—were
made, including books for the emperors themselves.
The initials in this manuscript are unusually delicate
examples of this style.

SQVIHODIFRNA DIE

SACRAMENTARY

French (Saint-Benôit-sur-
Loire abbey), first quarter
of the eleventh century
Vellum, ten leaves
23.2 × 17.8 cm (9⅛ × 7⅟₁₆ in.)
Ms. Ludwig V 1;
83.MF.76
Illustration: Attributed
to Nivardus of Milan,
Decorated Initial *D*
(fol. 9)

Sacramentaries, the most important type of liturgical
book used in the early medieval Church, contain the
prayers said by a priest at High Mass. The initial letters
of the main prayers in this fragment, such as the *D*
shown here, are filled with elaborate interlace orna-
ment and foliate sprays that hark back to ninth-century
Carolingian models based on late antique motifs. The
lavish use of gold, silver, and purple in the decoration,
which also includes a full-page *Crucifixion*, suggests that
the book was made for a member of the royal circle,
possibly by Nivardus of Milan, an artist known to have
worked for the French court.

SACRAMENTARY

German (Mainz or Fulda),
second quarter of the
eleventh century
Vellum, 179 leaves
26.6 × 19.1 cm (10½ × 7⁹⁄₁₆ in.)
Ms. Ludwig V 2; 83.MF.77
Illustration: *The Women at
the Tomb* (fol. 19v) and cover

The seven full-page
miniatures in this book
of prayers to be said

at mass reveal the monu-
mentality of Ottonian
painting. Set against col-
ored bands, these scenes
from sacred history are
infused with an other-
worldly, timeless quality.
The manuscript's luxuri-
ous binding in silver
and copper gilt, showing
Christ in Majesty in
high relief, dates from
the twelfth century.

Gospel Book

German (Helmarshausen
abbey), circa 1120–40
Vellum, 168 leaves
22.8 × 16.4 cm (9 × 6½ in.)
Ms. Ludwig II 3; 83.MB.67
Illustration: *Saint Matthew*
(fol. 9v)

The portraits of the evangelists (Matthew, Mark, Luke,
and John) in this manuscript exemplify the Romanesque
style developed at Helmarshausen abbey, an impor-
tant artistic center in northern Germany that enjoyed
the patronage of Henry the Lion, Duke of Saxony
and Bavaria (r. 1139–1180). The compositions are con-
structed from lively patterns, and the colors are warm
and saturated. The arrangement of the drapery folds,
the facial features, and the use of firm black outlines to
separate areas of different colors have much in common
with the work of Roger of Helmarshausen, a famous
metalsmith active at the abbey in the early twelfth cen-
tury. Saint Matthew is shown here writing his Gospel.

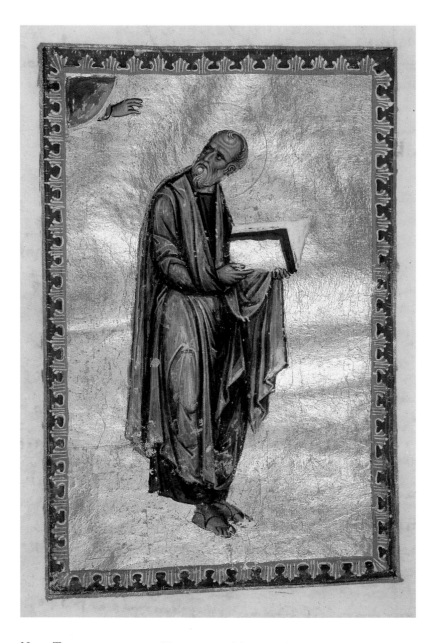

New Testament

Byzantine
(Constantinople), 1133
Vellum, 279 leaves
22 × 18 cm (8¹¹⁄₁₆ × 7⅛ in.)
Ms. Ludwig II 4; 83.MB.68
Illustration: *Saint John the
Evangelist* (fol. 106v)

The portraits of the evangelists in this New Testament
are among the finest achievements of Byzantine
illumination of the Comnenian period (named for the
Comneni emperors, who ruled from 1018 until 1185).
The artist's use of line and surface pattern to create
expressive effects is typical of the pictorial style of the
mid-twelfth century and is also to be found in monu-
mental art.

BREVIARY

Italian (Montecassino abbey),
1153
Vellum, 428 leaves
19.1 × 13.2 cm (7⁷⁄₁₆ × 5¹⁄₁₆ in.)
Ms. Ludwig IX 1; 83.ML.97
Illustration: Decorated
Initial *C* (fol. 138v)

Sigenulfus, the scribe of this breviary, identified himself in a prayer he penned on one of its leaves. He was a member of the monastic community at Montecassino, the cradle of the Benedictine order, which was founded in the sixth century by Saint Benedict. During the eleventh and twelfth centuries the monastery's scriptorium developed a distinctive style of decorative initial in which the paneled framework of the letter brims over with a frenzied mixture of interlaced tendrils and fantastic creatures.

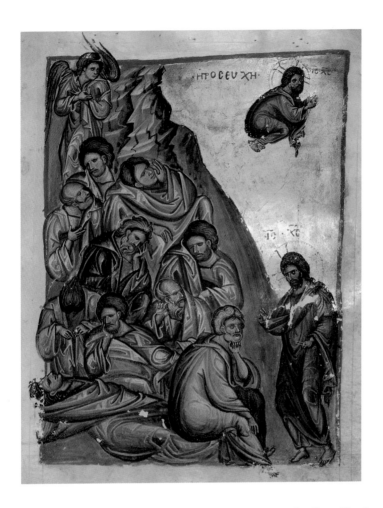

GOSPEL BOOK

Byzantine (Nicaea or
Nicomedia), early and
late thirteenth century
Vellum, 241 leaves
20.5 × 15 cm (8⅛ × 5⅞ in.)
Ms. Ludwig II 5; 83.MB.69
Illustration: *The Agony in
the Garden* (fol. 68)

The extensive decoration in this Gospel book was
executed at different stages over the course of the
thirteenth century and is thus an important witness to
changes in Byzantine art at a pivotal moment in
European history. This miniature from the end of the
century is representative of the Palaeologan phase
of Byzantine art, which flourished after the Western
Crusaders were expelled from Constantinople in 1261.
The Palaeologan style (which lasted into the fifteenth
century and is named after the imperial family of the
Palaiologoi) is noted for the use of large-scale figures
based on classical models and portrayed with dramatic
gestures and intensity of feeling. With the expansive
composition of the apostles against the mountain,
the three-dimensionality evident in the drapery folds,
and the care taken to individualize each figure, *The
Agony in the Garden* stands as an impressive monument
of later Byzantine art.

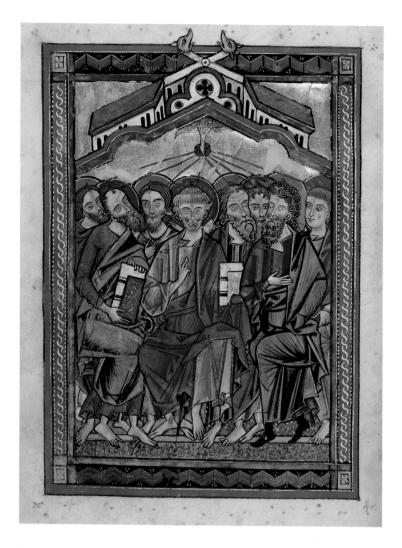

PSALTER

German (Würzburg),
circa 1240–50
Vellum, 192 leaves
22.6 × 15.7 cm (8¹⁵⁄₁₆ × 6⅟₁₆ in.)
Ms. Ludwig VIII 2; 83.MK.93
Illustration: *Pentecost*
(fol. 111v)

Richly illuminated psalters enjoyed widespread popu-
larity in the thirteenth century as a form of deluxe
private devotional book. The abundant decoration of
this psalter includes twelve illuminated calendar pages,
each decorated with the full-length figure of a prophet;
six full-page miniatures depicting imagery from the
Old and New Testaments; and ten elaborate, large his-
toriated initials.

The finely chiseled features of the figures and the
angular folds of their draperies are typical of thirteenth-
century German illumination as practiced in Thuringia
and Saxony, in the north, and in Würzburg, in the south-
west, which was influenced by the northern schools.
The forms of this so-called Zigzag style are remarkably
expressive.

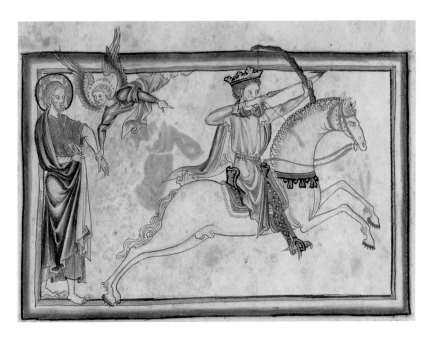

APOCALYPSE WITH COMMENTARY BY BERENGAUDUS

English (probably London),
circa 1255–60
Vellum, forty-one leaves
31.9 × 22.5 cm (12⅞₆ × 8⅞ in.)
Ms. Ludwig III 1; 83.MC.72
Illustration: *The Opening of the First Seal: The First Horseman* (fol. 6)

A fashion for richly illustrated copies of the Apocalypse, Saint John's vision of the end of the world as recorded in the New Testament Book of Revelation, developed in England in the mid-thirteenth century. In manuscripts such as this one, which contains eighty-two half-page miniatures, aristocratic lay patrons could contemplate the calamitous events Saint John described through pictures as well as text.

Remarkable for their lively interpretation of the saint's vision, the miniatures show him witnessing the extraordinary events as they occur. The figures were outlined in pen and ink and then modeled with thin, colored washes. Their elegant poses, the graceful contours of the forms, and the decorative patterns of the drapery folds typify early English Gothic illumination at its finest.

CANON TABLES FROM THE ZEYTᶜUN GOSPELS

Armenian (Hromklay), 1256
Vellum, eight leaves
26.5 × 19 cm (10⁷⁄₁₆ × 7½ in.)
Ms. 59; 94.MB.71
Illustration: Tᶜoros Roslin,
canons 7 and 8 (fol. 6)

Canon tables present a concordance of passages relating the same events in the four Gospels. Canon table pages were an important field for decoration in manuscript Bibles and Gospel books throughout the Middle Ages, the columns of numbers inviting an architectural treatment. On this page, the Armenian illuminator Tᶜoros Roslin has placed the text within a grand and brilliantly colored architecture that includes animal heads and human faces, and he has enlivened the page with a variety of plants and birds.

ANTIPHONAL

Italian (Bologna), late
thirteenth century
Vellum, 243 leaves
58.2 × 40.2 cm
(22 $^{15}/_{16}$ × 15 $^{11}/_{16}$ in.)
Ms. Ludwig VI 6; 83.MH.89
Illustration: Master of
Gerona, Initial *A* with
Christ in Majesty (fol. 2)

This manuscript is the first volume of a multivolume
antiphonal, a compilation of chants for the Divine
Office, the services celebrated at regular intervals
throughout the day. Like all liturgical choir books, its
format is large so that all members of the choir could
see the music it contains. It may have been made for the
monastery of San Jacopo de Ripoli, outside Florence,
since the same artist provided that religious community
with at least two other choir books. He probably trained
in Bologna, a major center of Gothic art in Italy. The
facial types, abstract patterns of drapery highlights, and
certain iconographic motifs in this antiphonal reflect
the impact of Byzantine art. The brilliant luminosity
and monumental figure style achieved by the artist link
his work with the most important Bolognese manu-
scripts produced at this time.

VIDAL MAYOR

Spanish (northeastern Spain),
circa 1290–1310
Vellum, 277 leaves
36.5 × 24 cm (14⅜ × 9⁷⁄₁₆ in.)
Ms. Ludwig XIV 6; 83.MQ.165
Illustration: Initial *N* with
*King Jaime I of Aragon
Overseeing a Court of Law*
(fol. 72v)

This sumptuous volume is the only known copy of
the law code of Aragon, which King Jaime I (r. 1214–
1276) ordered Vidal de Canellas, the Bishop of Huesca,
to compile in 1247. The manuscript, a translation into
the vernacular (Navarro-Aragonese), probably was
made for one of Jaime's royal successors. It is illustrated
with ten large and numerous small scenes set into
initials. The style of illumination, painted in primary
colors, emulates Parisian court art in both the settings
and the slender figural and facial types.

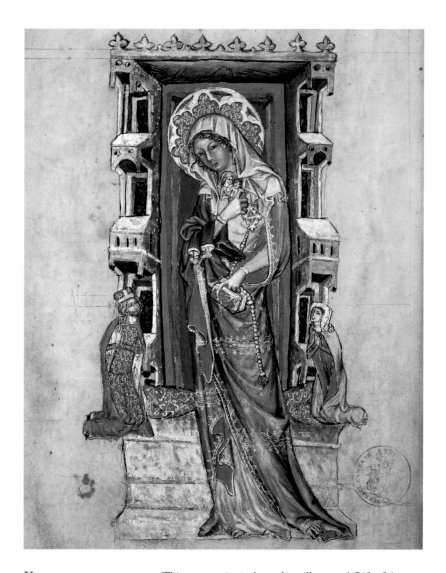

VITA BEATAE HEDWIGIS

Silesian, 1353
Vellum, 204 leaves
34.1 × 24.8 cm (13⁷⁄₁₆ × 9¾ in.)
Ms. Ludwig XI 7; 83.MN.126
Illustration: Court atelier of
Duke Ludwig I of Liegnitz
and Brieg, *Saint Hedwig with
Donors* (fol. 12v)

This manuscript is the earliest illustrated *Life of the
Blessed Hedwig*, whose subject was a thirteenth-century
duchess of Silesia (a duchy on the border between
Poland and Germany). It contains one of the master-
pieces of Central European manuscript illumination: a
full-page miniature of Saint Hedwig herself. Hedwig,
who founded a number of religious houses in Silesia,
carries a book, a rosary, and a small statue of the
Madonna, all references to her devout character. The
small-scale donor portraits represent Duke Ludwig I
of Liegnitz and Brieg, the saint's descendant, and his
wife, Agnes, who commissioned the manuscript in 1353.

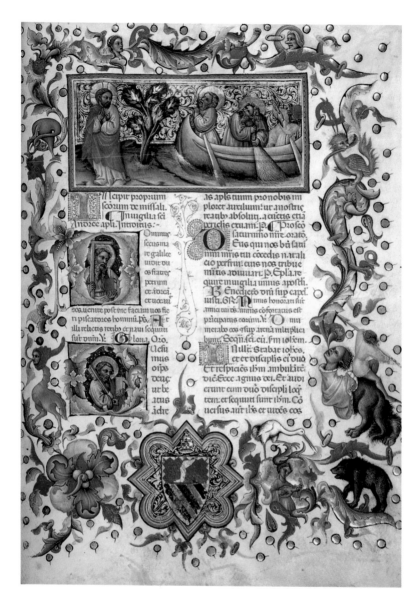

MISSAL

Italian (Bologna),
1389–1406
Vellum, 277 leaves
33 × 24 cm (13 × 9⁷⁄₁₆ in.)
Ms. 34; 88.MG.71
Illustration: Master of the
Brussels Initials, *The Calling
of Saints Peter and Andrew*
(fol. 172a)

The Master of the Brussels Initials, an Italian artist
who is credited with the sumptuous illumination in this
missal—a service book used to celebrate mass—was a
key figure in the development of the International style.
The border style seen here, with its exuberant foliage
inhabited by whimsical creatures, was introduced by
him into Paris and was adopted by many French artists
in the early fifteenth century. The missal was commis-
sioned by the Bolognese cardinal Cosimo de' Migliorati
and acquired subsequently by the antipope John XXIII,
whose coat of arms appears in the lower margin.

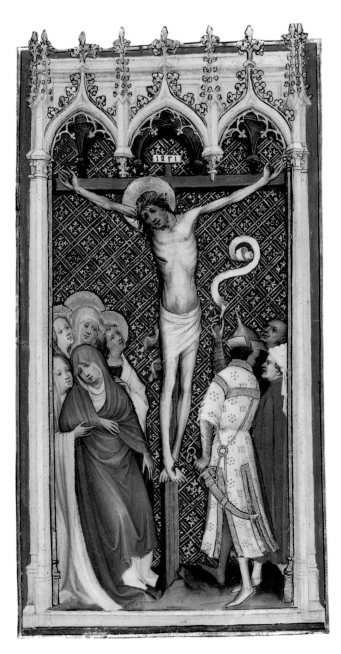

Two Miniatures

German (Cologne),
circa 1400–10
Vellum
23.6 × 12.5 cm (9⁵⁄₁₆ × 4⁷⁄₈ in.)
Ms. Ludwig Folia 2; 83.MS.49
Illustration: Master of Saint
Veronica, *The Crucifixion*
(leaf 1)

The courtly elegance of the International style is cap-
tured in the rich costumes, brilliantly diapered back-
grounds, and softly modeled forms of this *Crucifixion*
and its companion miniature, *Saint Anthony*. Attributed
to the Master of Saint Veronica, a leading artist of
Cologne, these leaves may once have been part of a
liturgical manuscript.

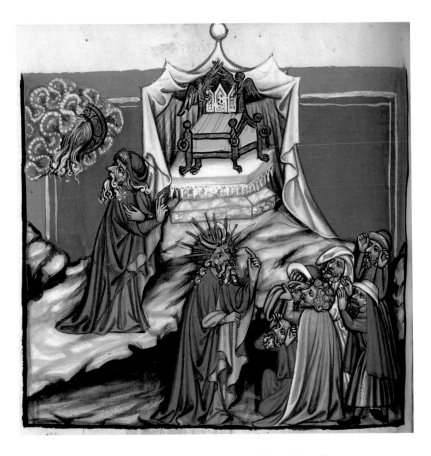

RUDOLF VON EMS, *WELTCHRONIK*

Bavarian (Regensburg),
circa 1400–10
Vellum, 309 leaves
33.5 × 23.5 cm (13⁷⁄₁₆ × 9¼ in.)
Ms. 33; 88.MP.70
Illustration: *Moses' Vision of the Back of God's Head; Moses' Shining Face and the Ark of the Covenant* (fol. 89v)

The World Chronicle of Rudolf von Ems was written in rhymed couplets that weave biblical, classical, and other secular texts into a continuous history of the world beginning with Creation. This miniature depicts two scenes: an unusual representation of Moses' vision of the back of God's head (Exodus 33:12–23) and Moses after his descent from Mount Sinai (Exodus 34:29–35). He is represented with horns, the result of a medieval misunderstanding of Saint Jerome's translation of the original Hebrew text.

The vigorous, broadly painted miniatures with contrasting, often incandescent colors find few parallels in European art of the first half of the fifteenth century. The miniatures of *The World Chronicle* have a bold narrative style; the figures have intense expressions and interact dramatically. The identity of the original owner, undoubtedly an important nobleman, is unknown. Duke Albert IV of Bavaria (r. 1463–1508) and Duchess Kunigunde owned the manuscript later in the fifteenth century.

GIOVANNI
BOCCACCIO, *DES
CAS DES NOBLES
HOMMES ET FEMMES*

French (Paris), circa 1415
Vellum, 318 leaves
42.5 × 29.3 cm
(16¾ × 11⁷⁄₁₆ in.)
Ms. 63; 96.MR.17
Illustration: Boucicaut Master
and Workshop, *Samson and the
Lion* (fol. 26v)

The Florentine poet Giovanni Boccaccio (1313 – 1375)
is best known today for the *Decameron*, one of the great
early works of fiction written in Italian. In the later
Middle Ages, however, *The Fates of Illustrious Men and
Women*, written in Latin, was one of his most popular
efforts. It relates the stories of notables from biblical,
classical, and medieval history. Laurent de Premierfait,
who translated the text into French, embellished the
original with many colorful tales from other authors,
including Livy (59 B.C. – A.D. 17) and Valerius Maximus
(fl. circa A.D. 20).

The first quarter of the fifteenth century proved to
be one of the most original and influential epochs of
Parisian manuscript illumination, due in significant part
to the genius and industriousness of the anonymous
illuminator called the Boucicaut Master. With the aid
of numerous highly trained collaborators, this artist's
work became known throughout Europe and influenced
not only the direction of French illumination for more
than a generation but that of Flemish painting as well.

BOOK OF HOURS

French (probably Paris),
circa 1415−25
Vellum, 247 leaves
20.1 × 15 cm (7¹⁵⁄₁₆ × 5⅞ in.)
Ms. 57; 94.ML.26
Illustration: Spitz Master, *The Flight into Egypt* (fol. 103v)

The primary artist of this book of hours was deeply versed in the art of the International style, especially that of the Limbourg Brothers (circa 1386−1416), the official painters of one of the great patrons of manuscripts, John, Duke of Berry. Indeed, seven miniatures in this book draw upon compositions of the Limbourgs from the duke's *Très Riches Heures* (Chantilly, Musée Condé) and *Belles Heures* (New York, The Cloisters). The Spitz Master, however, departs from the elegant, sophisticated style of the Limbourgs; his art is both more playful and more direct. In this miniature, for example, the threatening presence of Herod's soldiers, in pursuit of the Holy Family as they flee to Egypt, is communicated by their exaggerated size. The Spitz Master expanded on the narratives of a number of the miniatures by including scenes in the borders. Here the apocryphal story of the Miracle of the Wheat Field is depicted.

BOOK OF HOURS

Flemish (probably Ghent),
circa 1450–55
Vellum, 286 leaves
19.4 × 14 cm (7⅝ × 5½ in.)
Ms. 2; 84.ML.67
Illustration: Master of Guille-
bert de Mets, *Saint George
and the Dragon* (fol. 18v)

This deluxe manuscript, with gigantic, brightly colored foliage wending through its borders, exemplifies the inventive, often playful character of the decorated borders in Flemish manuscripts. The acanthus leaves dwarf Saint George and the princess, whom he has rescued from the dragon. The anonymous illuminator was a leading Flemish artist in the first half of the fifteenth century.

Hours of Simon de Varie

French (Tours and
perhaps Paris), 1455
Vellum, ninety-seven leaves
11.5 × 8.2 cm (4½ × 3¼ in.)
Ms. 7; 85.ML.27
Illustration: Jean Fouquet,
*Coat of Arms Held by a
Woman and a Greyhound*
(fol. 2v)

This heraldic miniature and the three
other frontispiece miniatures in this
book of hours are the work of Jean Fou-
quet, one of the great fifteenth-century
French painters. Influenced by Italian
Renaissance painting, the figural style
and compositions in Fouquet's minia-
tures have a geometric simplicity and
monumentality that transformed French
art. His technical mastery is evident in
the flesh tones of the woman, rendered
in points of color invisible to the naked
eye, and in the transparent cascade
of hair through which the background
of the miniature can be seen. Fouquet,
a panel painter as well as an illuminator,
worked successively at the courts of
Charles VII (r. 1422–1461) and Louis XI
(r. 1461–1483) of France.

This manuscript is a portion of a
book of hours made for Simon de Varie,
a high official at the royal court. De
Varie's mottoes appear in the borders of
the miniatures. In this one *Vie à mon
Desir* (Life according to my desire), an
anagram of his name, is inscribed on
the collar of the heraldic dog supporting
the arms. Separated from the Getty
volume in the seventeenth century, the
two other portions of the book are
now in the Royal Library at The Hague.

Miniature

Italian (possibly Mantua),
circa 1460–70
Vellum
20.1 × 12.9 cm (7^{15}/$_{16}$ × 5^{1}/$_{16}$ in.)
Ms. 55; 94.ms.13
Illustration: Girolamo da
Cremona, *Pentecost*

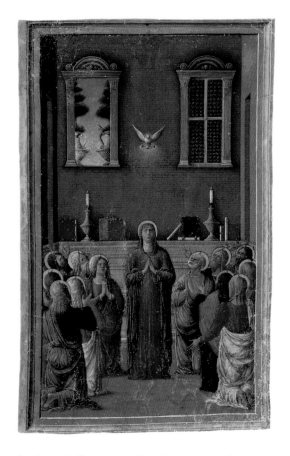

Girolamo da Cremona (active circa 1455–1483) was one
of the major interpreters of the new Renaissance style
in the art of book illumination. An itinerant artist,
he worked for patrons in Ferrara, Padua, Mantua, Siena,
and Florence, ending his career in Venice, where he
was engaged primarily in the illumination of deluxe
printed books. From 1461 to 1470 he seems to have been
at work in Mantua, having been recommended to the
Gonzaga court by Andrea Mantegna. Girolamo's debt
to Mantegna is clearly seen in this miniature, which
probably came from a book of hours or a liturgical
manuscript. The pervasive classicism, the sculptural
quality of the modeling, and the sense of symmetry and
order are all trademarks of Mantegna's style. The illu-
sionistic frame and the expansive space of the grand
architectural setting indicate that Girolamo conceived
of this miniature as monumental in its effect.

Prayer Book of
Charles the Bold

Flemish (Antwerp
and Ghent), 1469
Vellum, 159 leaves
12.4 × 9.2 cm (4⅞ × 3⅝ in.)
Ms. 37; 89.ML.35
Illustration: Attributed to the
Master of Mary of Burgundy,
The Deposition (fol. 111v)

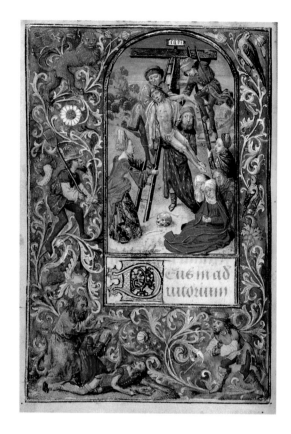

Late medieval religious imagery sought to heighten the
immediacy of the story of Christ, especially of the Pas-
sion, the events of his persecution and death. This small
miniature showing the removal of Christ's body from
the cross draws us close to the event's meaning by hold-
ing up for our inspection his limp and fragile corpse.
It is an early work by an anonymous illuminator known
as the Master of Mary of Burgundy.

Documents of payment survive for portions of
this prayer book. It was commissioned by Charles the
Bold, the Duke of Burgundy and son of Duke Philip
the Good, the greatest of Burgundian bibliophiles. In
1469 payments were made to the scribe Nicolas Spierinc
of Ghent, whose beautiful script, with its elaborate
flourishes and cadelles, made him the finest of fifteenth-
century Flemish scribes, and to the illuminator Lieven
van Lathem of Antwerp, who was aided by several art-
ists. The Master of Mary of Burgundy was the youngest
and most gifted among them.

GUALENGHI-D'ESTE HOURS

Italian (Ferrara), circa 1469
Vellum, 211 leaves
10.8 × 7.9 cm (4¼ × 3⅛ in.)
Ms. Ludwig IX 13; 83.ML.109
Illustration: Taddeo Crivelli,
The Annunciation (fol. 3v)

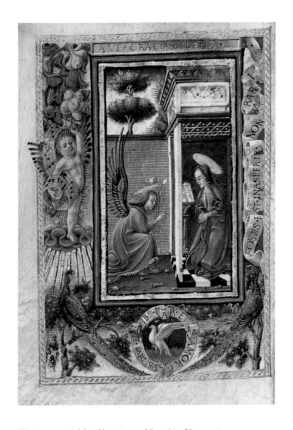

This tiny, richly illuminated book of hours is one
of the finest examples of manuscript illumination from
the school of Ferrara, whose ruling family, the Este,
were ambitious bibliophiles and patrons of the arts.
The humanist values of their court and, more generally,
the Renaissance culture that flourished in much of Italy
are reflected in the classical details of the architecture,
carved stone inscriptions, and putti in the borders. Like
other painters from Ferrara, Crivelli used deep shadows
and bright highlights to model figures, giving them
their characteristic sculptural quality. The manuscript
probably was made for Orsina d'Este, who married
Andrea Gualengo in 1469.

ample ouuerte et moult nece qny efforent illeaß
obfcure cefte vallee efort buuflece et ordee et fonet

LES VISIONS DU CHEVALIER TONDAL

Flemish (Valenciennes and
Ghent), 1475
Vellum, forty-five leaves
36.3 × 26.2 cm
(14⁵⁄₁₆ × 10³⁄₁₆ in.)
Ms. 30; 87.MN.141
Illustration: Attributed to
Simon Marmion, *The Valley
of Homicides* (fol. 13v)

The Visions of Tondal is a medieval cautionary tale
about a wealthy Irish knight whose soul embarks on a
dreamlike journey through hell, purgatory, and heaven,
during which he learns the wages of sin and the value
of penitence. Written in Latin in the middle of the
twelfth century, the popular story was translated into
fifteen European languages over the next three cen-
turies. This sumptuous manuscript, commissioned by
Margaret of York, Duchess of Burgundy, is the only
known illuminated copy of the text and contains twenty
miniatures. In the scene illustrated here, Tondal's
guardian angel shows the soul of the knight a burning
valley in which murderers' souls are cooked on an
iron lid. Above it the slim, naked figures of the damned
rise and fall in a graceful ballet of torment.

MINIATURE FROM
VALERIUS MAXI-
MUS, *FAITS ET DITS
MÉMORABLES*

Flemish (Bruges),
circa 1475–80
Vellum
17.5 × 19.4 cm (6¹⁵⁄₁₆ × 7⅝ in.)
Ms. 43; 91.MS.81
Illustration: Master of the
Dresden Prayer Book, *The
Temperate and the Intemperate*

The Memorable Deeds and Sayings of the Romans is
a compilation of stories about ancient customs and
heroes. Originally written in Latin in the first century
A.D. by Valerius Maximus (59 B.C.–A.D. 17), it was
read during much of the Middle Ages. Loosely orga-
nized by moral and philosophical categories (Temper-
ance, Charity, Cruelty, etc.), it served as a textbook
of rhetorical exercises. This cutting derives from
a sumptuous large-scale copy of the French translation
commissioned by Charles V of France (r. 1364–1380),
which was made for Jan Crabbe, abbot of the Cistercian
abbey of Duinen, south of Bruges. The miniature shows
Valerius instructing the Emperor Tiberius (to whom
the text is dedicated) on the value of temperance. The
upper classes and clergy shown at the back illustrate
this virtue, while lower class characters descend glee-
fully to illustrate its opposite. In the work of this
wry illuminator from Bruges, the appropriate behavior
seems staid, while the poor example amuses us.

SPINOLA HOURS

Flemish (Ghent or
Mechelen), circa 1515
Vellum, 312 leaves
23.2 × 16.6 cm (9⅛ × 6⁹⁄₁₆ in.)
Ms. Ludwig IX 18; 83.ML.114
Illustration: Gerard Horen-
bout, *The Annunciation*
(fol. 92v)

In one of the most inventive page designs of sixteenth-
century manuscript illumination, Gerard Horenbout
has unified the traditionally separate zones of miniature
and decorated border. The main subject, the Annuncia-
tion, shown taking place in the Virgin Mary's chamber,
is portrayed in the middle of the page. The exterior of
the building, where angels joyously pick flowers in the
Virgin's garden, is depicted in the surrounding border.
Thus the setting of the miniature has expanded beyond
its traditional boundaries to fill the page and incorpo-
rate additional devotional stories and events.

PRAYER BOOK
OF CARDINAL
ALBRECHT OF
BRANDENBURG

Flemish (Bruges),
circa 1525–30
Vellum, 337 leaves
16.8 × 11.5 cm (6⅝ × 4½ in.)
Ms. Ludwig IX 19; 83.ML.115
Illustration: Simon Bening,
Christ Before Caiaphas
(fol. 128v)

The Prayer Book of Albrecht of Brandenburg repre-
sents one of the pinnacles in the career of the illustrious
Flemish illuminator Simon Bening. The forty-one
full-page miniatures in this book dramatically recount
Christ's childhood and ministry followed by his
persecution, Crucifixion, and Resurrection. The artist
inspires the reader's compassion and understanding
through the depiction of Christ as a vulnerable man
who suffered continuous emotional and physical abuse
at the hands of his tormentors.

MIRA
CALLIGRAPHIAE
MONUMENTA

Vienna, 1561–62
and circa 1591–96
Vellum, 150 leaves
16.6 × 12.4 cm (6⁹⁄₁₆ × 4⅞ in.)
Ms. 20; 86.MV.527
Illustration: Joris Hoefnagel,
Carnation and Walnut (fol. 74)

Originally written for the Holy Roman Emperor Ferdinand I (r. 1556–1564), this volume is a compendium of display scripts by one of the great scribes of the Renaissance. The calligraphy on each page represents a different style of writing inventively arranged. Thirty years later, Emperor Rudolf II (r. 1576–1612), Ferdinand I's grandson, commissioned Hoefnagel to illuminate the same pages.

Paintings

During his lifetime J. Paul Getty purchased paintings from every major European school of art between the thirteenth and twentieth centuries. He did not, however, consider himself a collector of paintings. His writings, especially his diaries, repeatedly name the decorative arts as his first love. He also felt that the best paintings were already in museums. Significant pieces of furniture, however, could still be acquired, and for much less money than a first-class painting.

Nevertheless Getty began his painting and decorative arts collections at about the same time: during the 1930s. By World War II he owned two major pictures, Gainsborough's portrait of James Christie (see p. 142) and Rembrandt's *Portrait of Marten Looten* (see p. 4), as well as a number of lesser paintings. Getty again began to collect paintings actively in the 1950s, although it was not until the middle of the following decade that he attempted to buy pictures that equaled the stature of individual pieces in his decorative arts holdings. Curiously, he never bought paintings to complement the French furniture he collected with such enthusiasm.

During the last decade of his life, Getty gave funds to the Museum that allowed it to acquire paintings from periods he had not previously found interesting. When he left the bulk of his estate to the Museum, the opportunity presented itself to acquire major works on a wider scale; these pictures, which number more than half of the paintings on exhibit, have significantly transformed the galleries.

During Getty's years as a collector, he succeeded in gathering a representative group of Italian Renaissance and Baroque paintings, plus a few Dutch figurative works of importance. In recent years these collections have been expanded. The French and Dutch schools have been much strengthened, and later French pictures by the Impressionists and their successors have been added. As a result, there is a greater overall balance of holdings from the earlier periods until the end of the nineteenth century. More significantly, the works now displayed are often more representative and important examples than in the past.

It is expected that the Museum will continue to acquire and exhibit paintings of the highest quality during the coming years, to complete the collection's transformation from a fairly small personal holding into a moderately sized but exceptionally choice public repository.

BERNARDO DADDI

Italian, active
circa 1280–1348
*The Virgin Mary with Saints
Thomas Aquinas and Paul,*
circa 1330
Tempera and gold on panel
Central panel: 120.7 × 55.9 cm
(47½ × 22 in.); left panel:
105.5 × 28 cm (41½ × 11 in.);
right panel: 105.5 × 27.6 cm
(41½ × 10⅞ in.)
93.PB.16

Reflecting the burgeoning cult of the Virgin Mary in
fourteenth-century Italy, the triptych with an image of
the Madonna in the central panel, flanked by standing
saints in the wings, was one of the most popular forms
of devotional imagery. Here, the Virgin reads the
Magnificat (Luke 1:46–48) and gestures downward,
perhaps referring to a tomb or an altar over which
the triptych was placed. On the left, gesturing toward
her, is Saint Thomas Aquinas, displaying the text of
Ecclesiastes 12:9–10, one of his attributes. On the
right is Saint Paul, carrying a book of his epistles and
the sword by which he was martyred. These saints
were probably chosen because they had some special
significance to the unknown patron of the triptych.

The leading painter of his generation in Florence,
Daddi was renowned for creating affecting images.
Here, the Madonna is at once serene and majestic. The
elegant and graceful forms of the figures, the reso-
nant colors, and the exquisitely tooled gold all lend to
the ethereal effect of this well-preserved work.

MASACCIO

(Tommaso di Giovanni Guidi)
Italian, 1401–1428
Saint Andrew, 1426
Tempera on panel
52.4 × 32.7 cm (20⅝ × 12⅞ in.)
79.PB.61

This image of Saint Andrew holding his traditional symbols, a cross and book, comes from the only securely documented altarpiece by Masaccio, a polyptych painted in 1426 for the private chapel of Giuliano da San Giusto, a wealthy notary, in the church of the Carmine in Pisa. The panel was positioned on the right side of the upper tier, so that Andrew once appeared to gaze sadly toward the central panel depicting the Crucifixion.

The *Saint Andrew* exemplifies Masaccio's contribution to the founding of an early Renaissance painting style. The single figure is endowed with volume and solidity; his simplified draperies fall in sculptural folds. Since the panel stood high above the ground, the figure is slightly foreshortened for viewing from below. Furthermore, Masaccio has abandoned the elegant detachment of earlier styles in favor of a naturalistic treatment of emotion. It was this powerful combination of three-dimensional form and bold expression that so impressed his contemporaries.

GENTILE DA
FABRIANO

Italian, circa 1370–1427
The Coronation of the Virgin,
circa 1420
Tempera on panel
87.5 × 64 cm (34½ × 25½ in.)
77.PB.92

Probably painted for a church in Fabriano, Italy, Gentile's *Coronation* once formed part of a double-sided standard carried on a pole during religious processions. Stylistically it occupies the borderline between the essentially Gothic International style and the early Florentine Renaissance. Traces of the former linger in the richly patterned surfaces of the hanging and robes, which, however, clothe solidly constructed figures. The folds create a sense of volume as well as pattern, and the figures gesture with convincing naturalism.

VITTORE CARPACCIO

Italian, 1460/65–1525/26
Hunting on the Lagoon,
circa 1490–95
Oil on panel
75.4 × 63.8 cm (30 × 29 in.)
79.PB.72

One side of this painting shows bowmen hunting birds; the other is a trompe l'oeil painting of a letter rack. The marks of hinges on the latter side indicate that this panel once functioned as a decorative shutter or cabinet door. It is a fragment of a composition that included two women on a balcony with the lagoon visible between them.

BARTOLOMMEO VIVARINI

Italian, circa 1432–1499
Polyptych with the Madonna and Child, Saint James Major, and Various Saints, 1490
Tempera on panel
280 × 215 cm (110¼ × 84⅝ in.)
71.PB.30

Shown in this altarpiece are Saints Catherine and Ursula, the Virgin and Child, and Saints Apollonia, Mary Magdalene, John the Baptist, John the Evangelist, James Major, Bartholomew, and Peter.

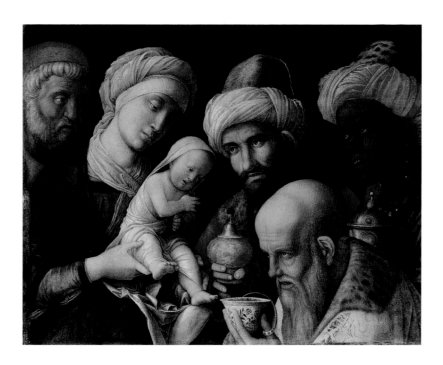

ANDREA MANTEGNA

Italian, circa 1431–1506
The Adoration of the Magi,
circa 1495–1505
Distemper on linen
54.6 × 70.7 cm (21½ × 27⅞ in.)
85.PA.417

Paintings of the Adoration of the Magi traditionally
provided the opportunity to create grandiose scenes of
Oriental richness. But for this private devotional work,
Mantegna exhibited the spirit of Renaissance humanism
by concentrating on the psychological interactions
among the principal characters in the sacred narrative.
The close-up scheme of half-length figures compressed
within a shallow space and set before a neutral back-
ground was created by the artist from his study of
ancient Roman reliefs, reflecting the Renaissance inter-
est in reviving classical antiquity.

The magi, or kings, represent the three parts of
the then-known world—Europe, Asia, and Africa—
and personify royal recognition of Christ's superior
kingship. They offer their gifts in vessels of carved
agate, Turkish tombac ware, and an early example of
Chinese porcelain in Europe. The subject was parti-
cularly appropriate for the painting's probable patrons,
the Gonzaga family, rulers of Mantua who employed
Mantegna as court painter from 1459 until his death.

Mantegna employed an unusual technique—thin
washes of pigment in animal glue—resulting in dazzling
color and a matte surface emphasizing the refined
draftsmanship and brushwork. Although the image is
somewhat darkened by varnish added at a later date
(now mostly removed), the refinement of painting and
the richness of detail still attest to Mantegna's mastery.

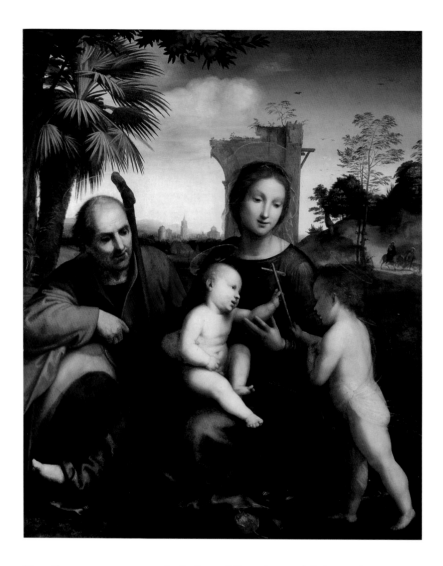

FRA BARTOLOMMEO

(Baccio della Porta)
Italian, 1472–1517
*The Rest on the Flight into
Egypt with Saint John the
Baptist*, circa 1509
Oil on panel
129.5 × 106.6 cm (51 × 42 in.)
96.PB.15

In this beautifully orchestrated dialogue of gesture and
glance, the Holy Family, having escaped Bethlehem and
King Herod's massacre of the innocents, take their ease
beneath a sheltering date palm tree. Mary and Joseph
look on as the infant Baptist greets the Christ Child.
The unusual inclusion of John the Baptist in a Rest on
the Flight can be explained by the saint's status as a
patron of Florence. He is also a poignant reminder that
the ultimate purpose of the Child's escape is his sacrifice
on the cross. Fra Bartolommeo reinforces the pathos by
depicting a pomegranate, a fruit that prefigures Christ's
death, and the sheltering palm, whose fronds would
pave the Savior's final entry into Jerusalem. The ruined
arch alludes to the downfall of the pagan order and the
rise of Christ's church, personified by Mary.

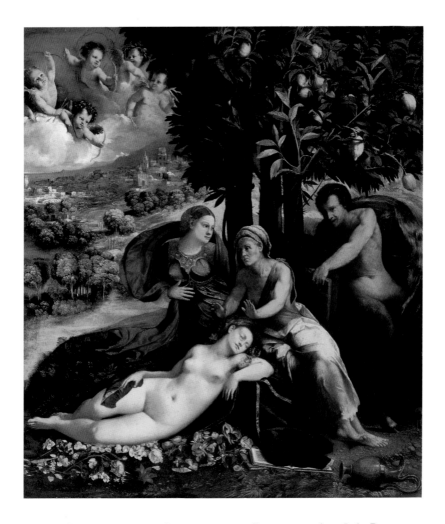

DOSSO DOSSI

(Giovanni de' Luteri)
Italian, circa 1490–1542
Mythological Scene, circa 1524
Oil on canvas
163.8 × 145.4 cm
(64½ × 57¼ in.)
83.PA.15

As court painter at Ferrara in northern Italy, Dosso was famous for his enchanting and mysterious landscapes inhabited by gods and legendary mortals. His dreamlike, ornamental compositions embody the idealized Renaissance image of classical antiquity developed earlier by the Venetian painter Giorgione.

Just as his work on this mythological scene neared completion, Dosso changed his mind about its subject and painted a landscape over the draped female now visible at the center left. The three remaining figures — the sleeping nude, the protective central figure, and the god Pan on the right — may have represented the story of Pan and the nymph Echo. During the nineteenth century the fourth figure, whose significance remains enigmatic, was detected under the landscape and revealed by scraping away the upper paint layer.

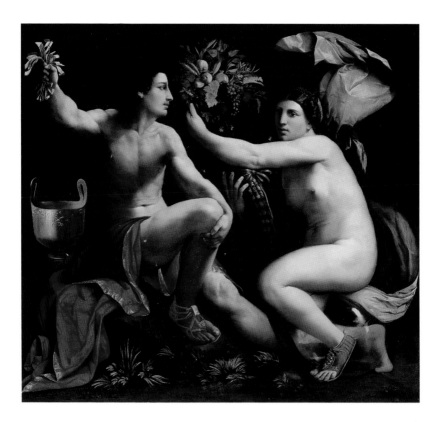

DOSSO DOSSI

(Giovanni de' Luteri)
Italian, circa 1490–1542
Allegory of Fortune, circa 1530
Oil on canvas
178 × 216.5 cm (70½ × 85½ in.)
89.PA.32

The nude woman represents Fortune, or Lady Luck, the indifferent force that determines fate. She holds a cornucopia, flaunting the bounty that she might bring, but sits on a bubble because her favors were often fleeting. The billowing drapery serves as a reminder that she is as inconstant as the wind, and she wears only one shoe to symbolize that she is capable of bestowing not only fortune but also misfortune.

The man, a personification of Chance, looks toward Fortune as he is about to deposit lots or lottery tickets in a golden urn. This was not a traditional attribute, but a reference to the civic lotteries with cash prizes that had recently become popular in Italy. The painting was probably made for Isabella d'Este (1474–1539), Marchioness of Mantua, one of whose emblems was a bundle of lots.

Dosso painted this work at least a decade after his *Mythological Scene* (see preceding page). The luminous, poetic coloring and atmosphere of Dosso's earlier work, adopted from Venetian paintings, here gives way to heroically proportioned and posed figures revealed by strong lighting, which the artist developed from studying Michelangelo's work in Rome.

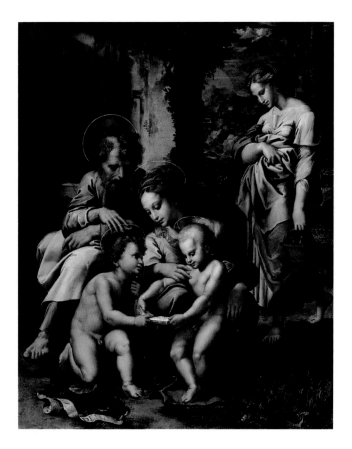

GIULIO ROMANO

(Giulio Pippi)
Italian, circa 1495–1546
The Holy Family, circa
1520–23
Oil (possibly mixed with
tempera) on panel
77.8 × 61.9 cm (30⅝ × 24⅜ in.)
95.PB.64

Guilio Romano was Raphael's most important protégé
during his later years in Rome. This work was executed
not long after his master's death in 1520, when his own
artistic personality was beginning to come into its
own. Guilio created a cleverly orchestrated group that
is solidly classical in the tradition of Raphael, but begin-
ning to show signs of the complicated, interlocking
compositions of the Mannerist style that he was instru-
mental in forging. Likewise, this painting foreshadows
other aspects of Guilio's mature style, including a
metallic palette, heavy physiognomies, and preoccupa-
tion with surface ornamentation.

Guilio sets this familiar subject at a specific time
and place. He illustrates the meeting of the Christ
Child and John the Baptist, thought to have taken place
following the Jewish ceremony of Purification, when
a new mother sacrifices turtle doves, such as those car-
ried by the women in the background.

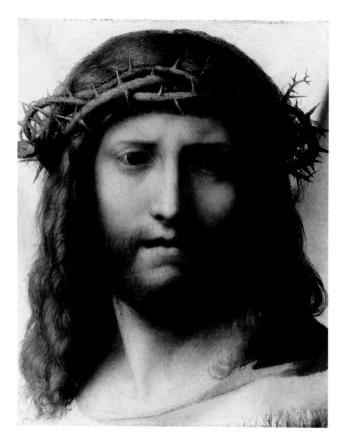

CORREGGIO

(Antonio Allegri)
Italian, 1489/94–1534
Head of Christ, circa 1525–30
Oil on panel
26.8 × 23 cm (11¼ × 9⅟₁₆ in.)
94.PB.74

Correggio, the foremost High Renaissance artist of the Emilian school, invented a type of devotional imagery in which the protagonists seem to be caught in vibrant, realistic moments. The *Head of Christ* is a mature work intended for contemplation and private prayer. The subject derives from the legend of Saint Veronica. When Christ fell on the way to the Crucifixion, he was comforted by Veronica, who wiped his face with her veil and then discovered his likeness miraculously impressed upon it. Instead of depicting the traditional iconic image of the Savior's face imprinted on the veil, Correggio portrays a hauntingly naturalistic Christ who turns toward the viewer and parts his lips as if to speak. Veronica's veil is the folded white cloth background that wraps around Christ's shoulder and ends in soft white fringes at the lower right. The painting's profound impact as a devotional image depends upon Correggio's bold invention of showing Christ wrapped within the veil the instant before the miracle. It is the living face of Christ and not his image that turns to confront the viewer.

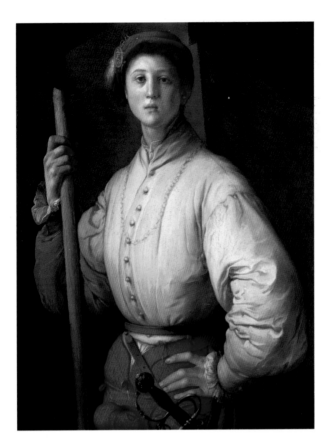

JACOPO PONTORMO

(Jacopo Carucci)
Italian, 1494–1557
*Portrait of a Halberdier
(Francesco Guardi?)*, 1528–30
Oil or oil and tempera on
panel transferred to canvas
92 × 72 cm (36¼ × 28⅜ in.)
89.PA.49

Jacopo Pontormo was one of the founders of the so-
called Mannerist style in Italy. After Michelangelo he
is recognized as the most important Florentine painter
of the sixteenth century. He and his pupil Bronzino
excelled as portraitists, and the *Halberdier* is Pontormo's
greatest achievement.

In 1568 the most famous contemporary recorder of
artists' lives, the painter Giorgio Vasari, noted that
Pontormo painted a most beautiful work, a portrait of
Francesco Guardi, during the 1528–30 siege of Flor-
ence. We know nothing about Francesco Guardi's
appearance, yet he was born in 1514, so he could be the
teenage sitter.

Pontormo shows his halberdier before a bastion sug-
gesting the defense of Florence. This youth is posed
like some new Saint George or David guarding his city.
His casual, swaggering pose is confident. His loose grip
on the halberd (spear) and slung sword suggests a con-
trol that his expression belies. Pontormo conveys the
sitter's unease with such vitality that we too feel startled
as we meet his gaze.

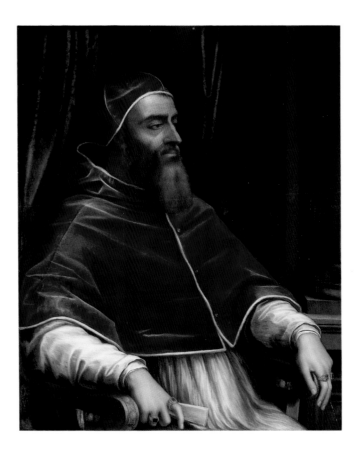

SEBASTIANO DEL
PIOMBO

(Sebastiano Luciani)
Italian, circa 1485–1547
Pope Clement VII,
circa 1531
Oil on slate
105.5 × 87.5 cm
(41½ × 34½ in.)
92.PC.25

This portrait depicts Giulio de' Medici (1478–1534), who reigned as Pope Clement VII from 1523 to 1534. An outstanding humanist, Clement is principally remembered as one of the greatest patrons of the Renaissance, commissioning major works from Raphael and Michelangelo as well as Sebastiano.

ᴗMichelangelo regarded Sebastiano as the greatest portrait painter of his day. The distinctive, monumental grandeur of his style was particularly suited to state portraits such as this one. The painter's characterization of the pope reflects the Renaissance cult of individuality in its bold projection of a powerful, unmistakable presence. The pontiff possesses an innate nobility and self-confidence, befitting both his position and his personality.

Aspiring to eternalize his works, Sebastiano began to experiment with painting on stone, rather than canvas or wood, in about 1530. The pope, apparently sharing the desire for an immortal image, had commissioned this portrait on slate by July 22, 1531, when the painter wrote to Michelangelo about it.

FRANCESCO
SALVIATI

(Francesco de' Rossi)
Italian, 1510–1563
Portrait of a Bearded Man,
circa 1550–55
Oil on panel
108.9 × 86.3 cm (42⅞ × 34 in.)
86.PB.476

The bold pose, affected gesture, strident colors, and glossy finish of this likeness are characteristic of mid-sixteenth-century Mannerism. Frozen images of aristocratic rank developed from portraits such as Pontormo's halberdier (see p. 102). However, this likeness reflects the influence of Pontormo's greatest pupil, Bronzino, whose portraits of the Medici court Salviati studied in the 1540s.

VERONESE

(Paolo Caliari)
Italian, 1528–1588
Portrait of a Man, circa
1576–78
Oil on canvas
192.2 × 134 cm
(75⅝ × 52¼ in.)
71.PA.17

Based on the approximate date of the canvas, the age of the subject, and the physical resemblance to known portraits of Veronese, this painting has sometimes been identified as a self-portrait. However, full-length portraits of artists were uncommon in the sixteenth century, and the privilege of wearing a sword was rarely granted to painters. It has recently been suggested that the sitter, whatever his identity, may have had some connection with the basilica of San Marco in Venice, which appears at the lower left.

TITIAN

(Tiziano Vecellio)
Italian, circa 1480–1576
Venus and Adonis, circa 1560s
Oil on canvas
160 × 196.5 cm (63 × 77⅜ in.)
92.PA.42

Titian won an international reputation through his portraits and mythological paintings. Most famous among the latter was a series of loves of the ancient gods — originally painted in 1554 for Philip II of Spain — that included a *Venus and Adonis*. Many of the canvases from this series were replicated and sold across Europe. The Getty *Venus and Adonis* shows Titian rethinking the Spanish original, and this version seems to have been the archetype for a cartoon that was used to generate several exact copies.

Titian depicts Venus, the goddess of love, beseeching Adonis to stay. Instead, he follows his eager hounds to his fatal encounter with a wild boar. Cupid's slumbering form and the upturned wine vase remind us that love will have no power over the lure of adventure that draws the hunter to his doom.

Venetian painters were famous for their sensuous treatment of light on textured surfaces. In *Venus and Adonis* the dog's rough fur, the glowing flesh, and the shimmering drapery glisten under the shafts of light. Forms are evoked, not described, to convey the lovers' final moment together.

DOMENICHINO

(Domenico Zampieri)
Italian, 1581–1641
The Way to Calvary,
circa 1610
Oil on copper
53.7 × 68.3 cm (21⅛ × 26⅞ in.)
83.PC.373

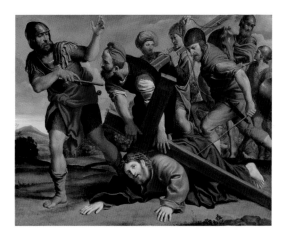

Domenichino continually sought ideal form and grandeur, known as *disegno*, in his compositions; this painting is one of the earliest realizations of that goal. He often painted on copper plates, using small, controlled brushstrokes to describe the massive volumes of the figures. As they lean over the fallen Christ, the tormentors embody the inexorable forces driving him to Calvary. Intent on their cruelty, they do not acknowledge Christ's pleading silence.

DOMENICO FETTI

Italian, circa 1589–1623
*Portrait of a Man with a
Sheet of Music,* circa 1620
Oil on canvas
173 × 130 cm (68 × 51⅛ in.)
93.PA.17

Even though the identity of the sitter remains a mystery, he surely represents either a musician or an actor because he holds a sheet of music and intensely regards the viewer while singing or speaking. In the background, one man gestures for another to keep quiet, as if the protagonist were rehearsing or performing. Based on the overturned cup in the lower left corner, it has been suggested that the sitter may be acting the part of Diogenes, the Greek Cynic philosopher, who despised worldly possessions.

GUERCINO

(Giovanni Francesco Barbieri)
Italian, 1591–1666
Pope Gregory XV,
circa 1622–23
Oil on canvas
133.4 × 97.8 cm (52½ × 38½ in.)
87.PA.38

Baroque portraits of exalted sitters often concentrate on the trappings of power without aiming to represent character. This picture is a remarkable exception. Instead of merely portraying the pontiff in his official capacity, Guercino depicted him sympathetically in the last months of his life, worn by the cares of office and failing health.

GIOVANNI LANFRANCO

Italian, 1582–1647
*Moses and the Messengers
from Canaan,* 1621–24
Oil on canvas
218 × 246.3 cm (85¾ × 97 in.)
69.PA.4

Painted in Rome about fourteen years after Domenichino's much smaller *The Way to Calvary* (see p. 106), Lanfranco's composition displays the same concern for monumentality. His stark, powerful work shows the spies returning to Moses (at the left with his characteristic staff) laden with grapes and other proof of the fruitfulness of Canaan (Numbers 13:21–25). This picture formed part of a set of nine paintings (the Museum owns one other) representing Old and New Testament miracles involving food and hence prefiguring the Eucharist.

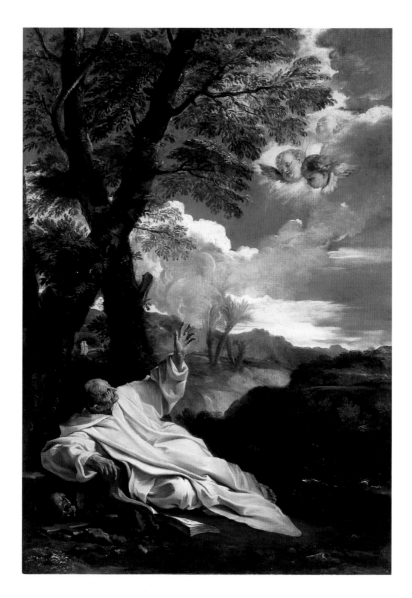

PIER FRANCESCO
MOLA

Italian, 1612–1666
The Vision of Saint Bruno,
circa 1660
Oil on canvas
194 × 137 cm (76⅜ × 53⅞ in.)
89.PA.4

Saint Bruno was the founder of the Carthusian order, a monastic community committed to solitary meditation as the most effective means of attaining union with God. Here the saint demonstrates this hermetic ideal, reaching to touch a vision that has appeared during his devotions in the wilderness.

Mola won fame in Rome for his rich landscapes with dramatic cloud formations based on Venetian examples. In this work he also demonstrates his exceptional ability to convey complex psychological states as he explores one of the most important themes of Baroque art: humanity's confrontation with the divine.

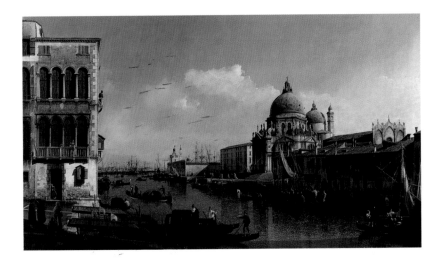

BERNARDO
BELLOTTO

Italian, 1721 – 1780
*View of the Grand Canal:
Santa Maria della Salute and
the Dogana from Campo Santa
Maria Zobenigo*, circa 1747
Oil on canvas
135.5 × 232.5 cm
(53¼ × 91¼ in.)
91.PA.73

Bernardo Bellotto's precocious talent was fostered by
his uncle, Canaletto (1697 – 1768), a painter famous
for idealized views of his native Venice. Painted while
Bellotto was still in Canaletto's studio, the *View of the
Grand Canal* is an early masterpiece that demonstrates
the young artist's ability to carry out a complex compo-
sition that is monumental in scale and bold in pictorial
handling.

This splendid view of the Grand Canal looks from
the small square, or *campo*, beside the Church of Santa
Maria Zobenigo toward the opening of the canal into
the great bay before Saint Mark's Square at the heart
of the city. At left are a portion of the *campo* and the
Palazzo Pisani-Gritti. The opposite bank is dominated
by the church of Santa Maria della Salute, the master-
work of Venetian Baroque architecture and one of the
city's most famous monuments.

Other than the row of modest houses at right,
demolished in the late nineteenth century, the buildings
depicted in Bellotto's view remain virtually the same
today. Studying the vista from the *campo* makes it clear
that the painter took substantial liberty in adjusting
the relationships of the structures to better suit his com-
position. Far more than a simple architectural record,
Bellotto's painting seems to capture the grandeur of
Venice at a specific moment in time, including the fleet-
ing, magical qualities of light uniquely found there.

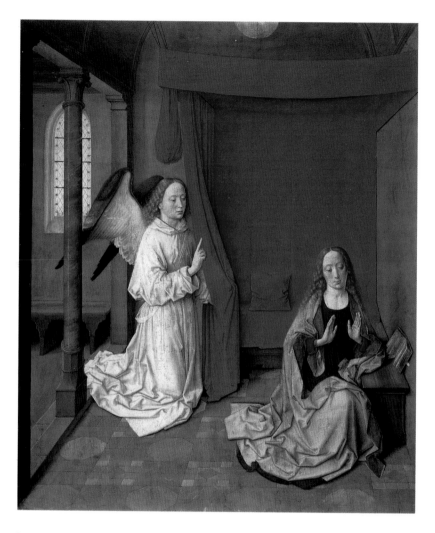

DIERIC BOUTS

Flemish, active
circa 1415–1475
The Annunciation,
circa 1450–55
Distemper on linen
90 × 74.5 cm (35⁷⁄₁₆ × 29⅛ in.)
85.PA.24

This painting represents the Incarnation, or conception of Christ, which occurred when the Archangel Gabriel announced to the Virgin Mary, "You shall conceive and bear a son, and you shall give him the name of Jesus" (Luke 1:31). Mary, seated on the ground to indicate her humility, responds with a gesture conveying her acknowledgment of the miracle and acceptance of God's will. Bouts created a composition of surprising simplicity, minimizing symbolic detail to establish a mood of hushed solemnity. This image was executed in an equally austere technique. Thin washes of pigment in animal glue were applied to fine linen to give the scene a delicate, luminous quality. This was the first scene in an altarpiece relating the Life of Christ; the final scene, *The Resurrection*, is in the Norton Simon Museum, Pasadena.

JAN GOSSAERT

(called Mabuse)
Flemish, circa 1478–1532
Francisco de los Cobos
y Molina,
circa 1530–32
Oil on panel
43.8 × 33.7 cm (17¼ × 13¼ in.)
88.PB.43

The most accomplished Flemish painter of his genera-
tion, Gossaert combined keen observation of form,
facile rendering of surface textures, and psychological
insight to create portraits remarkable for their strong
physical presence. This one probably represents
Francisco de los Cobos, a major Spanish patron who
was the powerful secretary and chief financial adviser
to Emperor Charles V (r. 1519–1556).

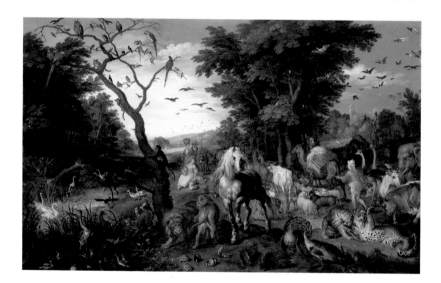

JAN BRUEGHEL THE ELDER

Flemish, 1568–1625
The Entry of the Animals
into Noah's Ark, 1613
Oil on panel
54.6 × 83.8 cm (21½ × 33 in.)
92.PB.82

This is the first of a group of Paradise landscapes devel-
oped by Brueghel, the most important Flemish land-
scape painter working at the dawn of the Baroque era.
In this episode from the story of Noah's ark (Genesis
68), Brueghel celebrates the beauty and variety of
God's creations. His encyclopedic representation of
animals reflects the new interest in natural history.
While court painter to the Archduke Albert in Brussels,
he studied the exotic animals and birds in the royal
menagerie. This painting exemplifies Brueghel's metic-
ulous attention to detail and use of vivid colors.

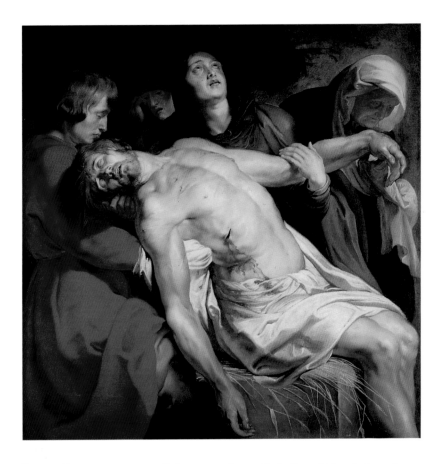

PETER PAUL
RUBENS

Flemish, 1577–1640
The Entombment, circa 1612
Oil on canvas
131 × 130.2 cm (51⅛ × 51¼ in.)
93.PA.9

Rubens was a devout Catholic, and his paintings give
tangible form to the main concerns of his religion.
This powerful work was carefully composed to focus
devotion on Jesus Christ's sacrifice and suffering.
The head of Christ, frozen in the agony of death, is
turned to confront the observer directly. Rubens also
compels us to regard the gaping wound in Christ's
side, placing it at the center of the canvas. The viewer
is obliged to join the mourners, whose grief is focused
in the Virgin Mary, weeping as she implores heaven.

Rubens also introduces symbolic elements that
reflect the theological and political concerns of the
Counter-Reformation in the early seventeenth century.
Thus, the slab on which the body is placed suggests an
altar, while the sheaf of wheat alludes to the bread
of the Eucharist, the equivalent of Christ's body in the
mass. At this time the Roman church was defending
the mystery of Transubstantiation, the belief in the real
presence of the body of Christ in the Eucharist, against
Protestant criticism.

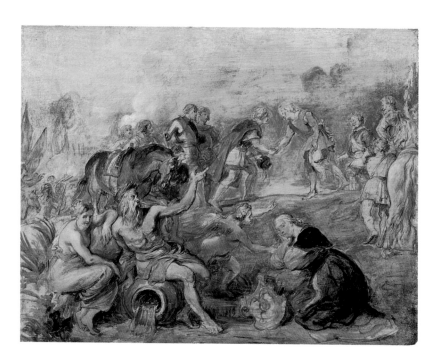

PETER PAUL
RUBENS

Flemish, 1577–1640
The Meeting of King Ferdi-
nand of Hungary and the
Cardinal-Infante Ferdinand
of Spain at Nördlingen, 1635
Oil on panel
49.1 × 63.8 cm (19⁵⁄₁₆ × 25⅛ in.)
87.PB.15

In 1635 the Cardinal-Infante Ferdinand, brother of King
Philip IV of Spain (r. 1621–1665) and newly appointed
governor of the southern Netherlands, made his tri-
umphal entry into Antwerp. In celebration, the city's
magistrates commissioned from Peter Paul Rubens a
series of temporary structures to line the parade route.

This sketch served as a model for Rubens's shop in
the production of a large canvas that decorated the Stage
of Welcome. It depicts the meeting of the Cardinal-
Infante and his Habsburg cousin shortly before their
combined armies scored an important victory over
Protestant forces in 1634. Since the Spanish Habsburgs
recently had lost the northern Netherlands to the Prot-
estant cause, this subject promoted the role of dynastic
alliance in the preservation of the Catholic faith.

In typical Baroque manner, the historical personages
are flanked by allegorical figures who comment on the
event's significance. The meeting took place on the
Danube, represented here as a classical river god sitting
on an urn flowing with water and blood, an allusion to
the coming battle. At right Germania gazes mournfully
at the viewer as a winged genius draws her attention to
the meeting and the promise of peace.

Sketches such as this have been highly valued since
Rubens's day; executed entirely by the artist, they are
direct records of a great master creating a complex,
dramatic composition in a spirited, economical way.

ANTHONY
VAN DYCK

Flemish, 1599–1641
Agostino Pallavicini,
circa 1621
Oil on canvas
216 × 141 cm (85⅛ × 55½ in.)
68.PA.2

Shortly after arriving in Italy, van Dyck is known to
have painted Agostino Pallavicini dressed in the
robes of an ambassador to the pope. The sketchy cur-
tain behind the sitter here bears the Pallavicini coat
of arms, and his dramatic robes surely were intended
for ceremonial duties. Van Dyck emulated his master
Rubens's rich and dramatic painting style but brought
to portraiture a unique aristocratic refinement that
transformed the genre.

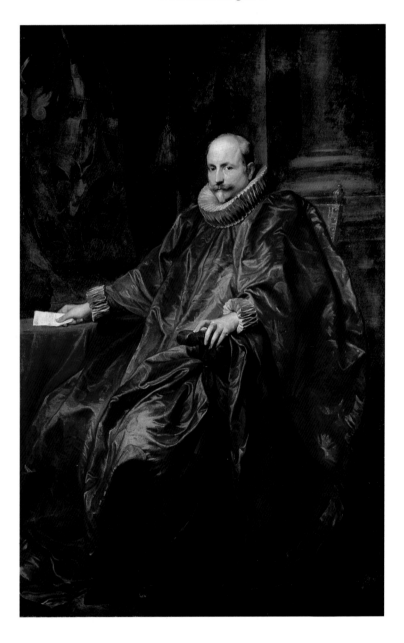

JOACHIM WTEWAEL

Dutch, 1566–1638
*Mars and Venus Surprised by
Vulcan*, circa 1606–10
Oil on copper
20.25 × 15.5 cm (8 × 6⅛ in.)
83.PC.274

In this small painting Wtewael has depicted a scene from
Ovid's *Metamorphoses* (4:171–189) with appropriate
raucous humor. As Vulcan (at the bottom right) draws
his forged net from the bed, the lovers Mars and Venus
(Vulcan's wife) reel back. Cupid and Apollo raise the
canopy for a peek, and a gleeful Mercury (wearing a
winged cap) looks up to Diana in the clouds at the right.
Saturn (holding a sickle) and Jupiter crane their necks
to behold the embarrassed adulterers. The rhythmically
paired heroic nude figures show Wtewael at the height
of his inventive powers as a Mannerist artist.

The use of copper as a support for paintings was
especially widespread during the late sixteenth and
early seventeenth centuries. The very hard and polished
surface was well suited for the present picture, since
it allowed for subtler gradations of tone and greater in-
tensity of color than canvas.

This tiny cabinet picture may have been painted for
the private enjoyment of a connoisseur familiar with
Ovid's text and capable of appreciating both the artist's
skill and the significance of the painting's symbolic
details. It was probably the painting commissioned by
Joan van Weely, a jeweler from Amsterdam.

HENDRICK TER
BRUGGHEN

Dutch, 1588–1629
Bacchante with an Ape, 1627
Oil on canvas
102.9 × 90.1 cm
(40½ × 35½ in.)
84.PA.5

This devotee of Bacchus, with her fruit, nuts, and ape (a symbol of appetite or gluttony), may represent the sense of taste. Caravaggio had set the fashion for half-length figures representing the senses in Rome at the turn of the century, and his works certainly influenced ter Brugghen's both in type and style. Coming from a Catholic city in largely Protestant Holland, ter Brugghen was one of the few Dutch artists to visit Italy in an era of religious controversy and so became instrumental in the spread of new Italian styles to the North. The lively, unidealized portrayal of the model and the sculptural modeling of the flesh in darks and lights are characteristic of the Caravaggesque style ter Brugghen adopted while in Rome (1604–14) and carried back to his native Utrecht.

PIETER JANSZ. SAENREDAM

Dutch, 1597–1665
*The Interior of the Church of
Saint Bavo, Haarlem,* 1628
Oil on panel
38.5 × 47.5 cm (15¼ × 18¾ in.)
85.PB.225

Pieter Saenredam, the great renovator of architecture painting in the Netherlands, transformed the idealized, artificial perspective of earlier pictures done mostly by Flemish artists. By minimizing anecdote and adopting an unusually low viewpoint, Saenredam concentrated on the depiction of light, color, and space in monumental buildings.

The Interior of the Church of Saint Bavo, Haarlem is the earliest known painting by Saenredam. It is the first of twelve paintings of the interior of this church—one of the finest Gothic buildings in Holland—that he painted between 1628 and 1660. Saenredam conceived his views of church interiors with the help of detailed, on-the-spot studies, extensive measurements, and perspective drawings. In this painting, the artist transcends mere architectural portraiture by merging two distinct views of the church: from the north transept straight ahead into the south transept, and to the east, into the choir. Different shades of white paint—ranging from bluish-white to creamy yellow—suggest the northern and southern light shining into the building. Remarkably, Saenredam substituted an altarpiece for the doors in the church's south transept and included a stained glass window with a depiction of the Immaculate Conception. These elements suggest a Catholic commission for this painting.

REMBRANDT HARMENSZ. VAN RIJN

Dutch, 1606–1669
The Abduction of Europa, 1632
Oil on panel
62.2 × 77 cm (24½ × 30⁵⁄₁₆ in.)
95.PB.7

Rembrandt regarded history painting—the portrayal and interpretation of great stories of the past—as his most important activity. During his early years in Amsterdam he turned to classical mythology for subjects such as *The Abduction of Europa*, which derives from Ovid's *Metamorphoses*. In it Jupiter, the king of the gods, has transformed himself into a beautiful white bull in order to seduce Europa, the princess of Tyre. Beguiled, she climbs onto the bull's back and is spirited across the sea to the continent that will one day bear her name. Rembrandt evokes the poetry of Ovid's tale by showing Europa as she "trembles with fear and looks back at the receding shore, holding fast a horn . . . her fluttering garments stream[ing] . . . in the wind." He enriches the narrative through his vivid characterization of emotion and accentuates the drama by contrasting the shadowed immobility of the land with the shimmering movement of the sea and the sky.

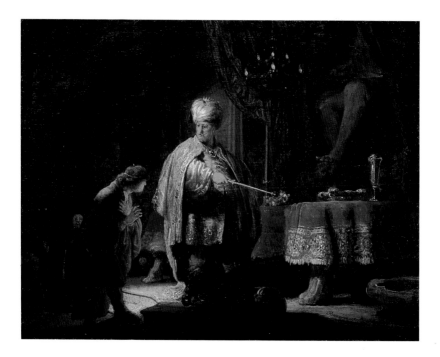

REMBRANDT
HARMENSZ.
VAN RIJN

Dutch, 1606–1669
*Daniel and Cyrus Before
the Idol Bel*, 1633
Oil on panel
23.4 × 30.1 cm (9¼ × 11⅞ in.)
95.PB.15

Rembrandt took this ancient detective story from
the apocryphal Book of Daniel. It tells of Daniel's
unmasking of idolatry at the court of Babylon, where
he had become a confidant of King Cyrus of Persia.
When Cyrus asked his trusted adviser why he did not
honor the deity Bel, Daniel replied that he worshiped
the living God, not an idol. The king insisted that Bel
too was a living god, indicating the offerings of food
and wine he provided for Bel's consumption each night.
In this rendering, Daniel gently points out that bronze
statues don't eat. The worried face of one of the priests
confirms that Daniel is on to something, and Cyrus
begins to realize that he may have been duped. Later in
the story, Daniel secretly spreads ashes on the floor
of the temple, and, the next morning, the footprints of
the priests and their families reveal the truth.

Rembrandt evokes a mood of mystery with flicker-
ing light and the partial view of the monumental idol.
He then tells the story with gesture and expression,
emphasizing the contrast between the large, powerful
Cyrus and the small, humble Daniel. Created the year
after *The Abduction of Europa* (see previous entry), this
work shows Rembrandt's evolution toward the more
concise and dramatically focused compositions of his
mature style. Both paintings demonstrate the humanity
at the heart of Rembrandt's genius as a storyteller.

REMBRANDT
HARMENSZ.
VAN RIJN

Dutch, 1606–1669
*An Old Man in Military
Costume*, circa 1631
Oil on panel
66 × 50.8 cm (26 × 20 in.)
78.PB.246

From the beginning of
his career, Rembrandt
was occupied with his-
torical subjects. He soon
took up a related genre,
which he made his own:
studies of individual cos-
tumed figures.

 Such works as *An Old
Man in Military Costume*
are not primarily por-
traits but rather studies
in which Rembrandt
explored the human
condition.

PHILIPS KONINCK

Dutch, 1619–1688
Panoramic Landscape, 1665
Oil on canvas
138 × 167 cm (54½ × 65½ in.)
85.PA.32

Koninck's expansive view, like Rembrandt's drawings and prints of landscapes (see p. 168), combines real and imagined elements to create the illusion of sweeping space seen from a great height.

REMBRANDT HARMENSZ. VAN RIJN

Dutch, 1606–1669
Saint Bartholomew, 1661
Oil on canvas
86.5 × 75.5 cm (34⅛ × 29¼ in.)
71.PA.15

Rembrandt's subject has been identified as Saint Bartholomew by virtue of the knife—the instrument of his martyrdom—gripped in his right hand, but the actual sitter may have been one of the artist's friends or neighbors in Amsterdam. Rembrandt painted several deeply moving studies of such men in the guise of saints and apostles in the early 1660s. Somberly colored and expressively painted, the *Saint Bartholomew* is an examination of age and introspection. The momentary distraction of the *Old Man in Military Costume* (see p. 120) has given way to the saint's profound absorption; his thoughts are far removed from the present. During the thirty years between the *Old Man* and this painting, Rembrandt's style also shifted from concern for surface effects to a probing analysis of form and structure.

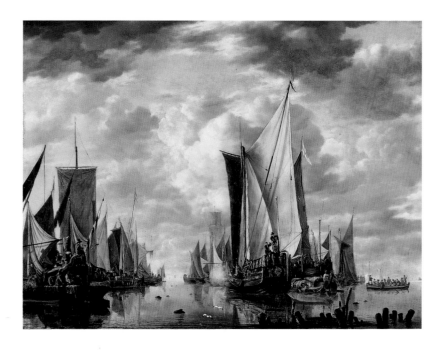

JAN VAN DE
CAPPELLE

Dutch, 1625/26–1679
*Shipping in a Calm at Flushing
with a States-General Yacht
Firing a Salute*, 1649
Oil on panel
69.7 × 92.2 cm (27⅞ × 36¼ in.)
96.PB.7

In the mid-seventeenth century, when the Dutch
Republic had reached its height of power as a global
trading empire, its domination of the seas found expres-
sion in the nascent specialization of marine painting. In
1649, Jan van de Cappelle and Simon de Vlieger changed
the course of Dutch seascapes with an innovation
known as the "parade" picture, which showed grand
ships convening for special occasions under towering,
cloud-filled skies.

In *Shipping in a Calm* a stately yacht fires a salute,
which announces the arrival of a dignitary, who is
conveyed to shore in a launch at right. Unaffected by
the shot, porpoises glide peacefully through the
calm waters. They were known to frequent Flushing
(Vlissingen), the busy port used by the Dutch East
India Company, which was frequently portrayed in van
de Cappelle's paintings.

As one of his earliest known signed and dated
works, this painting displays van de Cappelle's highly
developed style and remarkable technical virtuosity.
The painter demonstrates an accomplished graphic
handling of form in the detailed ships, rigging, and sails,
and his mastery of optical effects in the treatment of
reflections in the water. This dramatic avenue of ships
framing an infinite vista of the sea is a pioneering con-
tribution to the genre of marine painting.

Jan Steen

Dutch, 1626–1679
The Drawing Lesson,
circa 1665
Oil on panel
49.3 × 41 cm (19⅛ × 16¼ in.)
83.PB.388

Frans van Mieris the Elder

Dutch, 1635–1681
Pictura, 1661
Oil on copper
12.5 × 8.5 cm (5 × 3½ in.)
82.PC.136

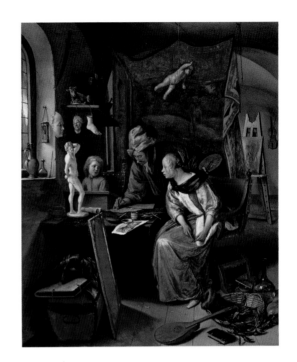

These two compositions are both allegories of the painter's art. The Steen shows the interior of a painter's studio, cluttered with symbolic objects, while the painter, his apprentice, and a young woman concentrate on correcting a drawing. Several of the symbolic objects in *The Drawing Lesson* also appear as attributes of Pictura, a personification of the art of painting. Along with her palette, brushes, and statue, this figure wears a mask hung on a chain around her neck. The mask may be an emblem of deceit or illusion (the painter creates an illusion of reality), or it may refer to the dramatic arts (like the dramatist, the painter must invent and "stage" convincing scenes).

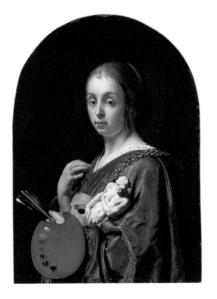

PAULUS POTTER

Dutch, 1625–1654
The Piebald Horse,
circa 1650–54
Oil on canvas
49.5 × 45 cm (19½ × 17¹¹⁄₁₆ in.)
88.PA.87

GERARD TER
BORCH

Dutch, 1617–1681
Horse Stable, circa 1654
Oil on panel
45.3 × 53.5 cm
(17¹³⁄₁₆ × 21¹⁄₁₆ in.)
86.PB.631

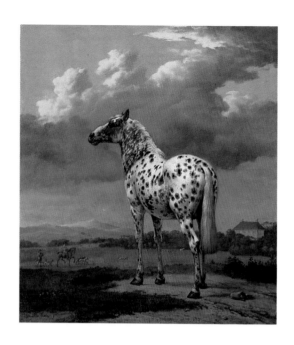

A horse was valuable
property in seventeenth-
century Holland. Both of
these paintings reflect
the pride the prosperous
Dutch took in their
costly livestock. Potter,
the most successful ani-
mal painter of his time,
painted this magnificent
piebald horse as a monu-
mental creature, attesting
to its nobility. The horse-
man in the background,
returning with his groom
and dogs to his country
house, may be the ani-
mal's owner. Ter Borch's
Horse Stable is roughly
contemporary. A fine
riding horse is repre-
sented in a barn, tended
by a man dressed in
distinctly middle-class
attire, as is the woman
at the right. This subject
was highly unusual for
ter Borch, normally
a painter of sophisticated
genre scenes and portraits.

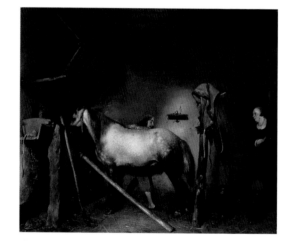

JAN VAN HUYSUM

Dutch, 1682–1749
Vase of Flowers, 1722
Oil on panel
79.5 × 61 cm (31¼ × 24 in.)
82.PB.70

AMBROSIUS BOSSCHAERT THE ELDER

Dutch, 1573–1621
Flower Still Life, 1614
Oil on copper
28.6 × 38.1 cm (11¼ × 15 in.)
83.PC.386

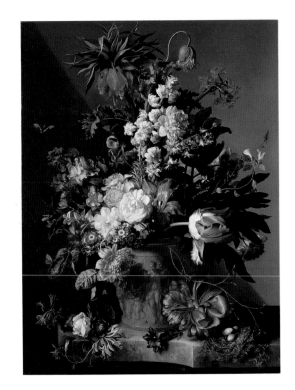

The mania for cultivating flowers in Baroque Europe fostered the development and popularity of flower painters. One of the earliest of these specialists, Ambrosius Bosschaert the Elder, has grouped flowers from different seasons—roses, tulips, forget-me-nots, cyclamen, a violet, and a hyacinth—along with insects equally beautiful and short-lived. Jan van Huysum's bouquet of a century later includes several of the same flowers and insects as well as a bird's nest. Both painters celebrated the decorative qualities of their subjects but also intended to provoke serious reflection on the transience of life and beauty.

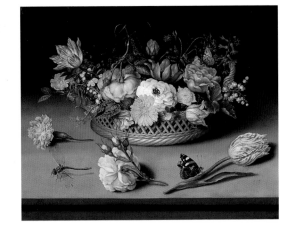

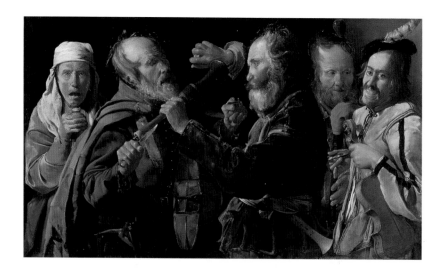

GEORGES DE
LA TOUR

French, 1593–1652
The Beggars' Brawl,
circa 1625–30
Oil on canvas
85.7 × 141 cm (33¾ × 55½ in.)
72.PA.28

This early La Tour composition shows a scuffle between two beggar musicians. Scholars have suggested that the two troupes are fighting for possession of a lucrative street corner; that the scene was taken from comedic theater; and that the man in velvet is unmasking the false blindness of the hurdy-gurdy player by squirting lemon juice in his eye. La Tour illuminates this frieze of beggars with a cold, overhead light. His strange palette, attention to unusual textures such as the wrinkled skin of the aged beggar, and the detached treatment of characters made La Tour one of the most original and enigmatic artists of the seventeenth century.

NICOLAS POUSSIN

French, 1594–1665
The Holy Family, 1651
Oil on canvas
100.6 × 132.4 cm
(39⅝ × 52⅛ in.)
81.PA.43
(Owned jointly with the
Norton Simon Art
Foundation, Pasadena)

The traditional Holy Family, which includes the Virgin and Child with Saint Joseph, has here been extended to include the youthful Saint John the Baptist with his mother, Saint Elizabeth. Framed by the passive figures of their parents, the holy children reach out in a lively embrace. Six putti bearing a basket of flowers, a ewer, a towel, and a basin of water may prefigure Saint John's later baptism of Christ. Painted in Poussin's late classicizing style, *The Holy Family* reflects his study of Raphael and antique sculpture. Poussin's intellectual approach to painting, his insistence on harmony among all parts of the composition, and his concentration on the ideal and the abstract contrast with the dramatic style of the Caravaggist painter Valentin.

CHARLES LE BRUN

French, 1619–1690
*The Martyrdom of Saint
Andrew*, circa 1647
Oil on canvas
98.5 × 80 cm (38¾ × 31½ in.)
84.PA.669

Charles Le Brun was the first artist to hold the influential title of first painter to the king under Louis XIV (r. 1643 – 1715). Le Brun's classical manner owed a great deal to Poussin (see previous entry), whom he had followed to Rome in 1642. This oil study illustrates Le Brun's admiration for Poussin and the Baroque as well as his knowledge of classical antiquity. In the painting Saint Andrew appeals dramatically to the heavens as he is being tied to the cross of his martyrdom amid a turbulent group of soldiers and mourners.

JEAN-FRANÇOIS DE TROY

French, 1679–1752
Before the Ball, 1735
Oil on canvas
81.8 × 65 cm (32⅛ × 25⁷⁄₁₆ in.)
84.PA.668

De Troy, a painter of historical, religious, and mythological subjects, is best remembered for his invention of the *tableau de mode* showing elegant company in fashionable interiors. Inspired by the *fêtes galantes* of Watteau and his circle and by seventeenth-century Dutch genre paintings, de Troy depicts a group of gallants preparing for a masked ball. Their lavish dress and the fine furniture add to the opulence of the setting. The mood of hushed expectancy is enhanced by the flickering candlelight that illuminates the room.

MAURICE-QUENTIN DE LA TOUR

French, 1704–1788
Gabriel Bernard de Rieux,
circa 1739–41
Pastel and gouache on paper
mounted on canvas
Unframed: 200 × 150 cm
(79 × 59 in.)
Framed: 317.5 × 223.5 cm
(125 × 88 in.)
94.PC.39

Maurice-Quentin de La Tour was the most sought-after portraitist of his day. He worked exclusively in pastel, producing likenesses of the nobility and the wealthy middle class that were acclaimed both for their technical mastery and for their brilliant verisimilitude. After seeing the portrait of Gabriel Bernard de Rieux at the Salon of 1741 a viewer wrote, "It is a miraculous work, it is like a piece of Dresden china, it cannot possibly be a mere pastel." The fine differentiation between textures, the play of light over reflective surfaces, and the overall high degree of finish were qualities expected from oils, but they were extraordinarily difficult to achieve in frangible pastels. The work was La Tour's successful challenge to the prestigious medium of oil.

This monumental full-length portrait, still in its original massive gilt frame, transcends the intimate conventions of pastel. During his long career La Tour did only one other like it, the portrait of Madame de Pompadour now in the Musée du Louvre, Paris. The Getty Museum's portrait, assembled from separate sheets of paper laid on canvas, shows Gabriel Bernard de Rieux (1687–1745) dressed in the robes of his office as President of the Second Court of Inquiry in the Parliament of Paris.

JEAN-BAPTISTE
GREUZE

French, 1725–1805
The Laundress, 1761
Oil on canvas
40.6 × 31.7 cm (16 × 12⅞ in.)
83.PA.387

"This little laundress is charming, but she's a rascal I wouldn't trust an inch," wrote the critic Denis Diderot when he saw this painting exhibited at the Salon of 1761. The instant rapport Greuze's painted characters achieve with their flesh-and-blood audience—the exhibition-going public—was the source of his success in his own time and remains one of his great strengths today. The theatrical and moralizing qualities of his work are of primary importance: where will this young servant's bold appraisal of the viewer lead? Yet the painting's technical qualities also deserve notice. Just as sensual as the laundress's glance and exposed ankle are the creamy brushstrokes delineating the folds of laundry, warm ceramic and wood surfaces, gleaming copper pots, and the woman's youthful skin.

JACQUES-LOUIS
DAVID

French, 1748–1825
*The Farewell of Telemachus
and Eucharis*, 1818
Oil on canvas
87.2 × 103 cm (34½ × 40½ in.)
87.PA.27

David found the story of the romance between Telema-
chus, son of the Homeric hero Odysseus, and the
nymph Eucharis in the didactic novel *Télémaque*, writ-
ten by the French prelate Fénelon in 1699. The ideal-
ized lovers, physically perfect and morally pure, take
refuge in a grotto for a last embrace before Telemachus
departs in search of his errant father. *The Farewell*'s
erotic theme, sumptuous coloring, and sensually
painted half-length figures are characteristic of David's
late history paintings executed in Brussels after his exile
from France in 1816. His saturated reds and blues and
vividly convincing flesh tones—reflecting the influence
of the Flemish Baroque artist Rubens—are here mar-
ried to the Greek perfection of line and form character-
istic of late Neoclassicism.

THÉODORE
GÉRICAULT

French, 1791–1824
*The Race of the Riderless
Horses*, 1817
Oil on paper laid on canvas
19.9 × 29.1 cm (7¹³⁄₁₆ × 11⁷⁄₁₆ in.)
85.PC.406

Géricault devoted much of his year in Rome (1816–17)
to planning a monumental painting of the race of
the riderless horses, the climax of the Roman Carnival
season. The furious struggle between lunging animals
and their handlers at the start of the race may symbolize
the Romantic artist's search for a balance between his
own passions and his need for professional discipline.

THÉODORE
GÉRICAULT

French, 1791–1824
Three Lovers, 1817–20
Oil on canvas
22.5 × 29.8 cm (8⅞ × 11¾ in.)
95.PA.72

Drawn curtains and a statue of Venus frame a dramati-
cally lit interior. Within it a couple, clothed in contem-
porary dress, make love while a nude, reclining woman
watches them. Géricault's direct presentation of an
erotic subject, without moralizing or sentimental justi-
fication, is unprecedented. His translation of a contem-
porary event into a timeless setting makes modern life
appropriate for high art. The free technique of this
small-scale, independent finished sketch unites the emo-
tional immediacy of the subject with the dramatic spon-
taneity of the artist's touch.

THÉODORE
GÉRICAULT

French, 1791–1824
Portrait Study, circa 1818–19
Oil on canvas
46.7 × 38 cm (18⅜ × 15 in.)
85.PA.407

This portrait may represent Joseph, the professional artist's model who posed for Géricault's masterpiece *The Raft of the Medusa* (Paris, Musée du Louvre), completed in 1819. A haunting character study never used in the larger work, this portrait belongs to an important group of paintings and drawings of African men by Géricault.

JEAN-FRANÇOIS
MILLET

French, 1814–1875
Louise-Antoinette
Feuardent, 1841
Oil on canvas
73.3 × 60.6 cm (28⅞ × 23⅞ in.)
95.PA.67

Before his move to Barbizon and international success
as a painter of peasant life, Jean-François Millet earned
his living as a portraitist. Millet depicted Louise-
Antoinette Feuardent in the middle of his two-year
stay in the Norman city of Cherbourg. The young wife
of Millet's lifelong friend, Félix-Bienaimé Feuardent,
a clerk in the city library, is portrayed with carefully
deliberated simplicity. The setting is plain, the costume
unpretentious, and the mood contained and still. This,
one of his most tender and moving portraits, captures
the understated virtue of a modern woman from the
provinces.

JEAN-FRANÇOIS
MILLET

French, 1814–1875
Man with a Hoe, 1860–62
Oil on canvas
80 × 99 cm (31½ × 39 in.)
85.PA.114

When Millet first exhibited *Man with a Hoe* at the Salon of 1863, it raised a storm of controversy that lasted well into the twentieth century. The artist intended his image of an exhausted peasant to represent the dignity and strange beauty of manual labor. By contrasting the bent, awkward figure with the richly painted, broken earth of the field, Millet was calling attention to the costs and benefits of agrarian life. The division of the foreground into distinct patches of stony, thorny terrain and cultivated earth graphically portrays the results of the peasant's toil. However, the starkness of the scene and harsh characterization of the peasant were attacked by most of the critics who reviewed the 1863 exhibition. Moreover, since it concluded a long series of similar subjects Millet painted during a decade of heated public debate over the fate of the peasant in French society, *Man with a Hoe* was taken by some to represent the socialist position on the laboring poor. In response to claims that his painting was both ugly and politically radical, Millet responded, "Some tell me that I deny the charms of the country. I find more than charms, I find infinite glories. . . . But I see as well, in the plain, the steaming horses at work, and in a rocky place a man, all worn out, whose 'Han!' has been heard since morning, and who tries to straighten himself for a moment and breathe. The drama is surrounded by beauty."

PIERRE-AUGUSTE
RENOIR

French, 1841–1919
La Promenade, 1870
Oil on canvas
81.3 × 65 cm (32 × 25½ in.)
89.PA.41

Renoir's promenading couple heads for the undergrowth.
Although the subject owes its inspiration to Watteau,
Courbet, and Monet, the technique of using different
brushwork for different purposes was entirely Renoir's.
Thus he defined the white dress with long, flowing
strokes but created the landscape with short touches
that skitter and dance on the surface. Light, atmosphere,
and the diagonal movements of the lovers unify the
composition. The artist's vigorous enjoyment of
pleasure—both amorous and painterly—animates
every aspect of this early Impressionist work.

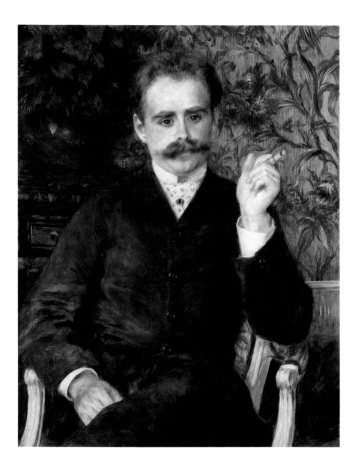

PIERRE-AUGUSTE
RENOIR

French, 1841–1919
Albert Cahen d'Anvers, 1881
Oil on canvas
79.8 × 63.7 cm (31⁷⁄₁₆ × 25⅛ in.)
88.PA.133

In the late 1870s and early 1880s Renoir earned most of his income from portraiture. The solid monumentality of his portrait of the orchestral composer Albert Cahen d'Anvers (1846–1903) is typical of these works and reflects Renoir's growing interest in Renaissance art some ten years after he painted *La Promenade* (see previous entry). Not typical is the subject of a male sitter by an artist best known for his flattering and often sentimental depictions of women and children. Cahen d'Anvers is elegantly dressed and nonchalantly posed as he smokes a cigarette in the salon at Wargemont, the home of Renoir's great patron Paul Bérard. The young man's vivid coloring probably inspired Renoir to base his composition on contrasting reds and blues. The painter cleverly reinforces the unity between sitter and setting through the unexpected repetition of forms, such as the curl of Cahen d'Anvers's mustache, the curves in the wallpaper pattern behind him, and the sparkling highlights glinting from his buttons, cravat, and eyes.

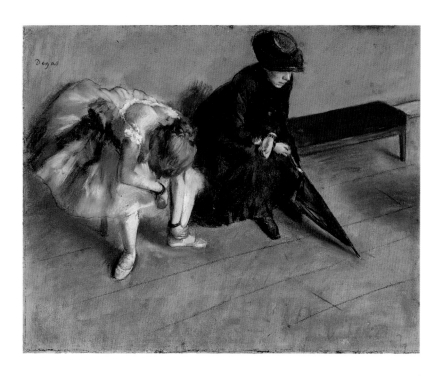

EDGAR DEGAS

French, 1834–1917
Waiting, circa 1882
Pastel on paper
48.2 × 61 cm (19 × 24 in.)
83.GG.219
(Owned jointly with the
Norton Simon Art
Foundation, Pasadena)

Unlike his contemporaries the Impressionists, Degas arranged his subjects into compositions of great formal beauty laden with emotional power. He returned frequently to favorite poses or figures, finding fresh significance in each new combination, viewpoint, or variation. In this pastel Degas may have intended the juxtaposed figures on the bench to contrast the brilliant, artificial world of the theater with the drabness of everyday life. If the suggestion is correct that the scene shows a dancer and her mother from the provinces awaiting an audition at the Paris Opera, then a contrast between the ephemeral glamour of the opera dancer and the dreary respectability of the provincial woman may also be implied. Each figure is absorbed in her own thoughts, yet they share a sense of tension and anticipation.

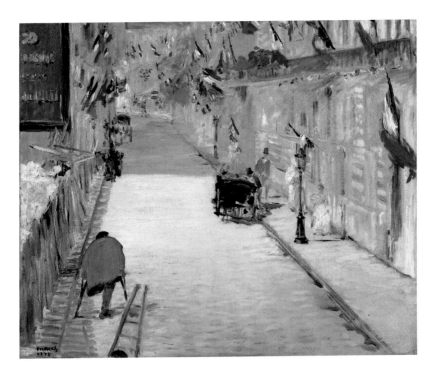

ÉDOUARD MANET

French, 1832–1883
The Rue Mosnier with Flags,
1878
Oil on canvas
65.5 × 81 cm (25¼ × 31¼ in.)
89.PA.71

On June 30, 1878, the day of a national celebration, Manet painted two canvases of his street with its decoration of flags. This deceptively casual rendering, executed as late afternoon shadows advanced down the rue Mosnier, captures the scene with brilliant economy. Virtuoso brushwork describes the scene with minimal fuss and maximum effect. Manet's commitment to subjects from modern life makes this painting more than an urban landscape, however; the poignant juxtaposition of the *quartier*'s one-legged beggar with elegant façades and carriages along the street suggests the inequities of life in the new urban environment.

CLAUDE MONET

French, 1840–1926
*Wheatstacks, Snow Effect,
Morning*, 1891
Oil on canvas
65 × 100 cm (25½ × 39¼ in.)
95.PA.63

In the fall of 1890 Monet began his first series. His motif was the wheatstacks located in a field just outside his garden at Giverny. Using brightly colored, rhythmically applied pigments Monet produced thirty canvases that captured what he called his "experience" of the wheatstacks as they were transformed by nature's permutations.

Monet completed this, one of the earliest and most tightly structured paintings in the series, in February 1891 and sold it four months before his famous exhibition of wheatstack paintings at the Galerie Durand-Ruel, Paris. In this quintessential Impressionist work, light, form, and color take on the same flickering visual substance. The painting's densely worked, complex surface reveals Monet's long, intense efforts in the studio striving to capture a precise, evanescent moment. The artist said, "For me a landscape hardly exists at all as a landscape, because its appearance is constantly changing; but it lives by virtue of its surroundings—the air and the light—which vary continually."

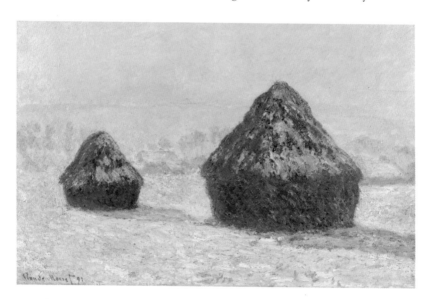

PAUL CÉZANNE

French, 1839 – 1906
Still Life with Apples,
1893 – 94
Oil on canvas
65.5 × 81.5 cm (25¾ × 32⅛ in.)
96.PA.8

The still life held an important, even obsessive position throughout Cézanne's career. The immobility and long-lasting nature of the objects he chose allowed him the time and control to pursue his pictorial analysis of the relationship between space and object, between visual experience and pictorial rendering.

Still Life with Apples is an elegantly composed, powerfully rendered image of familiar objects. The graceful rhythms created by the swinging black arabesques of the blue cloth, the looping rattan, and the swelling curves of the pots and fruit are played against the strong horizontals and verticals of the composition. Cézanne self-consciously integrates the objects to lock the composition together; a black arabesque "escapes" from the blue cloth to capture an apple in the center; the sinuous curves of the blue ginger pot's rattan straps are visually continued in the bottle. The green of the vase is counterbalanced by the red and yellow apples in this predominantly blue painting. His careful orchestration results in an image of balance, stasis, and control. Cézanne's professed goals "to do Poussin again after nature" and to make of Impressionism "something solid and enduring" are here achieved in the classical stability of this masterful work.

JEAN-ÉTIENNE LIOTARD

Swiss, 1702–1789
*Maria Frederike van
Reede-Athlone at Seven
Years of Age*, 1755–56
Pastel on vellum
57.2 × 43 cm (22½ × 18½ in.)
83.PC.273

Liotard strived to record three-dimensional objects faithfully, a technique he called "deception painting." His definition of volume through subtle gradations of color and his brilliant description of surface textures create the startling realism that makes his work unique. Here he has captured the alert intelligence of a seven-year-old girl from an aristocratic Dutch family with amazing immediacy. By choosing a plain background, Liotard focuses attention on the sitter, her clothing, and her pet dog. He suggests an enigmatic shyness on the part of the girl, whose averted eyes imply a complex personality about to bloom. The child's refined elegance contrasts with the eager curiosity of the dog, who stares at the viewer. Utilizing the difficult medium of pastel, Liotard masterfully evoked both the physicality and psychology of his subject.

THOMAS GAINSBOROUGH

British, 1727–1788
James Christie, 1778
Oil on canvas
126 × 102 cm (49⅝ × 40⅛ in.)
70.PA.16

James Christie, founder of the London auction house that still bears his name, is depicted as if attending one of his own sales. Much praised at the time of its exhibition at the Royal Academy, the portrait epitomizes Rococo elegance and grace. The style's characteristic arabesques are found in Christie's relaxed pose, in the tree and foliage of the Gainsborough landscape he leans against, in the gilt frame of the painting behind it, and in the artist's accomplished, free handling of paint throughout the composition.

JOSEPH MALLORD WILLIAM TURNER

British, 1775–1851
Van Tromp, going about to please his Masters, Ships a Sea, getting a Good Wetting, 1844
Oil on canvas
91.4 × 121.9 cm (36 × 48 in.)
93.PA.32

Turner united two of his passions, the sea and Holland, in this painting, which he first exhibited at the Royal Academy in 1844. It depicts a combination of events from the lives of two men, Admiral Maarten Harpertszoon Tromp (1598–1653) and his son Cornelius (1629–1691). Both earned renown for their naval victories against British and Spanish fleets during the height of Dutch seafaring power.

CASPAR DAVID FRIEDRICH

German, 1774–1840
A Walk at Dusk,
circa 1832–35
Oil on canvas
33.3 × 43.7 cm (13⅛ × 17³⁄₁₆ in.)
93.PA.14

Caspar David Friedrich was a leading figure of the German Romantic movement. He is noted for his deeply personal religious imagery in which landscapes and natural phenomena serve as metaphors for the most profound human experiences and sentiments.

A Walk at Dusk shows an isolated figure—dressed as a scholar and perhaps intended as a self-portrait—contemplating a prehistoric grave with its implicit message of death's inevitability.

FRANCISCO JOSÉ DE
GOYA Y LUCIENTES

Spanish, 1746–1828
*The Marquesa
de Santiago*, 1804
Oil on canvas
209 × 126.5 cm
(82½ × 49¾ in.)
83.PA.12

An English visitor to Spain described the Marquesa de
Santiago as "very profligate and loose in her manners
and conversation, and scarcely admitted into female
society. . . . She is immensely rich." Goya has not
attempted to flatter his sitter in this portrait; its beauty
depends on the manner in which it was painted. Broad
brushstrokes create the deep and splendid landscape;
the dress is matte black on black. Thick impasto simu-
lates the glitter of gold braid on the sleeve, and the
diaphanous lace mantilla is described with broad, flat
strokes of shimmering color. Goya's expressionistic
painting style sets him apart from most other artists of
the age, who sought ideal beauty in their subjects and
high finish in their technique.

FRANCISCO JOSÉ DE
GOYA Y LUCIENTES

Spanish, 1746–1828
Bullfight, Suerte de Varas,
1824
Oil on canvas
52 × 62 cm (19¼ × 23⅞ in.)
93.PA.1

This work is Goya's final painted essay on the theme of the bullfight, a subject that he popularized and that recurs throughout his career. His passion for the sport is here overlaid with horror at the abusive tactics that emerged late in his life, when bullfighting was considered to be in decline.

A horde of men and horses stands in opposition to a lone bull, their battle plan in disarray as the bull has reduced their grim determination and their numbers. Wounded and weakened, the bull is presented not as a fierce, unbridled force of nature, but as a noble beast before the rabble. His very presence in the ring assures his death, but he has nonetheless won.

An inscription on the back of the canvas identifies this work as a gift, painted in Paris during the summer of 1824, for Goya's friend and compatriot in exile Joaquín María Ferrer. Goya had only recently left his native land, at age seventy-eight, worried over possible censorship and oppression following Ferdinand VII's return to the Spanish throne in 1823.

EDVARD MUNCH

Norwegian, 1863–1944
Starry Night, 1893
Oil on canvas
135 × 140 cm (53½ × 55⅛ in.)
84.PA.681

The coastline of Åsgårdstrand has changed little since Munch painted this view looking toward the Oslo fjord. The white rail fence still encloses an orchard of fruit trees, and the massed foliage of three tightly clustered lindens still looms above them. The summer night sky filled with stars and reflections—and with the reddish planet Venus hovering on the horizon—held a special symbolism for Munch, who associated it with memories of an unhappy love affair from his youth. Thus, despite its surprising accuracy as a landscape, this painting actually portrays a mood: romantic melancholy tinged with mysticism. Munch used the composition to introduce a series of images called the Frieze of Life, which treats the subjects of love and death in mythic, auto-biographical terms.

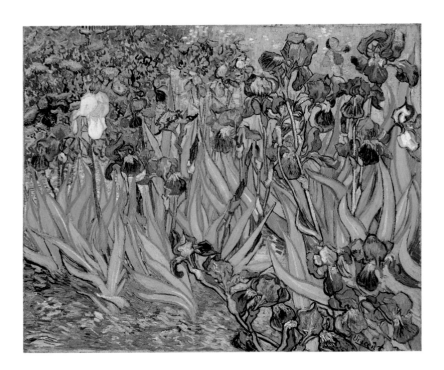

VINCENT
VAN GOGH

Dutch, 1853–1890
Irises, 1889
Oil on canvas
71 × 93 cm (28 × 36⅛ in.)
90.PA.20

Van Gogh painted *Irises* in the garden of the asylum at Saint-Rémy, where he was recuperating from a severe attack of mental illness. Although he considered the work more a study than a finished picture, it was exhibited at the Salon des Indépendants in September 1889. Its energy and theme—the regenerative powers of the earth—express the artist's deeply held belief in the divinity of art and nature. However, the painting's vivid color contrasts, powerful brushwork, and frieze-like composition reflect van Gogh's study of other artists, notably Paul Gauguin (French, 1848–1903) and the Japanese master Hokusai (1760–1849).

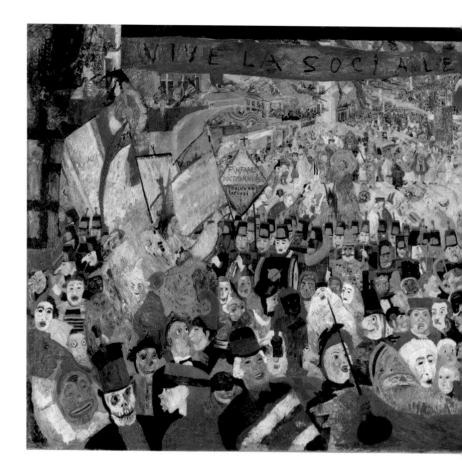

JAMES ENSOR

Belgian, 1860–1949
*Christ's Entry into Brussels
in 1889*, 1888
Oil on canvas
252.5 × 430.5 cm
(99½ × 169½ in.)
87.PA.96

James Ensor's enormous canvas detailing Christ's
entry into the capital city of the artist's native Belgium
presents us with a complex and terrifying vision of the
society of the future. Christ, whose face appears to be
the artist's self-portrait, rides a small donkey in the midst
of a teeming procession of Mardi Gras revelers. Many
in the crowd wear masks, Ensor's device for suggesting
the deceptiveness and artificiality of modern life.

The canvas's bold color contrasts and thick crusts
of paint give the impression of spontaneity, yet Ensor
planned every figure in advance. In both subject and
technique this masterpiece shocked nineteenth-century
viewers, and it could not be publicly exhibited until
1929. Yet its reputation brought many visitors to the
artist's studio, and its visual and emotional impact
contributed to the development of Expressionism early
in the twentieth century.

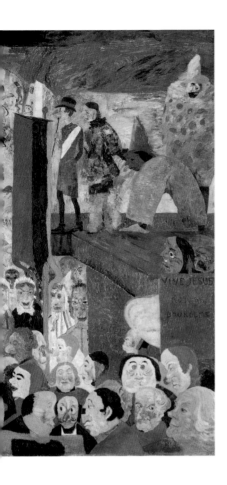

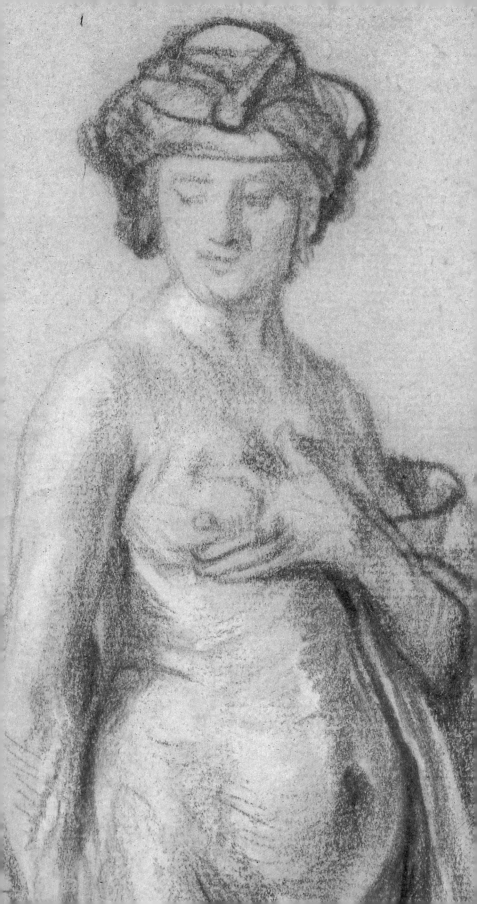

Drawings

Drawing is perhaps the most universal, spontaneous, and direct of all art forms. It embraces a wide variety of techniques, including metalpoint, graphite, pen and ink (often used in conjunction with wash), colored chalk, and watercolor. It is, moreover, the only art form practiced by most people, albeit often at a rudimentary level. The Museum's collection of drawings was begun in July 1981, five years after the death of J. Paul Getty, when Rembrandt's red chalk study *Nude Woman with a Snake* was purchased (see detail, left, and p. 167). A year later the Department of Drawings was formed. As of June 1995, the collection numbers some 450 sheets and includes two sketchbooks, one by Gericault and the other by Degas. The purpose is to create as representative a collection as possible of the different schools of Western European drawing from the second half of the fifteenth century to the end of the nineteenth, with emphasis on the work of the most important and accomplished draftsmen.

With only a few exceptions, the great artists of the past—painters, sculptors, printmakers, and architects alike—employed drawing as an integral part of the creative process. It was used to study nature as well as the human figure, to explore rough ideas prior to their realization in the more durable media of paint or stone, and as an end in itself, as in the magnificent watercolor *Still Life* by Paul Cézanne (see p. 176). Two drawings by the German Renaissance painter Albrecht Dürer demonstrate contrasting usages by one artist. His highly finished bodycolor study of a stag beetle (see p. 162) was drawn directly from nature and was made as a record in its own right. The more loosely drawn preparatory *Study of the Good Thief* (see p. 163) was evidently done for a painting or print representing the Crucifixion, although no such work has so far been identified. Many of the drawings are compositional studies for pictures. These include the *Sheet of Studies for "The Martyrdom of Saint George"* by the Venetian Renaissance painter Paolo Veronese (see p. 156) and *The Lictors Returning to Brutus the Bodies of His Sons* by the great French Neoclassical painter Jacques-Louis David (see p. 175). An even larger number of drawings are studies for individual figures or groups of figures within such compositions.

Drawings are sensitive to light and can only be exhibited for short periods. Those on show at any given time have been brought together to illustrate some common theme or a particular period in the history of art.

LEONARDO DA VINCI

Italian, 1452–1519
Studies for the Christ Child with a Lamb, circa 1503–6
Pen and brown ink and black chalk
21 × 14.2 cm (8¼ × 5⁵⁄₁₆ in.)
86.GG.725

Three of the studies in this drawing are in ink, while another three are faintly drawn in black chalk. The child wrestling with the lamb is either the infant Saint John the Baptist or the Christ Child. The number of different sketches for the same figural group indicates Leonardo's painstaking approach to the planning of his compositions. He probably made this drawing in preparation for a painting of the Virgin and Child with Saint John, now lost but known through copies. Leonardo inscribed the drawing at the top of the sheet and on the verso in his characteristic mirror script.

MICHELANGELO
BUONARROTI

Italian, 1475–1564
*The Holy Family with the
Infant Saint John the Baptist
(The Rest on the Flight into
Egypt)*, circa 1530
Black and red chalk with pen
and brown ink over stylus
underdrawing
28 × 39.4 cm (11 × 15½ in.)
93.GB.51

Michelangelo treated the subject of the Madonna and
Child many times during his long career—in painting
and sculpture, as well as in drawing. Here he chose
to represent an unusual variant of the theme, not specifi-
cally related in the Bible, in which the infant Baptist and
two angels join the Holy Family on an interlude in their
flight into Egypt to escape Herod's persecution; on the
right, the ass grazes contentedly, the packsaddle still on
its back.

The drawing's purpose is unknown, although it
may have been made for a low relief. From its style it
may be dated around 1530, during the artist's third
Florentine period (1516–34). Michelangelo studied the
same composition in a number of other sketches, while
a sculpture of the seated Virgin suckling the Christ
Child, in the Medici Chapel, Florence, shares a number
of analogies with the two figures in this drawing.

RAPHAEL

(Raffaello Sanzio)
Italian, 1483–1520
*Saint Paul Rending His
Garments*, circa 1515–16
Metalpoint heightened with
white bodycolor on pale
violet-gray prepared paper
23 × 10.3 cm (9¹/₁₆ × 4¹/₁₆ in.)
84.GG.919

Raphael was one of the
greatest draftsmen in
the history of Western
art. This study was made
in preparation for the
figure of Saint Paul in
The Sacrifice of Lystra,
one of a series of tapes-
tries commissioned
to decorate the walls of
the Sistine Chapel in
the Vatican. The violent
twisting of the saint's
body is convincingly
rendered by the high-
lighted drapery folds
that accentuate his
movement. Here Raphael
not only elucidates the
pose but gives an insight
into the saint's emotional
state.

LORENZO LOTTO

Italian, circa 1480 – after 1556
*Saint Martin Dividing
His Cloak with a Beggar,*
circa 1530
Brush and gray-brown wash,
white and cream bodycolor
heightening, and black chalk
on brown paper
31.4 × 21.7 cm (12⅜ × 8⁹/₁₆ in.)
83.GG.262

The steep perspective suggests that the composition
was intended either for a painted organ shutter or
a fresco to be seen above eye level. The lively move-
ment of the figures and the rich architectural back-
drop anticipate the compositions of the later Baroque
period, although the combination of media is typical
of sixteenth-century Venetian drawing.

PAOLO VERONESE

Italian, 1528–1588
*Sheet of Studies for "The Mar-
tyrdom of Saint George,"* 1566
Pen and brown ink and brown
wash
28.9 × 21.7 cm (11⅜ × 8⁷⁄₁₆ in.)
83.GA.258

These freely drawn studies are for various sections of
Veronese's altarpiece of *The Martyrdom of Saint George*
in the church of San Giorgio, Verona. The rapid pen
strokes of the sketches reflect the artist's creative
energy as he explored varying solutions to the different
figural problems posed by the composition. With great
sensitivity he subtly altered the media of the studies;
some are done in pen and wash, others in pen alone.
Although the individual sketches are distinct in charac-
ter, they are unified by the overall rhythmic flow
of the artist's hand as it moved quickly across the page.

ANNIBALE CARRACCI

Italian, 1560–1609
Four Studies of Heads Drawn over a Copy of a "Saint John the Evangelist" by Correggio, circa 1585
Black chalk
27.7 × 20.7 cm (10⅞ × 8⅛ in.)
85.GB.218

Annibale Carracci's style of drawing is admired for its forcefulness. A certain informality in his character made him fond of representing subjects from everyday life. In this sheet he has drawn a bearded man wearing a hat seen in right profile (the two studies top left), a youth with his head cupped in his hands, seen full face (top right), and a youth wearing a hat and gazing downward (bottom of the sheet, with it turned clockwise ninety degrees). This is the sort of drawing that Carracci would have made in his leisure, perhaps while observing his friends or family during a period of relaxation. The sketches are done over a weak tracing after a figure group by Correggio.

GIANLORENZO
BERNINI

Italian, 1598–1680
*Design for a Fountain, with
a Marine God Clutching a
Dolphin*, circa 1651–52
Black chalk
34.9 × 23.8 cm (13 ¹¹/₁₆ × 9⅜ in.)
87.GB.142

Bernini was an architect and a painter as well as the
most successful Italian sculptor of his day. The subject
of this drawing corresponds with a fountain that he
designed for the central niche of the palace of Duke
Francesco I d'Este at Sassuolo. The liveliness of
the figure as it struggles with the dolphin is typical of
Bernini's vigorous High Baroque style.

**GIOVANNI
BATTISTA
PIAZZETTA**

Italian, 1683–1754
*A Boy Holding a Pear
(Giacomo Piazzetta?),*
circa 1737
Black and white chalk on
blue-gray paper (two
joined sheets)
39.2 × 30.9 cm
(15⅜ × 12⅛ in.)
86.GB.677

Here Piazzetta has drawn a youngster, beautifully dressed in a brocade vest, full-sleeved shirt, and feathered cap. The lad holds up a pear as he gazes meaningfully at the viewer. This same boy, recognizable from his good-natured demeanor, appears in a number of Piazzetta's other works and has been tentatively identified as the artist's son, Giacomo. The drawing seems to have been made to be enjoyed in its own right, without any ulterior purpose. Piazzetta applied the chalk with varying degrees of pressure. In some areas it is lightly shaded and as a result seems soft and diffused. Elsewhere it is applied more heavily in rich, velvety patches. Piazzetta further enlivened the sheet with white chalk highlights—in the lace collar and linen sleeves, in the pear, and on the tip of the boy's nose.

GIOVANNI
BATTISTA
PIRANESI

Italian, 1720–1778
An Ancient Port,
circa 1749–50
Red and black chalk and
brown and reddish wash;
squared
38.5 × 52.8 cm
(15⅛ × 20¹³⁄₁₆ in.)
88.GB.18

Piranesi was one of the greatest etchers in Europe
during the eighteenth century. His best-known prints
are his views of Rome and his architectural fantasies.
This drawing of an ancient port served as a preparatory
study for an etching entitled *Part of a Large Magnificent
Port* that was first published in 1750 as part of a series
entitled *Opere varie.* The composition is made up of
huge interlocking architectural forms, including a
portal and bridge in the foreground, a triumphal arch
in the center, and a Coliseum-like structure, truncated
pyramid, and obelisk in the distance. Each section
of this building complex is decorated with an elaborate
sculptural program, and the whole is further drama-
tized by clouds of smoke. In the foreground are boats
reminiscent of those found in Piranesi's native Venice.

Piranesi first drew the main outlines in chalk,
then liberally added brown and red wash for shading
and some of the details. The black chalk grid lines
throughout were made to assist the process of transfer-
ring the design to the copperplate. The wash gives
a vibrancy to the whole that was not transmitted to the
etching. Piranesi made at least two drawings before
this finished sketch.

MARTIN
SCHONGAUER

German, 1450/53–1491
Studies of Peonies,
circa 1472/73
Bodycolor and watercolor
25.7 × 33 cm (10⅛ × 13 in.)
92.GC.80

The flowers (*paeonia officinalis L*) were evidently drawn from life. On the left is a stem with one blossom fully open, the head turned away, and one bud; on the right, a separate study of an open blossom, seen from the front. The blossoms and foliage are delicately modeled and colored. This large sheet, the only surviving nature study by Schongauer, is a singularly important drawing in the German Renaissance period. It was used as the model for some of the flowers in the background of his great altarpiece, *The Madonna of the Rose Garden,* painted in 1473 for the Dominican church at Colmar. The drawing is among the earliest manifestations of the urge toward the realistic depiction of nature in Northern Renaissance art and, as such, constitutes a vital precedent for Albrecht Dürer's nature studies of the early sixteenth century, for example the *Stag Beetle* (see p. 162).

ALBRECHT DÜRER

German, 1471–1528
Stag Beetle, 1505
Watercolor and bodycolor;
top left corner added; tip of
left antenna painted in by a
later hand
14.2 × 11.4 cm (5⁹⁄₁₆ × 4½ in.)
83.GC.214

This startling image is typical of Dürer's many studies
drawn directly from nature. His drawings of this type
form an illuminating counterpart to the more obviously
scientific renderings of plant and animal life by his
Italian near-contemporary Leonardo da Vinci. In this
drawing Dürer presents a living creature illusionis-
tically; the beetle casts its own shadow on the plain
ground of the paper as if it were actually crawling
across it. The modulations of tone along the creature's
ridged wing cases are also faithfully rendered.

ALBRECHT DÜRER

German, 1471–1528
Study of the Good Thief,
circa 1505
Pen and brown ink
26.8 × 12.6 cm (10%₁₆ × 5 in.)
83.GA.360

In this drawing the figure of the Good
Thief is sharply foreshortened, height-
ening its dramatic impact. The fingers
on his right hand are curled in agony,
underscoring the emotive force of the
whole. In addition, Dürer drew the cross
appearing to bend under the man's
weight. The use of the pen is completely
assured, from the confident handling
of the contours of the body to the clear
definition and modeling of its forms.

ALBRECHT ALTDORFER

German, circa 1482/85–1538
Christ Carrying the Cross,
circa 1510–15
Pen and black ink, gray
wash, and black chalk
DIAM: 30.4 cm (11¹⁵/₁₆ in.)
86.GG.465

Albrecht Altdorfer was the leading painter
of the Danube school. This drawing
shows Christ fallen under the weight of
the cross, submitting to the blows of his
tormentors. Bravura pen work heightens
the emotional resonance of the scene.
Altdorfer drew the figure of Christ
slightly from behind, a viewpoint that
has the effect of creating greater space
within the composition than a simple
profile view. The monumentality of the
conception is more consistent with a
large-scale painting, although Altdorfer
made this drawing as a design for a
stained glass window. It is the only such
drawing by him known to have survived.

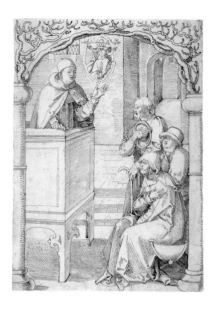

HANS BALDUNG GRIEN

German, circa 1484/85–1545
A Monk Preaching, circa 1505
Pen and brown ink over slight
black chalk underdrawing
30.8 × 22.3 cm (12⅛ × 8¹³/₁₆ in.)
83.GA.194

This drawing seems to have been made
as a preparatory study for a stained glass
window, a type of commission Baldung
is known to have undertaken. The pres-
ence of Christ, who is shown in a minia-
ture apparition above the preacher's left
hand, may indicate that the preacher's
subject is either the Salvation or the Last
Judgment. Baldung was one of the most
distinguished of Dürer's followers,
and his characteristically rhythmic and
sharply accented pen strokes owe much
to his master's style.

URS GRAF

Swiss, circa 1485–1527/29
Dancing Peasant Couple, 1525
Pen and black ink
20.6 × 14.7 cm (8⅛ × 5¹³/₁₆ in.)
92.GA.72

The graphic work of Urs Graf, who was
a mercenary soldier as well as an artist,
provides a glimpse of the violent and
bawdy aspects of life in early sixteenth-
century Switzerland. This is one of a
series of drawings of peasant dancers
that Graf made either as models for
prints or as independent works of art. In
this drawing a tattered peasant couple
dance with abandon. The man lewdly
grasps his partner's buttock, the meaning
of his gesture reinforced by the phallic
symbolism of the ax and dagger at his
waist. Graf's forceful line work comple-
ments the rawness of his subject matter.

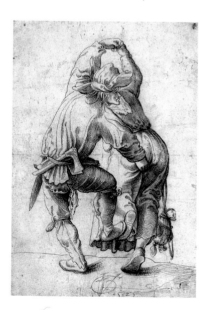

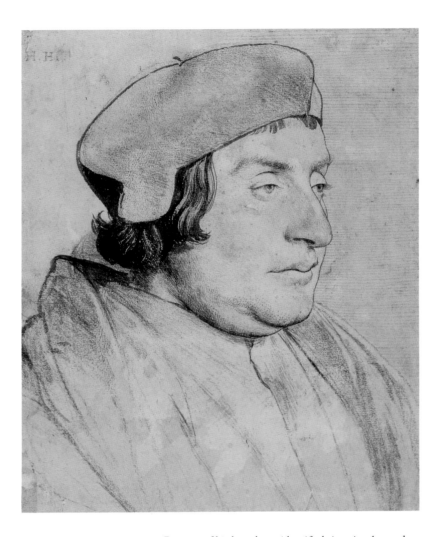

HANS HOLBEIN
THE YOUNGER

Swiss, 1497–1543
Portrait of a Scholar or Cleric,
circa 1532–43
Black and red chalk, pen and
brush and black ink, on pink
prepared paper
21.9 × 18.5 cm (8⅝ × 7¼ in.)
84.GG.93

Because of his hat, the unidentified sitter is taken to be
either a cleric or a scholar. Holbein probably made the
portrait during his second English period (1532–43),
when he served as painter to King Henry VIII, and the
sitter may well have been connected with the Tudor
court. Holbein sketched the contours of the man's face
in black chalk and then deftly went over it in black
ink. The face was softly modeled in red chalk, using the
pink of the paper as a middle tone. Outside the face,
the handling is broad and painterly, as in the hair and
robe. Holbein was attuned to the uniqueness of the
features of each of his sitters, which he rendered with
unparalleled precision and objectivity. For this reason
his portrait drawings present sixteenth-century person-
alities with greater freshness and fullness than almost
any other artist of his time.

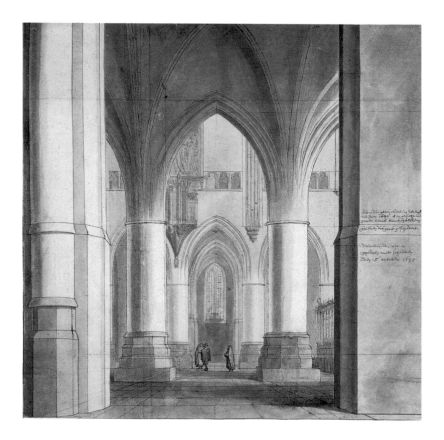

PIETER JANSZ. SAENREDAM

Dutch, 1597 – 1665
The Choir and North Ambulatory of the Church of Saint Bavo, Haarlem, 1634
Red chalk, graphite, pen and brown ink, and watercolor, the outlines indented for transfer (recto); rubbed with black chalk for transfer (verso)
37.7 × 39.3 cm
(14¹¹⁄₁₆ × 15⁷⁄₁₆ in.)
88.GC.131

Saenredam specialized in painting architectural subjects. Between 1634 and 1636 he made a number of drawings and paintings of the church of Saint Bavo in Haarlem, one of Holland's largest and most venerated Gothic buildings. This elaborate watercolor drawing, which is dated November 1634, is based on a sketch the artist drew on the spot in October 1634, now in the Gemeentearchief, Haarlem. The Museum's drawing is a finished preparatory study, with some differences in the proportions of the design, for the painting on panel now in the Muzeum Naradowe, Warsaw. The outlines of the drawing were traced directly onto the panel. An inscription on the Museum's drawing states that the painting was completed on October 15, 1635.

REMBRANDT
HARMENSZ.
VAN RIJN

Dutch, 1606–1669
Nude Woman with a Snake,
circa 1637
Red chalk with white
bodycolor heightening
24.7 × 13.7 cm (9¹¹⁄₁₆ × 5⁷⁄₁₆ in.)
81.GB.27

This is one of the best preserved and most fluent of all
of Rembrandt's red chalk drawings. The figure, which
is probably intended to represent Eve, is here shown
as an ordinary woman and not as an idealized type.
She presents her bare white breast to the spectator as
the snake, coiled around her legs, moves its head away
from her body. It was previously thought that the fig-
ure might be Cleopatra. The range of draftsmanship is
noteworthy, from the fine modeling of the right side
of the figure to the virtuoso passages of freely sketched
drapery at the right.

REMBRANDT HARMENSZ. VAN RIJN

Dutch, 1606 – 1669
Landscape with the House with the Little Tower,
circa 1651 – 52
Pen and brown ink and brown wash
9.7 × 21.5 cm (3¹¹⁄₁₆ × 8⁷⁄₁₆ in.)
83.GA.363

This is among the most sensitive and abstract of Rembrandt's landscape drawings. Space and atmosphere in the foreground are suggested by only a few lines, while a complex mixture of thinner lines, dots, and touches of wash creates a richer and more varied background. The drawing illustrates how a great artist can evoke vast space with the greatest economy of means.

PETER PAUL RUBENS

Flemish, 1577 – 1640
Korean Man, circa 1617 – 18
Black and red chalk
38.4 × 23.5 cm (15⅛ × 9¼ in.)
83.GB.384

This imposing portrait of a man in formal costume, which Rubens used as the basis for one of the background figures in his painting *The Miracles of Saint Francis Xavier,* is among the earliest representations of a Korean visitor to Europe. It is one of his most finely executed drawn portraits, and the likeness is enlivened by the touches of red in the face. The meticulous detailing of the flesh contrasts with the much broader rendering of the voluminous robe.

NICOLAS POUSSIN

French, 1594–1665
*Apollo and the Muses
on Mount Parnassus,*
circa 1626/27 or 1631/32
Pen and brown ink and
brown wash
17.6 × 24.5 cm (6¹⁵⁄₁₆ × 9¹¹⁄₁₆ in.)
83.GG.345

Poussin was an admirer of Raphael as well as of the
ancient classical tradition. The composition of this
drawing was inspired by Raphael's famous fresco in the
Stanza della Segnatura in the Vatican. The handling,
with broad washes, is unusually animated for Poussin.
Nevertheless, the artist shows his characteristic ten-
dency toward abstraction of form. The drawing
is a first idea for a painting now in the Prado, Madrid.

JEAN-ANTOINE
WATTEAU

French, 1684–1721
*Two Studies of a Flutist and
One of the Head of a Boy,*
circa 1716–17
Red, black, and white chalk
21.4 × 33.6 cm (8⁷⁄₁₆ × 13³⁄₁₆ in.)
88.GB.3

Watteau was one of the most influential artists of the
French Rococo period. A master of lyrical themes, he
invented the subject known as the *fête galante*, in which
elegant young men and women in an open landscape
dally to the sound of music, captivated by feelings of
love. Watteau, one of the most gifted draftsmen of all
time, probably made this drawing while attending a
concert. He studied the flute player from two different
angles, recording two distinct expressions on the musi-
cian's face. The boy at the left appears to be listening.
Watteau was a master of the technique known in France
as *trois crayons*, a combination of red, black, and white
chalk, almost invariably drawn on tinted paper.

JACQUES-LOUIS
DAVID

French, 1748–1825
*The Lictors Returning to
Brutus the Bodies of His
Sons,* 1787
Pen and black ink and
gray wash
32.7 × 42.1 cm (12⅞ × 16⁹⁄₁₆ in.)
84.GA.8

In this drawing, which is signed and dated 1787, David
represents a scene from ancient Roman history emblem-
atic of great moral and patriotic virtue. Brutus, who
had condemned his two sons to death for treason, sits
stoically in the foreground contemplating the conse-
quences of his decision while their bodies are carried
away to the left, in view of his mourning wife and
daughters. The drawing is a finished compositional
study, with changes, for David's famous painting of 1789
in the Musée du Louvre, Paris. It is among the most
monumental of his surviving drawings.

JEAN-AUGUSTE-
DOMINIQUE INGRES

French, 1780–1867
*Portrait of Lord
Grantham*, 1816
Graphite
40.5 × 28.2 cm
(15 15/16 × 11 1/8 in.)
82.GD.106

The drawing is signed and dated 1816. The sitter is
Thomas Philip Robinson, third Baron Grantham and
later Earl de Grey. Born in 1781, the sitter would have
been thirty-five at the time of this portrait. Ingres
had a lucrative practice as a portrait draftsman while he
lived in Italy, from 1806 to 1824. Many of his patrons
were wealthy visitors such as Lord Grantham. The
drawn portraits of Ingres are renowned for their sever-
ity of line, which exemplifies his strongly classical style.

EUGÈNE
DELACROIX

French, 1798–1863
The Education of Achilles,
circa 1860–62
Pastel
30.6 × 41.9 cm (12‍⅟₁₆ × 16½ in.)
86.GG.728

Delacroix was a leading painter of the Romantic movement in France. He greatly admired the work of Peter Paul Rubens, and his own paintings reflect this influence in their free handling and bright colors. Delacroix often represented exotic themes, especially those of the Orient.

The subject of this pastel, taken from Greek mythology, is Achilles learning the art of hunting from the centaur Chiron. The energy of the figures as they gallop through the landscape is matched by Delacroix's own vigorous touch. The palette is characteristically rich, consisting of dark greens, blues, and browns, which are varied by light flesh tones and reds. Delacroix completed two paintings of the same composition. He made this pastel as a gift for his friend the writer George Sand, who had expressed her admiration for those paintings.

HONORÉ DAUMIER

French, 1808–1879
A Criminal Case, circa 1860
Watercolor and bodycolor
with pen and brown ink and
black chalk
38.5 × 32.8 cm
(15⅛ × 12¹³⁄₁₆ in.)
89.GA.33

Best known for his satirical lithographs, Daumier also
made drawings, watercolors, paintings, and sculptures.
This watercolor is datable to the later part of his career,
when his style had become broader and his paintings
more monumental in effect, in spite of their small scale.

ÉDOUARD MANET

French, 1832–1883
Bullfight, 1865
Watercolor and bodycolor
over graphite
19.3 × 21.4 cm (7⁹⁄₁₆ × 8⁷⁄₁₆ in.)
94.GC.100

Manet traveled to Spain in August 1865, a visit that would influence the rest of his career. While there he visited a bullfight and made this sketch of it. The bull gores the picador's horse in the belly, pinning the beast against the side of the arena; the torero, dressed in red and still holding onto his cape, escapes by jumping over the barrier. The picador, caught helplessly between his mount and the barrier, is lifted away from danger by two spectators. The bright colors of the sketch and the bravura of the handling evoke the excitement and splendor of the spectacle. The beauty of the image makes the violence at its center all the more disturbing. Manet explored the theme of a bull goring a horse in two subsequent oil paintings, one at the Musée d'Orsay, Paris; the other at the Art Institute of Chicago.

PAUL CÉZANNE

French, 1839–1906
Still Life, circa 1900
Watercolor over graphite
48 × 63.1 cm (18¹⁵⁄₁₆ × 24⅞ in.)
83.GC.221

This is one of the largest and most finished of Cézanne's
watercolors. In its complexity it shares many of the
qualities of his paintings. The technique of superim-
posed layers of translucent watercolor suggests the plas-
ticity of forms with extraordinary resonance, in spite
of the frailty of the medium. The contrast between
the colored washes and the untouched passages of white
paper enhances the monumental effect.

VINCENT
VAN GOGH

Dutch, 1853–1890
Portrait of Joseph Roulin, 1888
Reed and quill pens and
brown ink and black chalk
32 × 24.4 cm (12⅝ × 9⅝ in.)
85.GA.299

Joseph Roulin was a postal worker with whom van
Gogh became friends during his stay in Arles from 1888
to 1889. Roulin and his wife and children sat for van
Gogh many times. The artist wrote that the postman's
physical appearance and philosophy reminded him of
Socrates; he was "neither embittered, nor happy, nor
always irreproachably just." Van Gogh's strong impres-
sion of Roulin is evident in the sitter's close-up, frontal
pose and intense gaze. The drawing is animated by the
patterns of his clothing and beard, drawn with two dif-
ferent pens and various techniques of hatching, shading,
and stippling to achieve the remarkably varied textures.

FRANCISCO JOSÉ DE
GOYA Y LUCIENTES

Spanish, 1746–1828
Contemptuous of the Insults,
circa 1808–12
Brush and india ink
29.5 × 18.2 cm (11⅝ × 7⁷⁄₁₆ in.)
82.GG.96

This sheet was once part of an album of drawings that Goya seems to have made for his private use. Drawn with great tonal subtlety and fluidity, it shows a gentleman expressing disdain for the insults of gnomes, possibly a symbol of Goya's contempt for the soldiers who caused great devastation in Spain during the Napoleonic Wars (1803–15).

WILLIAM BLAKE

British, 1757–1827
Satan Exulting over Eve, 1795
Watercolor, pen and black
ink, and graphite over
color print
42.6 × 53.5 cm (16¾ × 21⅙ in.)
84.GC.49

Although Blake was one of the greatest British artists
of the Romantic period, he is less well known than
some of his contemporaries. One reason for this is the
poetic and visionary basis of his art, which embodies
his own personal philosophy and mythology. His pow-
erful images reflect his visions, which he insists were
not "a cloudy vapour or a nothing; they are organized
and minutely articulated beyond all that the mortal
and perishing nature can produce." Yet, in spite of this
subjective inspiration, the compositional formulae
and figure types in his work depend on those of the great
old master tradition of painting and drawing, works
with which he was familiar from engravings.

Satan Exulting over Eve belongs to the gray area
between drawing and printmaking. It is one of twelve
color prints Blake created in 1795 by drawing and
brushing a design in broad color areas on a piece of
millboard, printing them on a piece of paper, and work-
ing them over considerably in watercolor and pen and
ink. Each version of the various designs is therefore
unique. Satan flies in malevolent glory over the beauti-
ful nude figure of Eve, who is entwined by his alter
ego, the serpent of the Garden of Eden.

Blake was trained as an engraver. Most of his career
was spent publishing his own uniquely illustrated poetry
and prose.

JOSEPH MALLORD
WILLIAM TURNER

British, 1775 – 1851
Conway Castle, North Wales,
circa 1800
Watercolor and gum arabic
with graphite underdrawing
53.6 × 76.7 cm (21⅛ × 30⅛ in.)
95.GC.10

The Welsh landscape exerted a strong hold on the young
Turner during the 1790s, when he made five sketching
trips there. He probably made this monumental
watercolor on commission, following his 1798 Welsh
tour. It shows Conway Castle, on the northern coast of
Wales, towering over a stormy bay as fishermen
struggle to pull their boats ashore. Turner's unique gift
in representing dramatic effects of natural light is
fully evident in this work. A break in the clouds allows
the sunshine to illuminate the castle and the coast
beyond. The tiny figures of the fishermen juxtaposed
against this vast expanse evoke a meditation on the
individual's natural place in a world governed by physi-
cal and temporal forces of unfathomable magnitude.

SAMUEL PALMER

British, 1805–1881
*Sir Guyon with the Palmer
Attending, Tempted by
Phaedria to Land upon the
Enchanted Islands —
"Faerie Queene,"* 1849
Watercolor and bodycolor,
with some gum arabic, over
black chalk underdrawing,
on "London board"
53.7 × 75.2 cm (21⅛ × 29⁹⁄₁₆ in.)
94.GC.50

Palmer has freely adapted a passage from Spenser's
Faerie Queene (Book 2, Canto 6) in which Phaedria fer-
ries Sir Guyon in her gondola across the Idle Lake to
the Enchanted Island. In the poem, however, Phaedria
refuses to take along the palmer (a pilgrim to the Holy
Land), while the drawing shows this figure in the boat.
Some autobiographical reference might have been
intended by this modification of Spenser's text. Palmer's
consummate skill as a watercolorist is shown in this
example. It exhibits a remarkable range of effects, from
the dappled clouds to the melting sunlight that modu-
lates all that it envelops. The liquid gold of the light,
the brilliance of the colors, and the delicacy of the
forms create a mood of enchantment that gives visual
expression to Spenser's poetry.

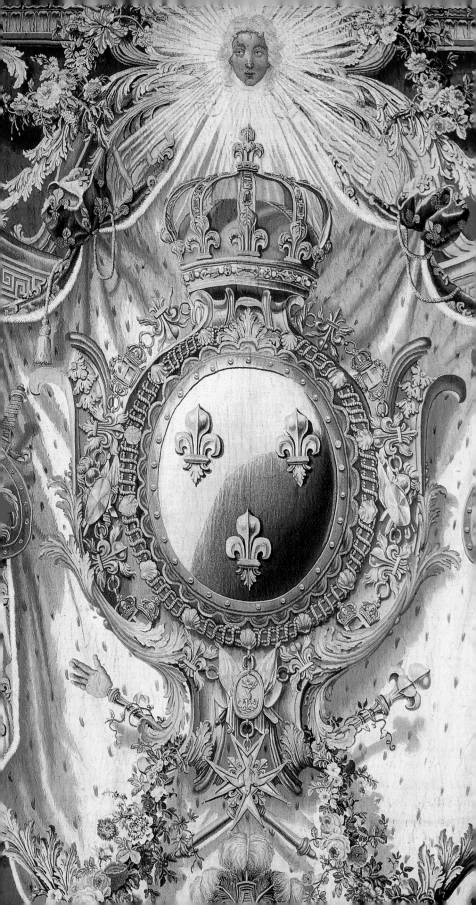

Decorative Arts

The Museum's collection of decorative arts—of which approximately twenty percent is illustrated here—consists mainly of objects made in Paris from the mid-seventeenth to the end of the eighteenth century. It contains furniture, silver, ceramics, tapestries, carpets, and objects made of gilt bronze. The latter include wall lights, chandeliers, firedogs, and clocks. All of these objects are displayed in chronological order in fifteen galleries, four of which are fitted with eighteenth-century paneling.

J. Paul Getty began to acquire European furniture in the late 1930s and continued to acquire slowly until the 1960s. Then, having opened his original small museum in Malibu, he stopped collecting for a time. At this point the entire collection of decorative arts, which consisted of about thirty objects, was housed in two galleries.

With the prospect of filling the much larger museum that was to open in 1974, Getty began to acquire again in the early 1970s and continued to do so until his death in 1976. In this period strong roots were put down, and some new curatorial policies were established. Gradually, a conception began to be realized, that of forming a representative collection of French decorative arts from the early years of the reign of Louis XIV (1643–1715) to the end of the reign of Louis XVI (1774–1792).

With the formation of the J. Paul Getty Trust, the confines of the collection were expanded to include objects made in other European countries, primarily Germany and Italy. It is to be expected that this expansion of the decorative arts collection will take place slowly. In keeping with the standards already set, only the finest pieces will be acquired, to be gleaned from an international market that is often restricted by laws pertaining to legal exportation. In this new Museum, set in the hills of the Santa Monica Mountains, the collection is now comfortably displayed, allowing a number of pieces formerly kept in storage to be viewed at last.

ONE OF A SET OF TEN PANELS

Design attributed to Charles
Le Brun (*premier peintre du
Roi* 1664; 1619–1690)
French (Paris), circa 1650–60
Painted and gilded oak
Two 213 × 88 cm
(6 ft. 11⅞ in. × 2 ft. 10⅝ in.);
two 213 × 79 cm
(6 ft. 11⅞ in. × 2 ft. 7⅛ in.);
two 120 × 80.4 cm
(3 ft. 11¼ in. × 2 ft. 9¼ in.);
two 118 × 80.4 cm
(3 ft. 10½ in. × 2 ft. 9¼ in.);
one 51 × 180.5 cm
(1 ft. 8⅛ in. × 5 ft. 11⅛ in.);
one 49.5 × 202.25 cm
(1 ft. 7½ in. × 6 ft. 8¼ in.)
91.DH.18.1–.10

These panels form part
of an ensemble that
would have been used to
line a room in a château
or a grand hôtel in Paris.
Two are painted with
an as-yet unidentified
monogram, and traces of
a Maltese cross can be
seen on some of them.
One of the smaller panels
exactly resembles in
its design a painted panel
still in situ in the *biblio-
thèque* (library) of the
Château de Vaux-le-
Vicomte. That painted
room was made for the
finance minister Nicolas
Fouquet by Charles
Le Brun in 1659. The
florid, highly colored
design is typical of
Le Brun's style. Many of
the elements of the
design reappear in his
later works made for
Louis XIV, especially
the series of large Savon-
nerie carpets.

READING AND WRITING TABLE

French (Paris), circa 1670–75
Walnut and oak veneered
with ivory, blue-painted horn,
and amaranth; gilt-bronze
moldings; steel; modern silk
velvet
63.5 × 48.5 × 35.5 cm
(2 ft. 1 in. × 1 ft. 7⅛ in.
× 1 ft. 2 in.)
83.DA.21

This small table, described in a posthumous inventory
of Louis XIV, is one of the few surviving pieces of fur-
niture to have belonged to that great monarch. Among
the rarest and earliest pieces in the collection, it is deco-
rated with ivory and horn that has been painted blue
underneath, perhaps to resemble lapis lazuli. The table
is fitted with an adjustable writing surface and a drawer
constructed to contain writing equipment.

TABLE

Attributed to Pierre
Golle (circa 1620 – 1684,
master before 1656)
French (Paris), circa 1680
Oak veneered with brass,
pewter, tortoiseshell, and
ebony, with ebony drawers;
gilded fruitwood and gilt-
bronze mounts
76.7 × 42 × 36.1 cm
(2 ft. 6½ in. × 1 ft. 4½ in.
× 1 ft. 2¼ in.)
82.DA.34

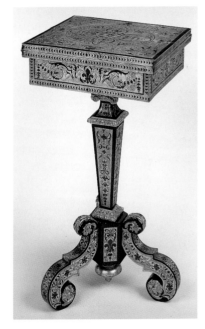

The top of this small table unfolds to
reveal a scene of three women taking tea
beneath a canopy. It is therefore likely
that the table was intended to support a
tea tray. The table is decorated with four
large dolphins and four fleurs-de-lis,
all in tortoiseshell. These emblems were
used by the Grand Dauphin, son of
Louis XIV, for whom this table and its
pair, now in the British Royal Collec-
tion, probably were made. The scene
on the top was copied after a drawing
by the Huguenot ornamentalist and
engraver Daniel Marot, which was later
engraved in the early eighteenth century.

CABINET ON STAND

Attributed to André-Charles
Boulle (1642 – 1732, master
before 1666)
French (Paris), circa 1675 – 80
Oak and snakewood veneered
with pewter, brass, tortoise-
shell, horn, ebony, ivory,
and wood marquetry; bronze
mounts; painted, gilded
figures; with drawers of
snakewood
229.9 × 151.2 × 66.7 cm
(7 ft. 6½ in. × 4 ft. 11½ in.
× 2 ft. 2¼ in.)
77.DA.1

This cabinet was probably made by André-Charles
Boulle for Louis XIV, whose likeness appears in a
bronze medallion above the central door, or as a royal
gift. The medallion is flanked by military trophies,
while the marquetry on the door below shows the
cockerel of France triumphant over the eagle of
the Holy Roman Empire and the lion of Spain and the
Spanish Netherlands. The cabinet is supported by two
large figures, the one on the right being Hercules.
Clearly made to glorify Louis XIV's victories, this piece
is one of a pair; the other is privately owned.

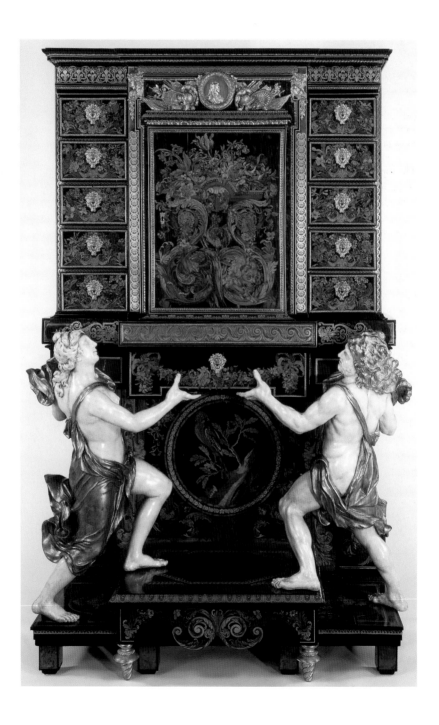

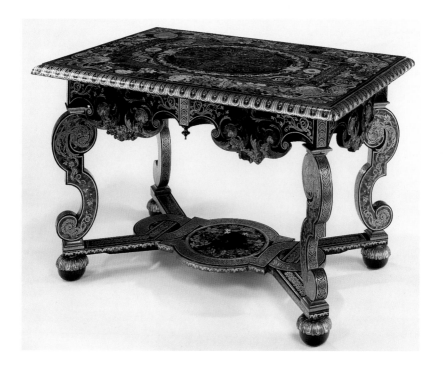

TABLE

Attributed to André-Charles
Boulle (1642 – 1732, master
before 1666)
French (Paris), circa 1680
Oak veneered with brass,
pewter, tortoiseshell, ebony,
horn, ivory, and marquetry
of stained and natural woods
72 × 110.5 × 73.6 cm
(2 ft. 4⅜ in. × 3 ft. 7½ in.
× 2 ft. 5 in.)
71.DA.100

This table is among the few pieces of furniture veneered
with both wood and tortoiseshell, and brass and pew-
ter that survive from the late seventeenth century.
Based upon the combination of these materials and the
fine craftsmanship, it is attributed to André-Charles
Boulle. The naturalistic marquetry flowers that enrich
its top, sides, and stretcher are recognizable: peonies,
hyacinths, daffodils, tulips, and ranunculus, among
others. Inventory documents record the presence of
similar tables in the residences of Louis XIV, although
this example cannot be precisely identified.

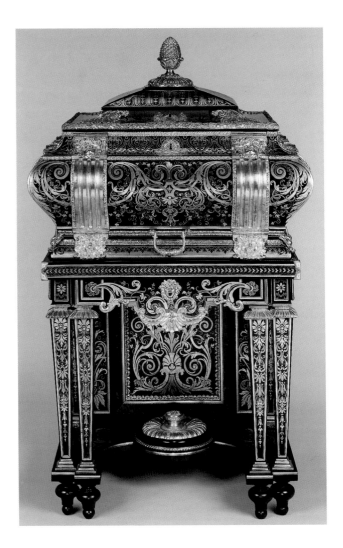

ONE OF TWO
COFFERS ON
STANDS

Attributed to André-Charles
Boulle (1642 – 1732, master
before 1666)
French (Paris), circa 1684 – 89
Oak and walnut veneered
with tortoiseshell, blue-
painted horn, ebony, rosewood,
cypress, pewter, and brass;
gilt-bronze mounts
156.6 × 89.9 × 55.8 cm
(5 ft. 1⅝ in. × 2 ft. 11⅛ in.
× 1 ft. 10 in.)
82.DA.109.1 –.2

This coffer and its pendant were almost certainly made
by André-Charles Boulle at a time when he was making
numerous pieces of furniture for the Grand Dauphin,
son of Louis XIV. A coffer of similar form delivered
by Boulle is listed in the Grand Dauphin's inventory of
1689. Such coffers were intended to hold jewelry and
other precious objects. The large gilt-bronze straps
at the front and sides can be let down to reveal small
drawers.

ONE OF A SET OF SIX TAPESTRIES

Woven under the direction
of Philippe Béhagle
(active 1684–1705)
French,
Beauvais manufactory,
circa 1697–1705
Wool and silk;
modern cotton lining
424 × 319 cm
(13 ft. 11 in. × 10 ft. 5½ in.)
83.DD.338

The Astronomers is one of a set of six tapestries from
the series entitled The Story of the Emperor of China.
It shows Emperor Shun Chih (1644–1661) in conver-
sation with members of his court and the European
Jesuit Father Adam Schall von Bell (1592–1666) around
a large globe. This was the first French tapestry series
to be created around a chinoiserie theme; it established
a long-lasting taste for the exotic and contributed to
the success of the Beauvais manufactory. The set was
woven for Louis-Alexandre, comte de Toulouse
(1678–1737), the second legitimized son of Louis XIV.
The border bears his coat of arms and monogram.

DESK

French (Paris), circa 1700
Oak and walnut; veneered
with brass, tortoiseshell,
mother-of-pearl, pewter,
copper, ebony, and painted
and unpainted horn;
with silvered and gilt-bronze
mounts
70.5 × 89 × 51 cm
(2 ft. 3¼ in. ×
2 ft. 11 in. × 1 ft. 8 in.)
87.DA.77

The top of this small desk bears an unidentified coat of
arms (a later replacement) beneath an electoral crown,
surrounded by the Collars and the Order of the Toison
d'Or and supported by standing, crowned lions. The
original pierced steel key for the desk drawers bears the
interlaced monogram *ME* beneath the electoral crown,
confirming that the desk was made for Maximilian II
Emanuel, Elector of Bavaria (1662–1726). In a partial
inventory of Maximilian's possessions taken in Munich
in 1704 a number of pieces of furniture are briefly
described as being veneered with brass, pewter, and
tortoiseshell. He obviously had a liking for highly
decorated furniture, such as this small desk, which was
made for him in Paris.

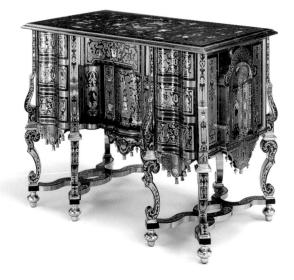

EWER

Ewer: Chinese, Kangxi
(1662 – 1722)
Mounts: French (Paris),
circa 1700 – 10
Porcelain, polychrome
enamel decoration; gilt-
bronze mounts
46.1 × 35.2 × 13.8 cm
(1 ft. 6⅛ in. × 1 ft. 1⅛ in.
× 5⅜ in.)
82.DI.3

This ewer is an early example of
the Parisian fashion for fitting Oriental
porcelain with gilt-bronze mounts.
Throughout the late seventeenth and
eighteenth centuries the French had
a passion for objects from the Far East
but were not content with the original
simple lines and elegant proportions.
They preferred to add gilt-bronze
or silver mounts, in keeping with the
luxurious tastes of the nobility.

MEDAL CABINET

Attributed to André-Charles
Boulle (1642–1732, master
before 1666)
French (Paris), circa 1710–20
Oak veneered with ebony,
brass, and tortoiseshell; gilt-
bronze mounts; *sarrancolin
des Pyrénées* marble top
82.5 × 140 × 72.5 cm
(2 ft. 8½ in. × 4 ft. 7¼ in.
× 2 ft. 4½ in.)
84.DA.58

The pair to this cabinet, in the State Hermitage, Saint
Petersburg, retains its twenty-four shallow drawers
for medals. These cabinets are of unique form and obvi-
ously were commissioned by a wealthy collector of
ancient coins or medals. A pair of cabinets of similar
form are listed in an inventory taken at the death of
Jules-Robert de Cotte in 1767. It is possible that he had
inherited the cabinets from his illustrious father, the
royal architect Robert de Cotte. The latter was closely
associated with André-Charles Boulle, whose style the
cabinets represent well.

MODEL FOR A
MANTEL CLOCK

French (Paris), circa 1700
Terracotta; enameled metal
plaques
78.7 × 52.1 × 24.2 cm
(2 ft. 7 in. × 1 ft. 8½ in.
× 9½ in.)
72.DB.52

It is remarkable that this full-size terracotta model for a
clock has survived in such a good state of preservation.
It was often the custom in the eighteenth century for a
model to be ordered from a cabinetmaker for approval
before the finished object was made. All of the very few
such models that survive today date from the late eigh-
teenth century. No clock of this model, which features
the rape of Persephone by Pluto below the dial, seems
to exist. It is possible that the model was made by one of
the royal craftsmen such as André-Charles Boulle for
the approval of Louis XIV.

TAPESTRY

Woven under the direction
of Jean de la Croix (active
1662 – 1712)
French, Gobelins manu-
factory, before 1712
Wool and silk; modern cotton
interface and linen lining
317.5 × 330.8 cm
(10 ft. 5 in. × 10 ft. 10¼ in.)
85.DD.309

This tapestry, representing the month of December and
the Château de Monceaux, is one of a series of twelve,
emblematic of the months of the year and of French
royal splendor. Each weaving portrays Louis XIV in a
daily activity, a royal residence, and a selection of the
monarch's riches and exotic animals. The series was
conceived by Charles Le Brun for production at the
royal workshop at Gobelins, and seven complete sets,
woven with gold thread, were made for the Crown
between 1668 and 1711. This example, however, is one
of a number made as private commissions and bears
the weaver's name.

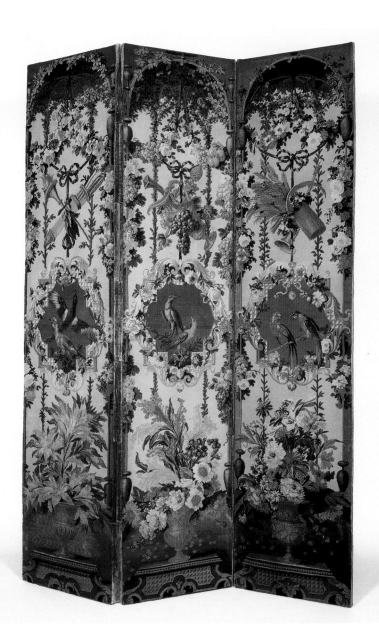

ONE OF A PAIR
OF SCREENS

French, Savonnerie
manufactory, 1714–40
Wool and linen; cotton twill
gimp; wooden interior frame
and modern velvet
273.6 × 193.2 cm
(8 ft. 11¾ in. × 6 ft. 4⅛ in.)
83.DD.260.1 –.2

This three-paneled screen of knotted wool pile was made
in the Savonnerie workshops, the royal manufactory
that produced carpets, screens, and upholstery covers
exclusively for the French Crown. Jean-Baptiste Belin
de Fontenay (1653 – 1715) and Alexandre-François
Desportes (1661 – 1743) provided the cartoons for this,
one of the two largest models. This example retains its
original brilliant coloring.

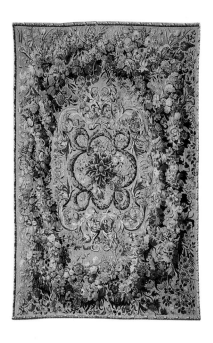

CARPET

French (Beauvais or Lille)
or Flemish (Brussels),
circa 1690 – 1720
Wool and silk
371.5 × 246.3 cm
(12 ft. 3 in. × 8 ft. 1 in.)
86.DC.633

The manufactory of this tapestry carpet has not been identified, but its style and color suggest an origin in northeastern France or in Flanders toward the end of the seventeenth century. The floral garlands are reminiscent of borders designed for tapestries produced in Brussels, while the mustard yellow ground color (now faded) is associated with a popular color known as *tabac d'Espagne* introduced at the Beauvais factory around 1685 – 90. Woven carpets of this date are extremely rare.

COMMODE

Made by Étienne Doirat
(circa 1675/80 – 1732)
French (Paris), circa 1725 – 30
Oak, pine, and walnut
veneered with kingwood
and amaranth; gilt-bronze
mounts; *brèche d'Alep* top
86.4 × 168.9 × 71.7 cm
(2 ft. 10 in. × 5 ft. 6½ in.
× 2 ft. 4¼ in.)
72.DA.66

Doirat, whose name is stamped on this commode, often worked for the German market. Since the rule requiring that all works be stamped with the maker's name was only instituted by the Parisian guild of *menuisiers-ébénistes* in 1751, it is unusual to find a piece of furniture stamped at this early date.

This commode may well have been intended for a German patron who would have liked its large scale, its exaggerated *bombé* shape, and the profusion of mounts. The lower drawer is provided with a small wheel, located at the front in the center, to support its weight and to facilitate its opening.

TERRESTRIAL GLOBE

Painted decoration attributed
to the Martin brothers
(active circa 1725–1780)
Terrestrial map engraved
by Louis Borde
(active 1730–1740s)
French (Paris), circa 1728–30
Printed paper; papier-mâché;
gilt bronze; alder painted with
vernis Martin; bronze; glass
H: 110 cm (3 ft. 7 in.);
W: 45 cm (1 ft. 5½ in.);
D: 32 cm (1 ft. ½ in.)
86.DH.705.1–.2

This globe and its accompanying celestial globe were designed and assembled by Abbé Jean-Antoine Nollet (1700–1770), a fashionable scientist who taught physics to the royal children. The terrestrial globe bears a dedication to the duchesse du Maine, the wife of Louis XIV's first illegitimate child, and is dated 1728. The celestial globe is dedicated to her nephew, Louis de Bourbon, comte de Clermont, and is dated 1730. The stands are painted with a yellow *vernis* ground, polychrome flowers, and red cartouches bearing chinoiserie scenes. This work probably was carried out by the Martin brothers, who obtained a monopoly for their varnish in the mideighteenth century.

Many contemporary portraits show the sitter with a globe close by, and such objects came to be considered essential adornments for the *bibliothèques* and *cabinets* of the aristocracy.

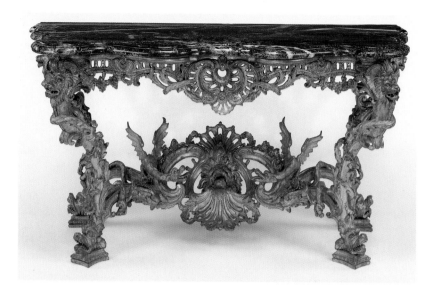

SIDE TABLE

French (Paris), circa 1730
Carved and gilded oak;
brèche violette top
89.3 × 170.2 × 81.3 cm
(2 ft. 11 in. × 5 ft. 7 in.
× 2 ft. 8 in.)
79.DA.68

This table is intricately carved with lions' heads, dragons, serpents, and chimerae, or composite mythological beasts. While the carving is deep and pierced in many areas, the table has remarkable strength and is well able to support its heavy marble top. It was originally part of a set including two smaller side tables; they would have stood in a large *salon* fitted with paneled walls carved with similar elements. It is possible that chairs, a settee, and a fire screen, all similarly carved, once completed the furnishings of the room.

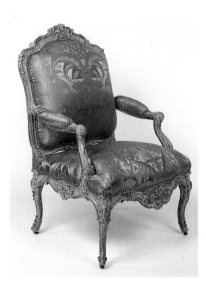

ONE OF A PAIR OF ARMCHAIRS

French (Paris), circa 1730–35
Carved and gilded beech;
brass casters; modern silk
upholstery
108.5 × 72.3 × 63.4 cm
(3 ft. 6¾ in. × 2 ft. 4½ in.
× 2 ft. 1 in.)
94.DA.10.1–.2

The design of this armchair dates from the early years of the Rococo style, which introduced characteristic elements such as the scrolling shape of the armrests where they join the seat rail, cabochons surrounded by auricular forms, and well-defined leaf and plant forms.

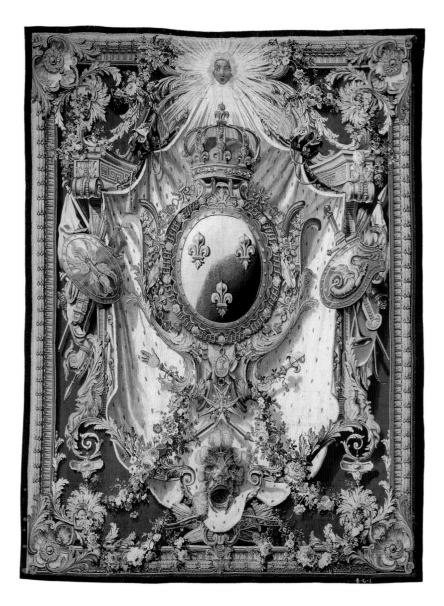

TAPESTRY

Woven under the direction
of Étienne-Claude Le Blond
(active 1727–1751)
French, Gobelins manu-
factory, circa 1730–43
Wool and silk
262.7 × 280.6 cm
(11 ft. 10⅞ in. × 9 ft. 2½ in.)
85.DD.100

Tapestries of this form, called *portières*, were used
extensively during the seventeenth and eighteenth cen-
turies in French royal residences, where they were
hung over nearly every door in the grand *appartements*.
They traditionally were decorated with symbols of
royal power. This example, though designed by Pierre-
Josse Perrot (active 1724–1750) for Louis XV (r. 1715–
1774), incorporates symbols—such as the head of
the god Apollo—that were associated with the king's
great-grandfather, Louis XIV, the Sun King. Twenty-
eight *portières* of this model were woven.

WALL CLOCK

Movement made by Charles
Voisin (1685 – 1761, master
1710)
French (Paris) and Chantilly
manufactory, circa 1740
Soft-paste porcelain, poly-
chrome enamel decoration;
gilt-bronze mounts;
enameled metal dial; glass
74.9 × 35.6 × 11.1 cm
(2 ft. 5½ in. × 1 ft. 2 in.
× 4⅜ in.)
81.DB.81

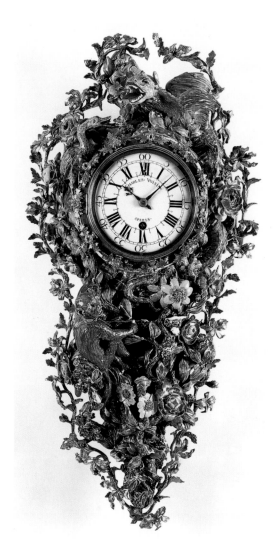

The case of this clock was made of soft-paste porcelain
at the Chantilly manufactory, which was established
in 1725 by the prince de Condé. The prince was a great
collector of Japanese porcelain, and initially the Chan-
tilly manufactory produced wares in the Japanese style.
This clock may have been intended to hang over a bed
and is fitted with a repeating mechanism; the pull of
a string makes it strike the time to the nearest hour and
a quarter, enabling the owner to learn the time at night
without having to light a candle.

CONSOLE TABLE

German (Northern?),
circa 1735–45
Gilded limewood;
brèche d'Alep top
91.4 × 108.6 × 53.3 cm
(3 ft. × 3 ft. 6¾ in. × 1 ft. 9 in.)
85.DA.319

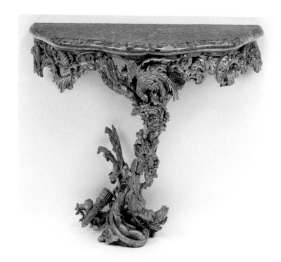

This console table exhibits the fanciful heights and extravagant forms achieved by German craftsmen working during the Rococo period. It is carved entirely with fantastic motifs intermixed with more traditional ones. This combination of incongruous elements— birds, a dragon, hunting implements, lightning bolts, and fruited vines—appears occasionally in German expressions of chinoiserie, the Western adaptation and interpretation of images derived from the Far East.

ONE OF A SET OF TWO ARMCHAIRS AND TWO SIDE CHAIRS

French (Paris), circa 1735–40
Carved and gilded beech;
modern silk upholstery
110.5 × 76.6 × 83.7 cm
(3 ft. 7½ in. × 2 ft. 6⅛ in.
× 2 ft. 8⅞ in.)
82.DA.95.1–.4

This early Rococo chair belonged to a set; two additional armchairs and two side chairs exist. The upholstered seat, back, and arm cushions were designed so that they could be removed and recovered according to the season.

GROUP OF "JAPANESE" FIGURES

Modeled by Johann Joachim
Kändler (1706–1775)
German, Meissen manu-
factory, circa 1745
Hard-paste porcelain, poly-
chrome enamel decoration,
gilding; gilt-bronze mounts
45.1 × 29.5 × 21.7 cm
(1 ft. 5¾ in. × 11⅝ in. ×
8⁹⁄₁₆ in.)
83.DI.271

This piece is documented to have been modeled by
Kändler, who was among the foremost European ceramic
modelers of the eighteenth century and certainly the
most important modeler at Meissen. An entry in his
workbook for November 20, 1745 clearly describes this
group. This unusually large piece is one of only two
known examples.

The document describes this piece as "a large Japa-
nese Group" (*eine grosse Japanische Grouppee*) even
though the figures appear to be Chinese. This merely
exhibits the confusion that often occurred in Europe
during the eighteenth century regarding the Orient;
the exoticism of the image was more important than a
specific reference. Therefore, this group is typical of
chinoiserie ornamentation (which was a Western adap-
tation and interpretation of images derived from the
Far East). Indeed, this composition is probably after a
design by a French eighteenth-century painter and may
be from a series representing the five senses.

ONE OF A PAIR OF
MOUNTED CERAMIC
GROUPS

Figure, rockwork, and dog:
Chinese, Kangxi (1662–1722);
spheres: Chinese, Qianlong,
1736–95; flowers: French,
Chantilly manufactory, circa
1740; mounts: French (Paris),
circa 1740–45
Porcelain; soft-paste porce-
lain, polychrome enamel deco-
ration; gilt-bronze mounts
30.4 × 22.8 × 12.7 cm
(1 ft. × 9 in. × 5 in.)
78.DI.4.1 –.2

As is often the case with eighteenth-
century groups of mounted Oriental
porcelain, this example is composed of
disparate elements never intended to
be used together. The boy was made to
be freestanding. The rockery originally
formed a base for the Foo dog, but
these elements were separated and the
perfume ball placed in between.

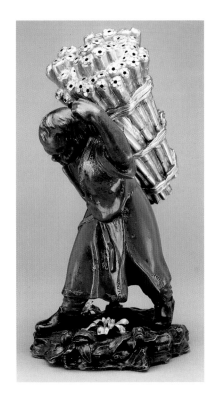

ONE OF A PAIR
OF DECORATIVE
BRONZES

Painted decoration attributed
to the Martin brothers
(active circa 1725–1780)
Bronzes: French (Paris), 1745–49
Silver: French (Paris), 1738–50
Painted bronze; silver
22.8 × 11.5 × 15.2 cm
(9 in. × 4½ in. × 6 in.)
88.DH.127.1 –.2

This bronze of a boy carrying a silver
bundle of sugar cane and its pair are
ornamental figures, masquerading
as sugar casters, that probably were not
intended to be functional. They ori-
ginally belonged to Madame de Pompa-
dour, mistress to Louis XV.

ONE OF A PAIR OF TUREENS AND STANDS

Made by Thomas Germain
(1673–1748)
French (Paris), 1744–50
Silver
Tureen: 30 × 34.9 × 28.2 cm
(11¹³⁄₁₆ in. × 1 ft. 1¾ in. × 11⅛ in.)
Stand: 4.2 × 46.2 × 47.2 cm
(1⅝ in. × 1 ft. 6³⁄₁₆ in.
× 1 ft. 6⁹⁄₁₆ in.)
82.DG.13.1 –.2

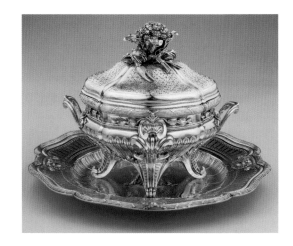

This large tureen and stand, along with its pair, are marked for the years 1744 to 1750. They are attributed to the royal silversmith Thomas Germain, who died in 1748, but may have been completed by his son, François-Thomas Germain. Both father and son were exceptionally skilled craftsmen who served many European royal courts, especially those of France and Portugal the finely worked vegetables and crustaceans on the lid, probably cast from natural models, demonstrate the virtuoso talent of the silversmith.

ONE OF A PAIR OF COMMODES

Carving attributed to Joachim Dietrich (d. 1753)
German (Munich), circa 1745
Painted and gilded pine;
gilt-bronze mounts; *jaune rosé de Brignolles* marble top
83.2 × 126.4 × 61.9 cm
(2 ft. 8¾ in. × 4 ft. 1¼ in.
× 2 ft. ⅜ in.)
72.DA.63.1 –.2

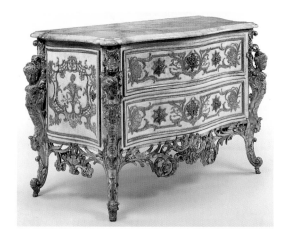

The design of this ornately carved German commode and its pair was influenced by the engravings of François de Cuvilliés (circa 1695–1768), architect for the Elector of Bavaria and one of the leading interpreters of the Rococo style.

CARTONNIER
AND CLOCK

Cartonnier made by Bernard II
van Risenburgh (b. after
1696 – circa 1766, master
before 1730); clock movement
made by Étienne II Le Noir
(1699 – 1778, master 1717);
the name of the maker of the
clock case is unknown; dial
enameled by Jacques Decla
(active 1742 – d. after 1764)
French (Paris), circa 1746 – 49
Oak veneered with ebonized
wood and painted with *vernis
Martin*; gilt-bronze mounts;
enameled metal dial; painted
bronze figures; glass
192 × 103 × 41 cm
(6 ft. 3⅝ in. × 3 ft. 4⁹⁄₁₆ in.
× 1 ft. 4⅛ in.)
83.DA.280

The *cartonnier* is stamped B.V.R.B. for the cabinetmaker
Bernard II van Risenburgh. The pigeonholes in the
central section and the narrow cupboards at the sides of
the base were intended to contain papers. The black
and gold decoration is of *vernis Martin*, a French imita-
tion of Oriental lacquer named after the Martin broth-
ers, who excelled in this technique. In the Rococo
period the use of Japanese or Chinese lacquer panels to
decorate furniture was popular; however, the exotic
lacquer was expensive for the client or difficult to obtain,
so Parisian craftsmen learned to imitate it. The clock
dial is dated 1746.

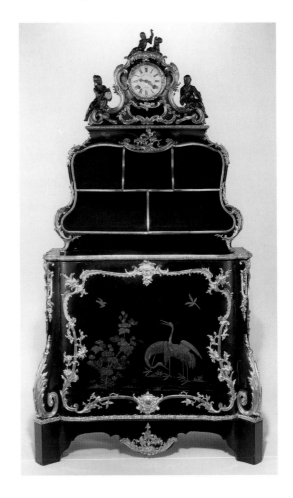

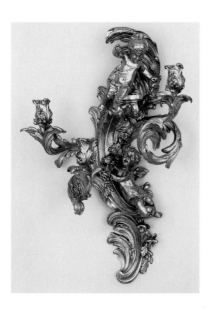

ONE OF A PAIR OF WALL LIGHTS

French (Paris), 1745–49
Gilt bronze
72.4 × 47.6 × 26.7 cm
(2 ft. 4½ in. × 1 ft. 6¾ in.
× 10½ in.)
89.DF.26.1–.2

Boldly sculptural, these wall lights are massive in scale and form. They undoubtedly were designed for a formal interior, probably en suite with other wall lights and a chandelier. The name of the maker is not known.

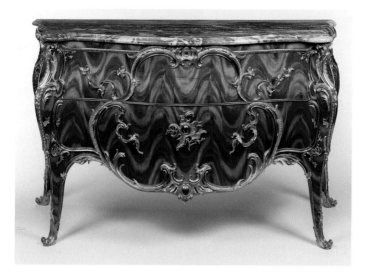

COMMODE

Made by Jean-Pierre Latz
(circa 1691–1754)
French (Paris), circa 1745–49
Oak veneered with *bois satiné*;
gilt-bronze mounts; *fleur de pêcher* marble top
87.7 × 151.5 × 65 cm
(2 ft. 10½ in. × 4 ft. 11⅝ in.
× 2 ft. 2⅝ in.)
83.DA.356

Although this commode is not stamped with a cabinet-maker's name, it can be firmly attributed to Latz since his stamp is found on a commode of precisely the same design now in the Palazzo Quirinale, Rome. That commode was taken to Italy in 1753 by Louise-Elisabeth, a daughter of Louis XV, who had married Philip, Duke of Parma, son of Philip V of Spain (r. 1700–1724, 1724–1746).

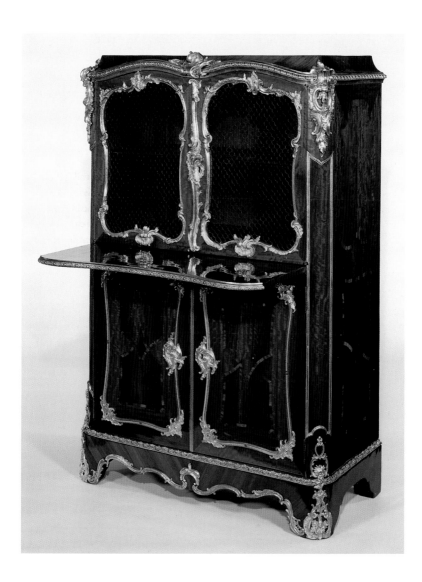

ONE OF A PAIR OF CABINETS

Made by Bernard II van Risenburgh (b. after 1696– circa 1766, master before 1730)
French (Paris), circa 1745–50
Oak veneered with *bois satiné*, amaranth, and cherry; gilt-bronze mounts
149 × 101 × 48.3 cm
(4 ft. 10⅜ in. × 3 ft. 3¼ in. × 1 ft. 7 in.)
84.DA.24.1–.2

Stamped B.V.R.B. (see p. 205), this low cabinet and its pair are of unique form and were probably used to hold small objets d'art such as porcelains and bronzes or natural curiosities such as shells, minerals, and coral. The cabinets are too deep to use for books. A slide, situated beneath the upper doors, can be pulled out and may have been used by the owner while rearranging and studying his or her collection.

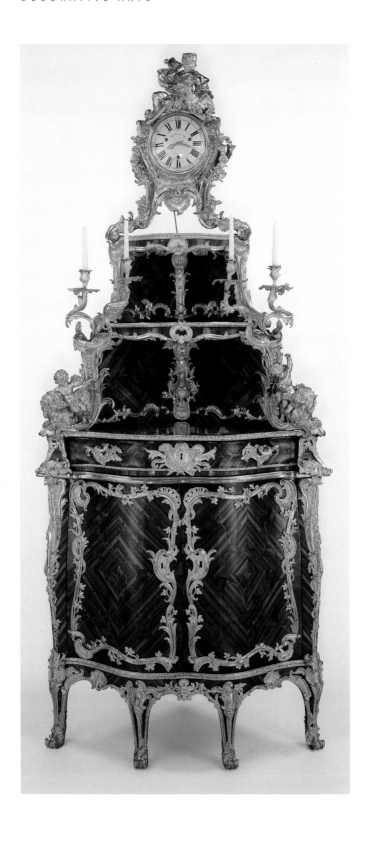

COMPOUND MICROSCOPE WITH CASE

French (Paris), circa 1750
Microscope: gilt bronze; glass
and mirror glass; enamel;
shagreen
Case: wood; tooled and
gilded leather; brass closing
fixtures; original lining of silk
velvet with silver braid; slides
of various natural specimens
and brass implements
Microscope: 48 × 28 × 20.5 cm
(1 ft. 6⅞ in. × 11 in. × 8 1/16 in.)
Case: 66 × 34.9 × 27 cm
(2 ft. 2 in. × 1 ft. 1¼ in.
× 10⅝ in.)
86.DH.694

This microscope was made for a noble dilettante scientist who would have used it in his *laboratoire* or *cabinet de curiosités* to explore the mysteries of the natural world being revealed during the Age of Enlightenment.

A microscope of the same form, known to have belonged to Louis XV, was kept in his *observatoire* at the Château de La Muette. The Museum's example is still in working condition. A drawer in the case holds extra lenses and eighteenth- and nineteenth-century specimen slides of such items as a geranium petal, hair, and a flea.

CORNER CUPBOARD

Made by Jacques Dubois
(circa 1694–1763, master
1742); clock movement
made by Étienne II Le Noir
(1699–1778, master 1717);
dial enameled by Antoine-
Nicolas Martinière (1706–
1784, master 1720)
French (Paris), circa 1744–53
Oak, mahogany, and spruce
veneered with *bois satiné* and
kingwood; enameled metal
clock dial; gilt-bronze mounts;
glass door clock
289.5 × 129.5 × 72 cm
(9 ft. 6 in. × 4 ft. 3 in.
× 2 ft. 4½ in.)
79.DA.66

This cupboard, stamped I. DUBOIS, was made for Count Jan Clemens Branicki, the head of the Polish army. It was delivered to him in Warsaw around 1753, and an inventory of the contents of his hôtel shows that it stood in a grand *salon* as a pendant to a large ceramic stove. Of unique form, the cupboard is based on a print of a drawing by the great Rococo ornamentalist Nicolas Pineau. The clock dial is dated 1744.

DOUBLE DESK

Made by Bernard II van Risenburgh (b. after 1696–circa 1766, master before 1730)
French (Paris), circa 1750
Oak and mahogany veneered with tulipwood, kingwood, and *bois satiné*; gilt-bronze mounts
107.8 × 158.7 × 84.7 cm
(3 ft. 6½ in. × 5 ft. 2½ in. × 2 ft. 9⅛ in.)
70.DA.87

The form of this massive desk, stamped B.V.R.B. (see pp. 205 and 207), is unique. Flaps let down on both sides to form writing surfaces, revealing pigeonholes and drawers. The desk was acquired by the Duke of Argyll in the nineteenth century and remained in his family until it was acquired by J. Paul Getty.

BED

Attributed to Jacques-Jean-Baptiste Tilliard (1723–1798, master 1752)
French (Paris), circa 1750–60
Gilded beech; modern silk upholstery
174 × 264.8 × 188 cm
(5 ft. 8½ in. × 8 ft. 8¼ in. × 6 ft. 2 in.)
86.DA.535

This large bed, known as a *lit à la Turque*, was undoubtedly made for a large *chambre à coucher* in a fashionable grand hôtel. It would have been placed against the wall, with a draped baldachin above. It is a masterpiece of its kind, unequaled in size, and the quality of the carving and gilding in two colors is particularly extravagant. Two smaller but similarly monumental and sculptural beds exist; both are stamped Tilliard. One is in Versailles and belonged at one point to Madame du Barry, a mistress of Louis XV.

COMMODE

Attributed to Joseph
Baumhauer (d. 1772)
French (Paris), circa 1750
Oak veneered with ebony;
set with panels of Japanese
lacquer, painted with *vernis
Martin*; gilt-bronze mounts;
campan mélangé vert marble top
88.3 × 146.1 × 62.6 cm
(2 ft. 10¼ in. × 4 ft. 9½ in.
× 2 ft. ⅝ in.)
55.DA.2

The front and sides of this commode are set with
panels of Japanese lacquer, the seams of which are hid-
den under the mounts. The remaining surfaces are
painted in imitation of *nashiji*, a clear lacquer sprinkled
with gold. This commode bears the trade label of the
eighteenth-century furniture dealer François-Charles
Darnault.

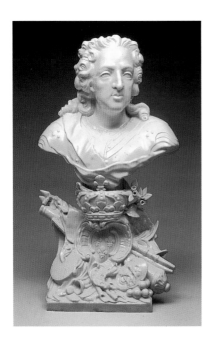

BUST OF LOUIS XV OF FRANCE

French, Mennecy manu-
factory, circa 1750–55
Soft-paste porcelain
43.2 × 24.5 × 14.5 cm
(1 ft. 5 in. × 9⁹⁄₁₆ in. × 5¹¹⁄₁₆ in.)
84.DE.46

In 1734 the duc de Villeroy established a
soft-paste porcelain manufactory, which
after 1748 was located at Mennecy.
Because of the difficulties of firing large
pieces of porcelain in the kilns, this
bust of the king was made in two pieces,
joined above the crown on the plinth.
The plinth is decorated with an asym-
metrical Rococo cartouche (enclosing
the French royal coat of arms) and with
military trophies.

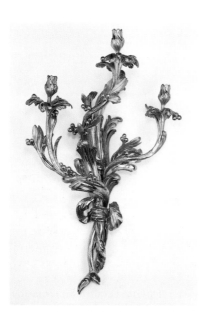

ONE OF A SET OF FOUR WALL LIGHTS

Made by François-Thomas
Germain (1726–1791)
French (Paris), 1756
Gilt bronze
99.6 × 63.2 × 41 cm
(3 ft. 3¼ in. × 2 ft. ⅞ in.
× 1 ft. 4⅛ in.)
81.DF.96.1–.4

Signed by François-Thomas Germain,
silversmith to the king (see p. 204),
these large, late Rococo wall lights were
finished with an unusually high degree
of attention to their casting and gilding.
The lights were commissioned by the
duc d'Orléans for his residence in Paris,
the Palais Royal. Later in the eighteenth
century they were bought by Louis XVI
(r. 1774–1792) and hung in rooms used
by Marie-Antoinette in the Château de
Compiègne.

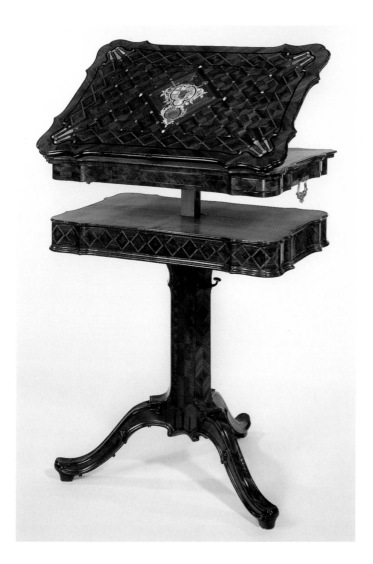

READING AND WRITING STAND

Made by Abraham Roentgen
(1711 – 1793)
German (Neuwied-am-
Rhein), circa 1760
Pine, oak, and walnut
veneered with rosewood,
alder, palisander, ivory,
ebony, and mother-of-pearl;
gilded metal fittings
76.8 × 71.7 × 48.8 cm
(2 ft. 6½ in. × 2 ft. 4½ in.
× 1 ft. 7¼ in.)
85.DA.216

The top of this stand is inlaid with the coat of arms of Johann Philipp von Walderdorff, Prince Archbishop and Elector of Trier. Walderdorff was Roentgen's most important patron, and in the 1750s and 1760s, the latter delivered some twenty pieces of elaborate furniture to Walderdorff's palace. This stand is fitted with numerous concealed drawers that open at the press of a button or turn of a key.

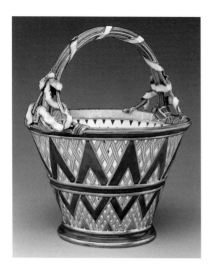

BASKET

French, Sèvres manufactory,
1756
Soft-paste porcelain,
green ground color, gilding
22 × 20.1 × 18 cm (8⅝ × 7⅞ × 7⅛ in.)
82.DE.92

A D painted on the bottom of this basket
indicates that it was made in 1756, the
year the French royal porcelain manu-
factory moved from Vincennes to a newly
built factory at Sèvres, a village on the
Seine near Paris. The piece also bears
the incised mark *pʒ* for the modeler who
cut the intricately pierced walls and
made the Rococo ribbons entwining
the handle. The green ground color with
which this basket is painted was first
developed in 1756, and this is an early
example of its use.

The piece has an unusual shape. It,
or one very similar to it, is described
in the 1757 records of the manufactory
as having been presented as a gift to
François Boucher, the court painter who
supplied many designs to the Sèvres
porcelain manufactory.

LIDDED POTPOURRI VASE

Painting attributed to
Charles-Nicolas Dodin
(1734–1803)
French, Sèvres manufactory,
circa 1760
Soft-paste porcelain, pink
and green ground color,
polychrome enamel
decoration, gilding
37.5 × 34.8 × 17.4 cm
(1 ft. 2¾ in. × 1 ft. 1¹¹⁄₁₆ in.
× 6¹⁵⁄₁₆ in.)
75.DE.11

This *vase vaisseau à mât*, or boat-shaped
vase, was designed to contain scented
potpourri — dried flower petals and
herbs — and its lid is pierced to allow
the scent to permeate the air. The
painted genre scene on the front is sur-
rounded by a ground of pink and green.
The gold fleurs-de-lis on the pennant
draped around the "mast" suggest royal
ownership. This soft-paste porcelain
vase is one of the rarest and most elabo-
rate of Rococo models produced in
the French royal porcelain manufactory
at Sèvres. Such vases were intended
to be sold with others of various shapes
to form a matching set, or garniture.

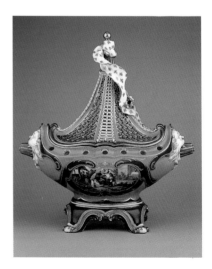

One of a Pair of Vases

Painting attributed to
Charles-Nicolas Dodin
(1734–1803)
French, Sèvres manufactory,
circa 1760
Soft-paste porcelain, pink,
green, and *bleu lapis* ground
color, polychrome enamel
decoration, gilding
29.8 × 16.5 × 14.6 cm
(11¼ × 6½ × 5¾ in.)
78.DE.358.1 –.2

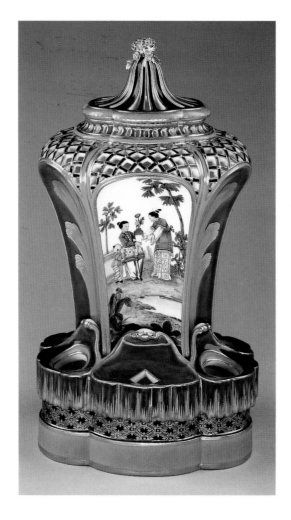

The lower sections of this vase and its pair were designed
to hold small flowering bulbs, while the tall central sec-
tion was intended to hold potpourri, the scent of which
would emanate through the pierced trellis at the top.
Such vases would have formed a garniture with others
of various shapes (see p. 214). The chinoiserie scene is
rare on Sèvres porcelain, and it is even more rare
to find three ground colors (pink, green, and dark blue)
on one piece. Each color required a separate firing of
the fragile porcelain. From archival records it is known
that these vases come from a set purchased by Madame
de Pompadour, mistress of Louis XV, from the Sèvres
manufactory in 1760.

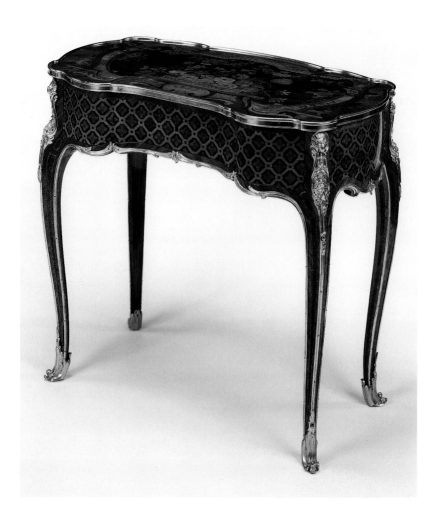

Writing and Toilet Table

Made by Jean-François Oeben
(1721 – 1763, master 1761)
French (Paris), circa 1754
Oak veneered with king-
wood, amaranth, tulipwood,
and other stained and
natural exotic woods; leather;
silk; gilt-bronze mounts
71.1 × 80 × 42.8 cm
(2 ft. 4 in. × 2 ft. 7½ in.
× 1 ft. 4⅞ in.)
71.DA.103

The top of this table of multiple uses slides back, and
a drawer unit can be pulled forward, revealing another
sliding top concealing compartments lined with blue
watered silk. These elaborate mechanisms and the fine
floral and trellised marquetry decorating it are trade-
marks of the table's maker, the royal *ébéniste* Jean-
François Oeben. Cosmetic pots and writing materials
would have been kept in this table and its surfaces used
for writing.

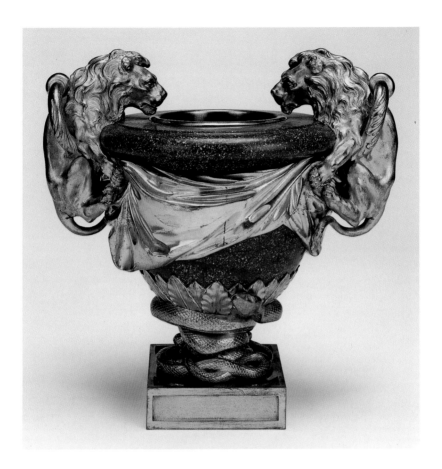

ONE OF A PAIR OF VASES

After an etching by Benigno
Bossi (1727–1792) of
a design by Ennemond-
Alexandre Petitot
(1727–1801)
French (Paris), circa 1765
Porphyry; red marble;
gilt-bronze mounts
38.7 × 41 × 27.7 cm
(1 ft. 3¼ in. × 1 ft. 4⅛ in. ×
10⅞ in.)
83.DJ.16.1–.2

Petitot's thirty designs for fantastic vases were etched
by Benigno Bossi in 1764, and the publication was dedi-
cated to Guillaume-Leon du Tillot, marquis de Felino,
first minister of the court of Parma. Petitot, a pupil of
Jacques-Germain Soufflot, became architect to the Duke
of Parma in 1753 and remained in Italy for the rest of
his life. The designs were probably intended for stone
garden vases, but here an anonymous *bronzier* working
with a *marbrier* has successfully converted the some-
what bizarre invention to ornamental vases suitable for
a classical interior.

LIDDED BOWL
ON STAND

Painted by Pierre-Antoine
Méreaud *père*
(circa 1735 – 1791)
French, Sèvres manufactory,
1764
Soft-paste porcelain, poly-
chrome enamel decoration,
gilding
Bowl H: 12.4 cm (4⅞ in);
W: 19.7 cm (7¾ in);
D: 15.2 cm (6 in.);
Stand H: 3.9 cm (1%6 in);
DIAM: 21.1 cm (8⅗6 in.)
78.DE.65

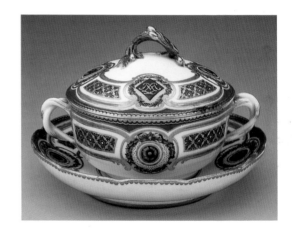

Decorated in the restrained transitional style of the
1760s, when the Rococo was giving way to the newly
fashionable Neoclassical taste, this lidded bowl is
painted with the monogram and coat of arms of the
eighth daughter of Louis XV of France, Madame Louise
(see p. 222). The porcelain is painted with the mark
of the painter Méreaud *père* and the date letter I for 1764,
the year Madame Louise is recorded in the archives at
Sèvres as having bought it.

CONSOLE TABLE

After designs by Victor Louis
(1737 – 1807); table attributed
to Pierre Deumier
(active from the 1760s)
French (Paris), circa 1765 – 70
Silvered and gilt bronze;
bleu turquin marble top
83.5 × 129.5 × 52 cm
(2 ft. 7⅞ in. × 4 ft. 3 in.
× 1 ft. 8½ in.)
88.DF.118

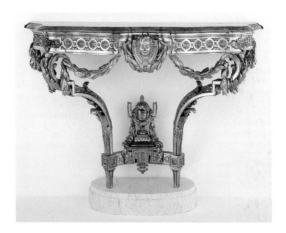

The design of this table follows two drawings—pre-
served in the University Library, Warsaw—one of
which was made by the French architect Victor Louis.
Louis had been commissioned in 1765 to renovate the
royal palace in Warsaw for Stanislas II Augustus,
King of Poland (r. 1764 – 1795). A table of this design
was delivered to the palace.

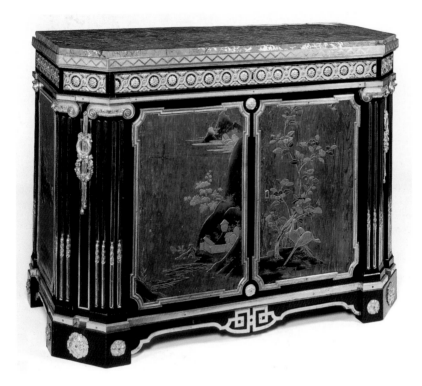

CABINET

Made by Joseph Baumhauer
(d. 1772)
French (Paris), circa 1765
Oak veneered with ebony,
tulipwood, and amaranth; set
with panels of seventeenth-
century Japanese lacquer;
gilt-bronze mounts; copper;
jasper top
89.6 × 120.2 × 58.6 cm
(2 ft. 11¼ in. × 3 ft. 11⅛ in.
× 1 ft. 11⅛ in.)
79.DA.58

The design of this early Neoclassical cabinet is severely
architectonic and includes such classical elements
as fluted, canted pilasters and Ionic capitals. Although
fairly simple in appearance, it is made from rare
and expensive materials. The *kijimaki-e* lacquer panels,
sanded so that the grain of the wood shows, are of
very fine quality and of late seventeenth-century date.
A semiprecious hard stone, yellow jasper, was used
for the top instead of less expensive marble.

The cabinet is stamped JOSEPH, the mark of the
cabinetmaker Joseph Baumhauer.

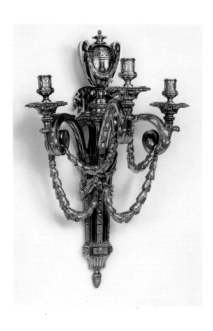

ONE OF A SET OF SIX WALL LIGHTS

Made by Philippe Caffieri
(1714–1774, master 1743)
French (Paris), circa 1765–70
Gilt bronze
64.8 × 41.9 × 31.1 cm
(2 ft. 1½ in. × 1 ft. 4½ in.
× 1 ft. ¼ in.)
78.DF.263.1–.4; 82.DF.35.1–.2

Signed gilt-bronze objects such as this are rare since the craftsmen who made them only occasionally put their names on their work. This light is further documented by a drawing signed by Philippe Caffieri and depicting the same model. These wall lights are after a design, possibly by Caffieri himself, made in 1768 for the redecoration of one of the residences of the King of Poland.

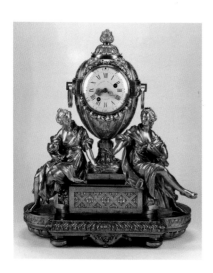

MANTEL CLOCK

Case attributed to Étienne
Martincourt (d. 1791, master
1762); movement made
by Étienne-Augustin Le Roy
(1737–1792, master 1758)
French (Paris), circa 1772
Gilt bronze; enameled metal;
glass
66 × 59.7 × 32.4 cm
(2 ft. 4 in. × 1 ft. 11½ in.
× 1 ft. ¼ in.)
73.DB.78

Known from documents to have belonged to Louis XVI, this clock is a remarkable work of casting, since details like the rosettes in the trellis were cast together with the elements they decorate. The usual practice was to cast all of these pieces separately. Although the clock, which came from the Palais des Tuileries, does not bear the name of its maker, a drawing for it by the *bronzier* Étienne Martincourt is known. The female figures flanking the urn represent Astronomy and Geography.

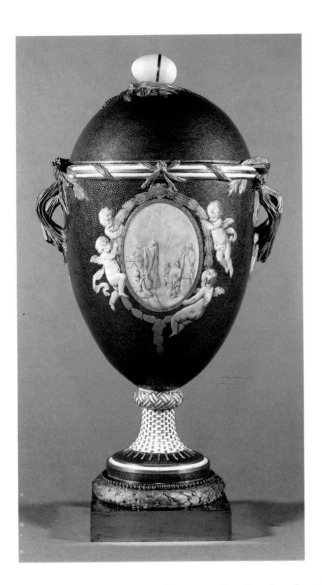

One of a Pair of Lidded Vases

Painted reserves attributed to
Jean-Baptiste-Étienne Genest
(active 1752–1789)
French, Sèvres manufactory,
circa 1768–69
Soft-paste porcelain, *bleu
Fallot* ground color, grisaille
enamel decoration, gilding;
gilt-bronze mounts
45.1 × 24.1 × 19.1 cm
(1 ft. 5¾ in. × 9½ in. × 7½ in.)
86.DE.520.1–.2

This vase is of nearly unique form. The grisaille
reserves and the pale blue ground strewn with gilded
dots create a subtle finish markedly different from
the strong, brightly colored decoration frequently
employed at the Sèvres porcelain manufactory in the
later eighteenth century.

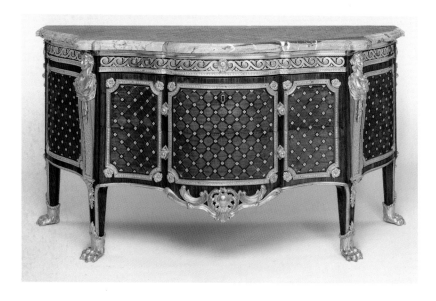

COMMODE

Made by Gilles Joubert
(1689 – 1775)
French (Paris), 1769
Oak veneered with kingwood,
tulipwood, holly, bloodwood
or *bois satiné*, and ebony; gilt-
bronze mounts; *sarrancolin*
marble top
93.5 × 181 × 68.5 cm
(3 ft. ¾ in. × 5 ft. 11¼ in.
× 2 ft. 3 in.)
55.DA.5

This commode and its pair (location unknown) were
delivered in 1769 to Versailles for use in the bedcham-
ber of Madame Louise, daughter of Louis XV (see
p. 218). It is inscribed on the back with the number 2556,
identifying it in the royal inventories. Gilles Joubert,
best known for his Rococo work, ventured to design this
commode in the newly fashionable Neoclassical style.

SECRÉTAIRE

Made by Philippe-Claude
Montigny (1734 – 1800,
master 1766)
French (Paris), circa 1770 – 75
Oak veneered with tortoise-
shell, brass, pewter, and
ebony bandings; gilt-bronze
mounts
141.5 × 84.5 × 40.3 cm
(4 ft. 7½ in. × 2 ft. 9 in.
× 1 ft. 3¾ in.)
85.DA.378

The front and sides of this Neoclassical *secrétaire-à-
abattant* are covered with large marquetry panels
of tortoiseshell, brass, and pewter dating from the late
seventeenth century. They originally were tabletops
that were reused by Montigny, who was well known as
a specialist in this type of work. The reuse of such
old panels or the making of new ones was fashionable
during the late eighteenth century among the most
advanced connoisseurs. This vogue is known as the
"boulle revival" after the technique's greatest seven-
teenth-century practitioner, André-Charles Boulle.

It is unusual to find an eighteenth-century prove-
nance for nonroyal furniture. Two previous owners —
both courtiers at Versailles — have been identified for
this *secrétaire*.

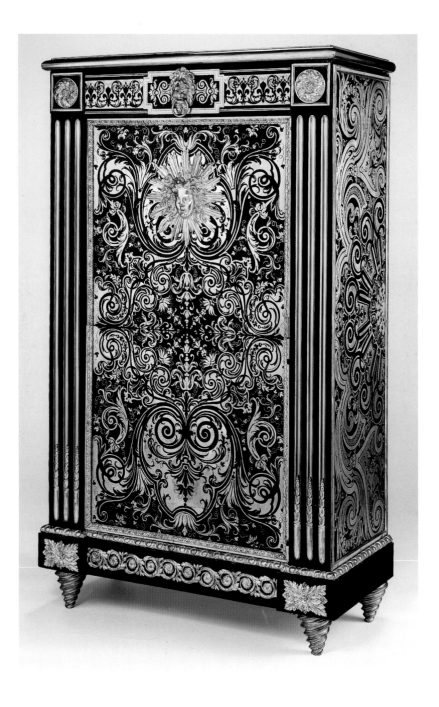

ONE OF A SET OF
FOUR TAPESTRIES

Woven under the direction of
Michel Audran (1701 – 1771)
and his son Jean Audran *fils*
(active 1771 – 1794)
French, Gobelins manu-
factory, 1772 – 73
Wool and silk;
modern cotton lining
371 × 507.5 cm
(12 ft. 2 in. × 16 ft. 7 in.)
82.DD.67

Entitled *The Feast of Sancho on the Island of Barataria*,
this tapestry is from a set of four depicting various
scenes from Cervantes's *Don Quixote* that was woven
at the Gobelins manufactory. They make up one of
many similar sets woven between 1763 and 1787 after
cartoons by the painter Charles Coypel (1694 – 1752).
The designs of the elaborate frames and surrounds
were altered periodically as styles changed. Such tap-
estries were often presented by the French king to roy-
alty and nobility from other countries in Europe. This
set was given by Louis XVI to the Duke and Duchess
of Saxe-Teschen, who were traveling in France in
1786 (the duchess was the sister of Marie-Antoinette).

A number of examples from the *Don Quixote* series
exist, but the Museum's tapestries are unusual in that
the colors remain relatively unfaded and retain many of
the softer hues now lost on other examples.

SECRÉTAIRE

Made by Martin Carlin (circa
1730–1785, master 1766)
French (Paris) and Sèvres
manufactory, circa 1776–77
Oak veneered with tulip-
wood, amaranth with holly,
and ebony stringing; soft-
paste porcelain plaques with
polychrome enamel decora-
tion and gilding; enameled
metal; gilt-bronze mounts;
marble top
107.9 × 103 × 35.5 cm
(3 ft. 6¼ in. × 3 ft. 4½ in.
× 1 ft. 2 in.)
81.DA.80

The upright *secrétaire*, a type of writing desk, came into
fashion in the mid-eighteenth century. The fall front of
this example lowers to form a writing surface, revealing
drawers and pigeonholes. This Neoclassical *secrétaire* is
decorated with flower-painted Sèvres porcelain plaques,
an expensive fashion introduced by the Parisian furni-
ture dealers in the 1770s. Its unusually small size sug-
gests that the desk was made for a bedroom.

GARNITURE OF THREE VASES

Models designed by Jacques-François Deparis (active 1746–1797); at least one vase finished by Étienne-Henry Bono (active 1754–1781); reserves painted by Antoine Caton (active 1749–1798); gilding by Étienne-Henry Le Guay (1719/20–circa 1799); jeweling by Philippe Parpette (active 1755–1806)
French, Sèvres manufactory, 1781
Soft-paste porcelain, *bleu nouveau* ground color, polychrome enamel decoration, enamel imitating jewels, gilding, gold foil
40.8 × 24.8 × 18.4 cm
(1 ft. 4 in. × 9¾ in. × 7¼ in.);
47 × 27.7 × 19.3 cm
(1 ft. 6½ in. × 10⅞ in. × 7⅝ in.); 40.5 × 25.4 × 18.3 cm
(1 ft. 3¹⁵⁄₁₆ in. × 10 in. × 7³⁄₁₆ in.)
84.DE.718.1–.3

This set of lavishly decorated vases (along with a similar pair now in the Walters Art Gallery, Baltimore) formed a *garniture de cheminée* that was purchased by Louis XVI on November 2, 1781, and placed in his library at Versailles. These vases, prime examples of the mature Neoclassical style at Sèvres, are among the most fully documented works of porcelain in the Museum's collection. Known as a *vase des âges*, this shape was produced at Sèvres from 1778 in three sizes that differ in the rendering of the "handles": bearded male heads for the largest size, female heads for the middle size, and boys' heads for the small size (in Baltimore). The oval reserves on the front of each vase were painted in polychrome enamels with scenes based on engravings by Jean-Baptiste Tilliard (circa 1740–1813) after designs by Charles Monnet (1732–after 1808). These engravings illustrated an edition of one of Louis XVI's favorite books, *Les Aventures de Télémaque*.

These vases are among the largest pieces of jeweled porcelain made at Sèvres. The procedure was exceptionally expensive and demanded great skill. It is clear that only the factory's most experienced and accomplished decorators were involved in producing this garniture. No directly comparable sets of vases are known.

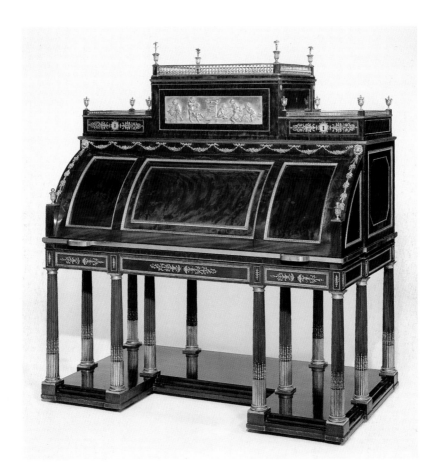

ROLLTOP DESK

Made by David Roentgen
(1743 – 1807, master 1780)
German (Neuwied-am-
Rhein), circa 1785
Oak and pine veneered with
mahogany and maple burl;
gilt-bronze mounts; steel
fittings
168.3 × 155.9 × 89.3 cm
(5 ft. 6¼ in. × 5 ft. 1⅛ in.
× 2 ft. 11½ in.)
72.DA.47

Made in the Neoclassical style, this desk is one of sev-
eral made by Roentgen, many of which were purchased
by Catherine the Great (r. 1762 – 1796). When the
writing surface is pulled out, a mechanism automati-
cally withdraws the solid rolltop back into the carcass,
displaying the drawers and pigeonholes inside the
desk. It is also fitted with both a reading stand and a
writing-surface unit, which could be used by a per-
son standing at the closed desk. This unit is concealed,
folded, behind the gilt-bronze plaque; it projects for-
ward when the weight-driven mechanism is activated
by the turn of a key. Roentgen specialized in furniture
with such elaborate mechanical fittings.

ONE OF A PAIR OF CANDELABRA

Attributed to Pierre-Philippe
Thomire (1751 – 1843, master
1772) after designs by Louis-
Simon Boizot (?) (1743 – 1809)
French (Paris), circa 1785
Gilt and patinated bronze;
white and *griotte* marbles
H: 83.2 cm (2 ft. 10¼ in.);
DIAM: 29.2 cm (11½ in.)
86.DF.521.1 – .2

Although the name of the maker is un-
known, this pair of candelabra has been
attributed on stylistic grounds to the
greatest *bronzier* of the late eighteenth
and early nineteenth centuries, Pierre-
Philippe Thomire. A drawing in the
Musée des Arts Décoratifs (Paris) shows
one of the candelabra displayed on a
fireplace with other objects, including a
clock with vestal virgins and a small
bronze figure of a reading girl on a lamp
base. The clock has always been attrib-
uted to Thomire as has the figure, which
was designed by Louis-Simon Boizot
in 1780 for the Sèvres manufactory. It is
known that Thomire did not personally
produce designs for his work, calling
instead on the best-known designers
of his period. It is therefore possible that
Boizot was responsible for the design of
this candelabrum.

STANDING VASE

Attributed to Pierre-Philippe
Thomire (1751 – 1843, master
1772)
Porcelain: Chinese, circa 1750
Mounts: French (Paris),
circa 1785
Porcelain, monochrome
enamel decoration; gilt-
bronze mounts; *rouge
griotte* marble
H: 81 cm (2 ft. 7¾ in.)
DIAM: 56.5 cm (1 ft. 10 in.)
70.DI.115

This large standing vase may have served as a jardi-
niere to be placed on a table or stand. It was reputedly
bought by Princess Isabella Lubomirska, cousin of King
Stanislas of Poland (r. 1704 – 1709, 1733 – 1735), after
the French Revolution. Another vase of identical form
is in the British Royal Collection; it was purchased
by the Prince Regent (later George IV [r. 1820 – 1830])
from Thomire et Cie., the company of the famous
bronzier Pierre-Philippe Thomire. The mounts on this
vase are therefore attributed to him.

ONE OF A PAIR OF
WALL LIGHTS

Attributed to Pierre-Philippe
Thomire (1751–1843,
master 1772)
French (Paris), circa 1787
Gilt bronze
107.9 × 57 × 30.1 cm
(3 ft. 6½ in. × 1 ft. 10⁷⁄₁₆ in.
× 11⁷⁄₈ in.)
83.DF.23.1–.2

This five-branched wall light, one of a pair, is attributed
to the *bronzier* Thomire. A bill from his workshop
survives describing in detail wall lights of this model,
six of which were delivered to the *salon des jeux du Roi*
in the Château de Saint Cloud in 1787. Those lights
are now in the Petit Trianon at Versailles, but other
examples exist, such as this pair with finely chased fruits
and berries, female masks, and pendant oak leaves.

CABINET

Gilt-bronze mounts cast by Forestier (either Étienne-Jean, master 1764, or his brother Pierre-Auguste, 1755 – 1835) and Badin (active last quarter of the eighteenth century) from models by Gilles-François Martin (circa 1713 – 1795), chased by Pierre-Philippe Thomire (1751 – 1843, master 1772) and gilded by André Galle (1761 – 1844); marble top supplied by Lanfant

Made by Guillaume Benneman (d. 1811, master 1785)
Cabinet: French (Paris), 1788
Plaques: seventeenth and eighteenth centuries
Oak veneered with mahogany and ebony; *pietre dure* plaques of seventeenth- and eighteenth-century date; gilt-bronze mounts; *bleu turquin* marble top
92.2 × 165.4 × 64.1 cm
(3 ft. ¼ in. × 5 ft. 5⅛ in. × 2 ft. 1¼ in.)
78.DA.361

This cabinet was created for the bedroom of Louis XVI at the Château de Saint-Cloud. The *pietre dure* plaques replace the original lacquer panels, which were taken off sometime after the Revolution. One of a pair, the other cabinet is now in the royal palace in Madrid.

CARVED RELIEF

By Aubert-Henri-Joseph
Parent (1753 – 1835)
French (Paris), 1789
Limewood
69.4 × 47.9 × 6.2 cm
(2 ft. 3⅜ in. × 1 ft. 6⅞ in.
× 2⅜ in.)
84.SD.76

This virtuoso display piece was made as both a work
of art and as a demonstration of the maker's skill in the
art of carving. It is made from a single piece of lime-
wood. The maker of this piece, Aubert Parent, is best
known for still life reliefs carved in fruitwoods. Parent
came to prominence in 1778 when he began working
for the French Crown. He had already traveled to Italy,
where he may have seen the work of Giuseppe Bonza-
nigo (1744 – 1820), a famous woodcarver from Turin.
After the French Revolution, he left France to work
in Berlin.

Prominent elements in the decoration of this relief
exhibit the interest in Roman antiquity that was an
important element in the Neoclassical style. The tablet
in the center of the vase representing a grasshopper in a
chariot drawn by a parrot is inspired by an engraving
reproducing a fragment of a wall painting found in the
excavations of Herculaneum. On the rectangular plinth
beneath the vase are represented a pair of Loves (putti)
with their torches reversed. A putto with a reversed
torch was a traditional Roman symbol of mourning and
is commonly found on ancient Roman sarcophagi.

WINE-BOTTLE COOLER

Model designed by Jean-Claude Duplessis (d. 1774); painted decoration attributed to Charles-Eloi Asselin (active 1765–1804) after engraved designs by Charles Monnet (1732–after 1808) and Jean-Baptiste-Marie Pierre (1713–1789); gilding attributed to Étienne-Henri Le Guay (1719/20–circa 1799)

French, Sèvres manufactory, circa 1790

Soft-paste porcelain, *bleu nouveau* ground color, polychrome enamel decoration, gilding

H: 18.9 cm (7⁷⁄₁₆ in.)
DIAM: 25.8 cm (10³⁄₁₆ in.)
82.DE.5

This wine-bottle cooler is painted with a dark blue ground color and two elaborate scenes of mythological subjects surrounded by carefully tooled gilding. The scene illustrated shows Hercules performing one of his twelve labors: capturing the man-eating horses of Diomedes. The cooler comes from one of the most important dinner services produced at Sèvres in the eighteenth century, which was ordered by Louis XVI in 1783 but not completed before his execution in 1793. The king's death marked the end of production of the costly service, of which 197 pieces had been completed. The partial service was dispersed at the time of the French Revolution. A major portion was acquired by the Prince Regent (later George IV, r. 1820–1830) and can be seen today at Windsor Castle, London.

Sculpture and Works of Art

The Department of Sculpture and Works of Art was established in 1984. Its primary goal is to build a collection of European sculpture representing the period from the Renaissance to the end of the nineteenth century. Its other aim is to complement the Department of Decorative Arts (responsible for Northern European decorative arts from 1650 to 1900) and to build the Museum's collection of all European decorative arts from the period prior to 1650 and in Southern Europe from 1650 to 1900.

The department now has important holdings in Renaissance ceramics and glass, a small number of silver, gold, and other precious metal objects, single examples of early seventeenth-century German and Netherlandish furniture, and Italian furniture ranging from the sixteenth through the nineteenth century. Covering the same time span, the sculpture collection includes important works by Laurana, Antico, Cellini, Giambologna, van der Schardt, Verhulst, Girardon, Houdon, Clodion, Canova, Barye, and Carpeaux.

HISPANO-MORESQUE DEEP DISH

Spanish (Valencia),
mid-fifteenth century
Tin-glazed and lustered
earthenware
H: 10.8 cm (4½ in.);
DIAM: 49.5 cm (19½ in.)
85.DE.441

In the first half of the fifteenth century Moorish potters in Spain produced the finest pottery in Europe. They specialized in highly prized lusterwares like this dish that were exported throughout the Mediterranean. The difficult luster technique—which produces a shimmering effect—was accomplished by firing metal oxides onto ceramic objects in a special "reduction" kiln starved of oxygen.

The center of the dish—known as a *brasero*—is inscribed IHS (Jesus Hominum Salvator), the monogram Saint Bernard of Siena held up for veneration at the end of his sermons. After his canonization in 1450, the monogram began appearing on works of art, substantiating the dating of this piece to mid-century. The leaf-spray embellishment that extends around the rim and down the sides is bryony (a tendril-bearing vine), parsley, or small carnation leaves. This motif is mainly found on Hispano-Moresque wares of the second and third quarters of the fifteenth century.

Braseros often were used as serving trenchers, although the large scale, elaborate decoration, and excellent state of preservation suggest that this deep dish was intended for display, perhaps on a credenza.

CYLINDRICAL DRUG JAR

Italian (Faenza), circa 1480
Tin-glazed earthenware
H: 31.5 cm (12⅜ in.);
DIAM (lip): 11.1 cm (4⅜ in.)
84.DE.104

This pharmaceutical *albarello* is decorated with a banderole label bordered with scrolling leaves. The interior is covered with a lead glaze, less expensive than the brilliant tin glazes on the exterior. The label identifies the original contents as *syrupus acetositatis citriorum*, or syrup of lemon juice, which was used to reduce inflammations of the viscera, to calm fevers, to quench thirst, and to counteract drunkenness and dizziness. The vessel's waisted form is appropriate to its use, since it was easy to remove from a pharmacy's shelf crowded with similar containers. The elegant shape and masterful glaze painting make this piece one of the finest fifteenth-century *albarelli* known.

EWER

Italian (Venice), late fifteenth or early sixteenth century
Free-blown soda glass; enameled and gilt decoration
H: 27.2 cm (10¹¹⁄₁₆ in.)
DIAM (at lip): 2.9 cm (1⅛ in.);
DIAM (at base): 13.9 cm (5⁷⁄₁₆ in.)
84.DK.512

Originally used as liturgical vessels in metal, by the fifteenth century ewers were being produced in glass and used as table pitchers to serve wine and other liquids. This example was formed in four separate parts: spout, handle (both originally gilt), body, and base. By the beginning of the sixteenth century, the enameled scale pattern made of small dots had become a popular Venetian glass motif. The flame design below the neck was less common. This piece is one of only a dozen glass ewers that have survived intact from the period.

ANTICO

(Pier Jacopo Alari-Bonacolsi)
Italian, circa 1460 – 1528
Bust of a Young Man,
circa 1520
Bronze with silver eyes
54.7 × 45 × 22.3 cm
(21½ × 17¾ × 8¾ in.)
86.SB.688

Trained as a goldsmith, Pier Jacopo became the princi-
pal sculptor at the court of Mantua in the late fifteenth
and early sixteenth centuries. He executed many bronze
reductions and variants of famous antiquities, earning
himself the nickname Antico. The Museum's bronze
is one of only seven known busts generally accepted
as being by him. It derives from an ancient marble bust,
now in the Hispanic Society of America, New York.
The use of silver for the eyes emulates a frequent prac-
tice of antiquity.

BENVENUTO
CELLINI

Italian, 1500 – 1571
Satyr, cast after a model of
circa 1542
Bronze
H: 56.8 cm (22⅛ in.)
85.SB.69

In 1540 Cellini, a leading sixteenth-
century sculptor, traveled to Fontaine-
bleau to work for King François I.
One of the artist's major commissions
was for the Porte Dorée, the monumen-
tal palace entrance ordered by the king
in 1542. The project called for a bronze
lunette depicting the nymph thought to
reside in the forest of Fontainebleau.
It was to be supported by two menacing
satyrs, one on either side of the door,
with winged personifications of Victory
in the spandrels. Although the door-
way never was completed, the Museum's
bronze was cast from Cellini's wax model
for one of the satyrs.

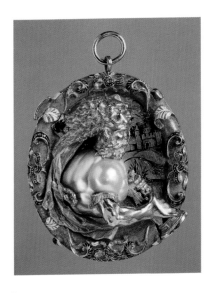

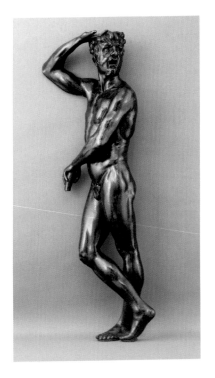

BENVENUTO
CELLINI?

Italian, 1500 – 1571
Hercules Pendant, circa 1540
Gold, enamel (white, blue,
and black), and a Baroque
pearl
6 × 5.4 cm (2⅜ × 2⅛ in.)
85.SE.237

A masterpiece of Renaissance jewelry,
this pendant can be associated with
the court of François I (r. 1515 – 1547) at
Fontainebleau. The subject, Hercules
with the columns of Cadiz, was one of
many such Herculean images utilized by
the king in royal commissions. The
pendant's style and unusual sculptural
quality recall the work of the Italian
sculptor Benvenuto Cellini, who was
employed at Fontainebleau from 1540 to
1545 (see entry at left).

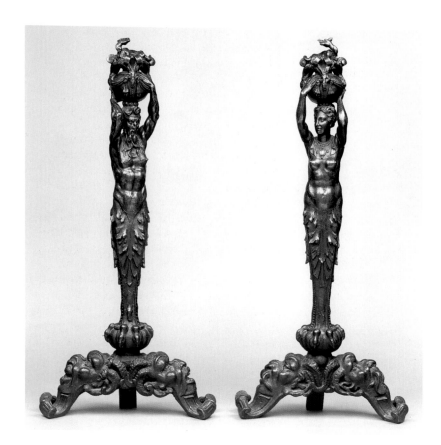

ITALIAN ARTIST
WORKING AT
FOUNTAINBLEAU,
FRANCE

Pair of Andirons in the Form
of a Nymph and a Satyr,
circa 1540–45
Bronze
Nymph: 84 × 39 × 14 cm
(33 × 15¼ × 5½ in.)
Satyr: 82 × 39.5 × 13 cm
(32¼ × 15½ × 5 in.)
94.SB.77.1–.2

On the basis of the Mannerist style of the figures, these andirons—the fireplace equipment that supports wood in a hearth—can be dated about 1540 to 1545. This date is supported by the fact that each figure holds in an urn above its head a salamander, the personal emblem of the French king François I (r. 1515–1547). It seems likely that they were executed for François I by one of the many Italian artists who had been brought to France to work at the king's château at Fontainebleau. These two objects are among the very few small bronzes that can be associated with Fontainebleau, and they appear to be the earliest known figural andirons. The twisted pose, vigorous musculature, and emotional expressiveness of the male figure have many points in common with Rosso's designs for sculptures and paintings in the Gallery of François I (1534–40), while the elongated, mannered proportions and chilly, detached classicism of the female figure evoke Primaticcio's stuccoed caryatids in the Chamber of Madame d'Étampes (1541–44).

BERNARD PALISSY

French, 1510(?)–1589/90
Oval Basin, circa 1550
Lead-glazed earthenware
48.2 × 36.8 cm (19 × 14½ in.)
88.DE.63

Palissy was a man of many interests and talents who, in addition to being a geologist, chemist, philosopher, and ceramist, was also an outspoken Huguenot imprisoned for his involvement in the Protestant riots of the mid-sixteenth century. His subsequent freedom and protection were due to the efforts of his influential Catholic patrons such as Anne de Montmorency and Catherine de' Medici. As a ceramist, Palissy produced his distinctive pottery, called rustic ware, by making life-casts of crustaceans, plants, and reptiles and attaching these casts to traditional ceramic forms. He then naturalistically decorated these wares, as on this example, with lead-based glazes that would melt into one another when fired in the kiln, increasing the realism of the river-like scenes. This basin is exceptional not only for the subtle modeling of its surface—with attention given to the most minute details and surface textures—but also for its unusual ground color; it is one of only three works by Palissy with similar light-colored grounds (that is, white or yellow). The great majority of Palissy wares have backgrounds colored either dark brown or blue. Palissy's rustic works were so popular that they were imitated during his own lifetime and copied in the nineteenth century by such notable ceramic manufactories as Sèvres in France and Wedgwood in England.

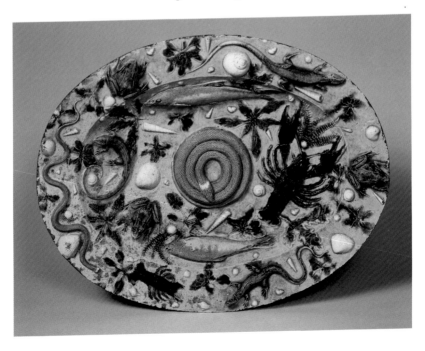

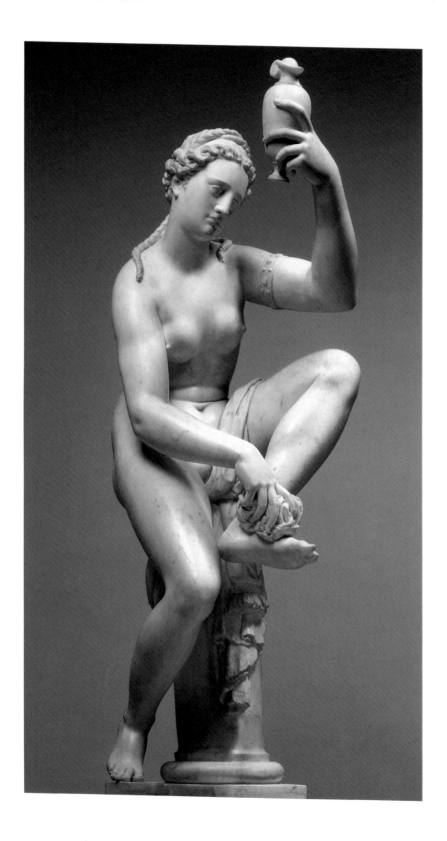

ORAZIO FONTANA OR HIS WORKSHOP

Italian, 1510 – 1571
Basin with Deucalion and
Pyrrha, circa 1565 – 71
Tin-glazed earthenware
H: 6.3 cm (2½ in.);
DIAM: 46.3 cm (18½ in.)
86.DE.539

One of the most active, innovative ceramists of his time, Orazio helped develop a new genre of maiolica decoration with elegant grotesque motifs. The central medallion tells the story of a husband and wife who renewed the human race after a devastating flood by casting stones behind them that assumed human form (Ovid, *Metamorphoses* 1 : 260 – 415).

GIAMBOLOGNA

(Jean Boulogne)
Italo-Flemish, 1529 – 1608
Female Figure (possibly
Venus, formerly called
Bathsheba), 1571 – 73
Marble
H: 115 cm (45¼ in.)
82.SA.37

Giambologna was one of the most innovative sculptors to experiment with the serpentine figure, the upwardly spiraling movement that demands to be looked at from every point of view. The figure's pose conforms to an ideal, artificial spiral achieved through the graceful but complicated twisting of limbs. For Giambologna, a natural stance was less important than the contrast between her long, smooth body and the detailed drapery folds, armband, and coiffure.

CALCEDONIO
FOOTED BOWL
(*COPPA*)

Italian (Venice), circa 1500
Free-blown chalcedony glass
H: 12.3 cm (4⅞ in.);
DIAM (at lip): 19.7 cm
(7¾ in.);
DIAM (at base): 10.6 cm
(4¹⁄₁₆ in.)
84.DK.660

This rare object is one of a small extant group of Renaissance bowls in chalcedony, or agate, glass, so called because of its opaque, marbled appearance, which resembles natural hardstones. Highly prized for the beauty of its colors and as a curiosity, chalcedony glass is an example of the Renaissance revival of antiquity, since vessels of the stone were popular in Roman times.

PILGRIM FLASK

Italian (Florence), Medici
porcelain factory,
circa 1575–87
Soft-paste porcelain; blue
underglaze decoration
H: 26.4 cm (10⅜ in.);
W: 20 cm (7⅞ in.);
DIAM (lip): 4 cm (1⁹⁄₁₆ in.)
86.DE.630

One of the rare wares produced in the Medici factory under Francesco I, this flask is among the earliest examples of European porcelain. Although Medici wares often display signs of being experimental this work is an exceptional piece with unusually brilliant color.

Almost certainly a display piece, this flask reflects the influence of contemporary maiolica and metalwork—in its shape and molded side loops—and of Chinese porcelain and Turkish Iznik ware in its stylized floral decoration.

ABRAHAM I PFLEGER

German, active 1558–d. 1605
Ewer and Basin, 1583
German (Augsburg), 1583
Parcel-gilt silver; enameled
plaques; engraving
Ewer H: 25 cm (9⅞ in.);
Basin DIAM: 50.5 cm
(19⅞ in.)
85.DG.33.1–.2

In addition to their practical function—serving perfumed water for guests to wash their hands during a meal—this ewer and basin commemorate the marriage of Maria Fugger to Nikolaus Palffy von Erdöd. The coats of arms of the two families, surmounted by the date and a pair of clasped hands, appear in enameled medallions on the top of the ewer, in the center of the basin, and engraved underneath it. The Fuggers, the most illustrious of German banking and mercantile families, wanted to form an alliance with the Palffys, since one of the main sources of the Fugger fortunes was their copper mines in the Palffys' native Hungary.

Abraham I Pfleger is recorded as one of the most important goldsmiths of sixteenth-century Augsburg. Few of his works have survived. This ewer and basin reveal a style of unusual purity, restraint, and formal severity.

JOHAN GREGOR
VAN DER SCHARDT

Dutch, circa 1530–81
Mercury, circa 1570–76
Bronze
H: 115 cm (45¼ in.)
95.SB.8

Van der Schardt was one of the first sculptors to introduce the Italian Mannerist style into Northern Europe. The influence of Italian and classical statuary on his work can be seen in this bronze *Mercury*, which borrows the pose of the famous *Apollo Belvedere* in Rome. Mercury played a central role in classical mythology as a divine messenger, but Van der Schardt chose to depict this athletic youth's return to the ground. Mercury's left arm is elegantly raised and his eyes follow the movement of his hand as if he were preparing to deliver an announcement from the gods. The academic ideal of eloquence that this figure symbolizes must have appealed to van der Schardt's courtly and bourgeois clientele. This *Mercury* can be traced back to the famous collection of the Nuremberg patrician Paul Praun (1548–1616), who owned numerous terracotta and bronze figures by van der Schardt.

COVERED
FILIGRANA BEAKER
(*STANGENGLAS*)

Glass: German or Italian
(Murano), circa 1550–1600;
mounts made by Martin Bair
(Augsburg, circa 1676–1734),
circa 1685
Free- and mold-blown soda
glass with *lattimo* threads;
silver-gilt mounts
H (with lid): 30.5 cm (12 in.);
DIAM (at base): 10.1 cm (4 in.)
84.DK.513.1 –.2

This *Stangenglas*, or tall, cylindrical, footed drinking glass, displays the remarkable technique of trapping small bubbles between threadlike white canes of glass in a net pattern. Although the fine quality of this so-called *vetro a reticello* is consistent with Venetian production of the late sixteenth century, the form is unmistakably Germanic. Given that many Venetians were working in German glasshouses by the second half of the century, it is possible that this beaker was produced by talented Venetian craftsmen north of the Alps.

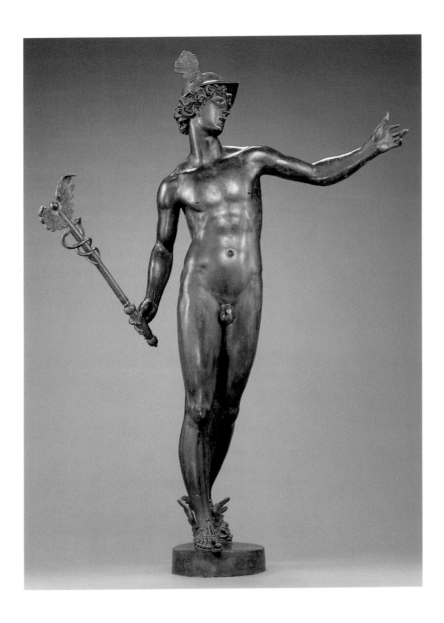

PIETRE DURE
TABLETOP ON A
GILT-WOOD BASE

Italian (Florence or Rome),
Tabletop: circa 1580 – 1600
Base: circa 1825
Tabletop: hard- and soft
stones including lapis lazuli,
coral, rock crystal,
and various types of marble,
breccia, and alabaster
Base: gilt wood
89.9 × 136.5 × 113 cm
(35⅛ × 53¾ × 44½ in.)
92.DA.70

Renaissance Italy, particularly Florence and Rome,
witnessed a renewed interest in the ancient art form of
stone mosaic. Initially, geometric patterns prevailed,
but by the end of the sixteenth century, as the demand-
ing technique was mastered, artists began to include
ever more pictorial elements, such as the scrolling
foliage on this tabletop. Every decorative element is
outlined in white marble, setting off each one from
the other and emphasizing the table's jewel-like quality.
The inclusion of a particularly rare and beautiful
stone — the black, speckled *breccia di Tivoli* in the field
surrounding the central oval — indicates the piece
must have been made after 1560, the year in which the
stone was discovered by Pope Pius IV (r. 1559 – 1565) in
the ruins of the ancient Villa of Quintiliolo at Tivoli.
The inclusion of this stone, together with the tabletop's
transitional style combining purely geometric with
foliate patterns, help date the piece to the last decades of
the sixteenth century.

PORTRAIT OF POPE CLEMENT VIII (IPPOLITO ALDOBRANDINI)

Italian, 1600–1
Designed by Jacopo Ligozzi
(Italian, circa 1547–1626)
Executed by Romolo di
Francesco Ferrucci (del
Tadda) (d. 1621) in the Galleria de' Lavori in *pietre dure*
Marble, lapis lazuli, mother-of-pearl, limestone, and calcite (some covering painted paper or fabric cartouches) on and surrounded by a silicate black stone
With frame: 101.7 × 75.2 cm
(39¹³⁄₁₆ × 29⅝ in.)
Without frame: 97 × 68 cm
(38³⁄₁₆ × 26¾ in.)
92.SE.67

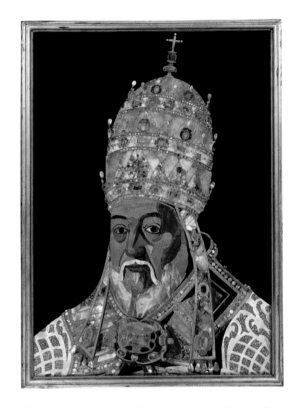

This hardstone-and-marble mosaic is one of four such portraits ordered by Ferdinando I and produced in his Galleria de' Lavori in *pietre dure*, Florence. The Grand Duke founded this workshop in 1588 so that local craftsmen could be trained to restore ancient objects as well as to create original works in the hardstone medium. The other three portraits depict Cosimo I de' Medici; Henri IV of France (now lost); and Ferdinando I de' Medici (also now lost). The sitter of the Museum's portrait, born Ippolito Aldobrandini, served as Pope Clement VIII from 1592 to 1605. Medici interest in the hardstone medium had been especially intense since the 1580s when Cosimo I began plans to decorate with precious stones a new chapel in the Sacristy of San Lorenzo that would serve as a mausoleum for the grand dukes of Tuscany and their families. The hardstone portraits of Medici family members were probably intended to hang in this chapel as representations of dynastic glory. In addition, these stone portraits, including this one of Clement VIII, exemplified the intrinsic and symbolic power of the stones, the permanence that these stones embody, and the "ingenious artifice" that so characterizes late Mannerism.

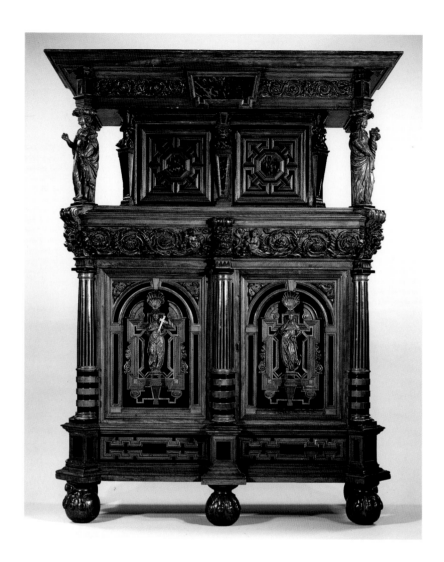

DISPLAY CABINET

Flanders (Antwerp?),
early seventeenth century
Walnut and oak veneered
with ebony, tortoiseshell,
coconut(?), and ebonized
wood
210 × 158 × 74.5 cm
(82¼ × 62¼ × 29⅛ in.)
88.DA.10

Antwerp was the most important center for furniture decoration in the Netherlands around the turn of the seventeenth century. As evidence, this cabinet inventively combines architectural forms with fine sculpted figures. The two front doors are decorated with the allegorical figures of Faith and Hope holding their respective attributes of cross and anchor. Charity appears on the front drawer, completing the triad of theological virtues. Behind the four fully sculpted caryatid figures that support the cornice at the very top, a receding cupboard opens to reveal an octagonal mirror surrounded by intricately inlaid geometric patterns.

BASIN WITH SCENES FROM THE LIFE OF CLEOPATRA

Italian (Genoa),
circa 1620–25
Perhaps modeled by
Francesco Fanelli (Italian,
1590[?]–after 1653) after a
sketch by Bernardino
Strozzi (Italian, 1581–1644).
Probably executed by a
Dutch or Flemish silversmith
Silver
DIAM: 75.5 cm (29¼ in.)
85.DG.81

The design of this spectacular basin, executed in excep-
tionally high relief, is closely based on an oil sketch by
the Genoese painter Bernardo Strozzi, now in the
Ashmolean Museum, Oxford. It may have been trans-
lated into precious metal by a Dutch or Flemish silver-
smith working in Genoa. As in Strozzi's image, the
basin depicts episodes from the story of Anthony and
Cleopatra. The organization of these narrative scenes—
which include dynamic portrayals of battle, suicide,
and death—into concentric bands surrounding a cen-
tral roundel confirms the basin's Genoese origin.

By the seventeenth century Genoa had become one
of the most important Italian centers for the production
of precious metalwork, and a great quantity of early
Genoese silver must once have existed. Despite this,
very few secular examples survive from this period;
scarcely more than a dozen of high quality are known.
Among these the Museum's basin is the largest and most
technically daring in its remarkable depth of relief and
precision of chasing.

ADRIAEN DE VRIES

Dutch, circa 1560–1626
Rearing Horse, circa 1610–15
Bronze
49.5 × 54.6 × 17.8 cm
(19½ × 21½ × 7 in.)
86.SB.488

Throughout his professional life, de Vries seems to have satisfied the dictates of princely taste, for he was courted as a sculptor by some of the most powerful, discerning patrons of Europe, including Charles Emmanuel I, Duke of Savoy, and Emperor Rudolf II of Prague (r. 1576–1612). De Vries worked primarily in bronze, a medium in which he achieved extraordinary virtuosity, and his bronzes are unusual for their consistently high quality and technical sophistication. The *Rearing Horse*—with its smooth musculature, expertly modeled anatomical details, richly colored, reflective surface, and daring balance of the animal's mass on two points—would have merited a prominent place in a royal or aristocratic collector's cabinet.

ADRIAEN DE VRIES

Dutch, circa 1560–1626
Juggling Man, circa 1615
Bronze
77.2 × 51.8 × 21.9 cm
(30⅜ × 20⅜ × 8⅝ in.)
90.SB.44

Adriaen de Vries received his artistic training in the Florentine workshop of the Mannerist sculptor Giambologna (1529–1608). De Vries went on to become the court sculptor to the Duke of Savoy and then to Emperor Rudolf II in Prague. Unlike his teacher, de Vries did not produce multiple versions of his bronzes or allow his models to be cast by other artists. The Museum's *Juggling Man* is therefore a unique composition and one of the sculptor's masterpieces. It was inspired by a Hellenistic marble entitled *Dancing Faun* in the collection of Medici dukes that is now in the Uffizi Gallery, Florence. De Vries changed the details of his prototype significantly: he eliminated the attributes of a tail and horns, replaced the foot organ with a bellows and the cymbals with plates for juggling. In de Vries's hands the faun has become a serious—but highly animated—depiction of dynamic equilibrium. The *Juggling Man* exhibits characteristics of de Vries's male figures, including the expressionistic treatment of the hair and musculature, a pointed chin and small mouth, an almost impish facial expression, and prominent veins in the feet and hands.

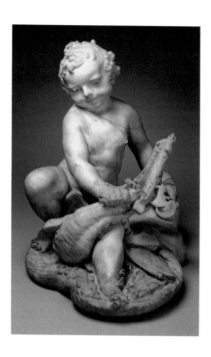

GIANLORENZO BERNINI

Italian, 1598–1680
Boy with a Dragon, circa 1614
Marble
55.7 × 52 × 41.5 cm
(22 × 20 × 16 in.)
87.SA.42

Bernini, the greatest, most precocious
Baroque sculptor, executed this marble
when he was only about sixteen years
old. It is described in early inventories
as representing the young Hercules with
a dragon. Unlike its antique precedents,
this sculpture presents an unidealized,
life-size urchin who cracks the dragon's
jaw not in a heroic struggle but with
a very human, mischievous smile. By
obscuring the boundary between art
and reality, Bernini invites the viewer's
psychological interaction with the
sculpture. *Boy with a Dragon*, fitted for
use as an indoor fountain, most likely
was commissioned by Maffeo Barberini
(later Pope Urban VIII) to decorate his
Roman palace.

WORKSHOP OF BLAUSIUS FISTULATOR

German, active 1587–1622
Architectural Scene and
Frame
Plaque: South German,
circa 1630–70
Scagliola
Frame: Italian, 1730–40
Ebonized wood with
gilt-bronze mounts
Plaque: 43.5 × 50 cm
(17⅛ × 19¹¹⁄₁₆ in.)
Frame: 73 × 67 cm
(28¾ × 26⅜ in.)
92.SE.69

Scagliola, a mixture of stucco, glue, and colorants placed upon a stucco surface, was first developed in South Germany at the end of the sixteenth century as a more pictorial and less labor intensive imitation of stone mosaic. The vibrant polychromy of its precisely rendered architecture, set against the subtle tonalities of the foliage and sky, make this plaque an artistic tour-de-force. The exuberant wood and gilt-bronze frame displays the arms of Pope Clement XII Corsini (r. 1730–40) and may indicate that the earlier plaque was given to him as a gift during his papal tenure.

GIOVANNI FRANCESCO SUSINI

Italian, circa 1585–circa 1644
*The Abduction of Helen
by Paris*, 1627
Base: circa 1750
Bronze on an eighteenth-
century gilt-bronze base
With base (whose height is
18.5 cm [47 cm]):
68 × 34.2 × 33.7 cm
(26¾ × 13½ × 13¼ in.)
90.SB.32

Susini learned the art of sculpture and bronze casting from his uncle Antonio, a close collaborator of the Medici's official court sculptor Giambologna (1529–1608). In this bronze, Giovanni Francesco drew upon Giambologna's influence in choosing a complex composition of struggling figures intended to be viewed from every angle. Nevertheless, the open spatial relationship of the figures, the concern for realistically depicting Helen's supple flesh, and the sense of a climactic moment frozen in time all recall the new Baroque style being practiced in Rome. *The Abduction of Helen*, a progressive and original work, represents the first important Florentine response to the Roman Baroque idiom in sculpture.

ATTRIBUTED
TO GIOVANNI
BATTISTA
CALANDRA

Italian, 1586–1644
Portrait of Camillo Rospigliosi,
circa 1630–40
Mosaic in gilt-wood frame
62 × 48.5 cm (24⅛ × 19 1/16 in.)
87.SE.132

Partly in response to the Counter-Reformation, the Paleo-Christian art form of mosaic production was revived in seventeenth-century Rome. Mosaic renderings were appreciated as "eternal" imitations of paintings, and this jewel-like portrait, of particular chromatic and pictorial subtlety, likely copies an unknown painting by one of the artist's famous contemporaries such as Andrea Sacchi or Guido Reni. Calandra was perhaps the greatest mosaicist of his time. His work was favored by the most important papal and royal patrons such as members of the Aldobrandini and Barberini families. A label on its gilt-wood frame, which displays the lozenges of the Rospigliosi family arms, identifies the sitter as Camillo Rospigliosi (1600–1669), Knight Commander of the Order of Santo Stefano and brother to Pope Clement IX.

DISPLAY CABINET

German (Augsburg),
circa 1620 – 30
Ebony, chestnut, walnut,
pearwood, and boxwood;
ivory, marble, and semi-
precious stones; enamel;
palm wood and tortoiseshell
Several carvings by
Albert Jansz. Vinckenbrinck
(Dutch, 1604/5 – 1664/5)
73 × 58 × 59 cm
(28¾ × 22¹³/₁₆ × 23¼ in.)
89.DA.28

This architecturally inspired collector's cabinet was
likely influenced by the projects of Ulrich Baumgartner,
the most prominent Augsburg cabinetmaker of the early
seventeenth century. It displays restrained proportions;
elegantly mannered carving in its so-called Auricular-
style, or earlobe-like, details above the front "doors";
and a sensitive colorism contrasting ebony with semi-
precious stone inlay. All four sides open to reveal
a surprisingly complex series of drawers and compart-
ments. The biblical, mythological, and historical
subjects represented on the inside were executed in a
variety of techniques and materials.

Marcus Heiden

German, active 1618–1664
Covered Standing Cup, 1631
(the figural elements probably
added later in the seventeenth
century)
Lathe-turned and carved ivory
H: 63.5 cm (25 in.)
91.DH.75

This lathe-turned and carved ivory goblet, like others
of this medium and date, was made as a demonstration
of artistic skill to amaze and delight the beholder rather
than to serve as a functional drinking cup. It was proba-
bly commissioned by Duke Johann Casimir of Saxe-
Coburg for display in his princely *Kunstkammer*, or
collector's cabinet. Two major innovations in the design
of such ivory goblets were introduced in the seven-
teenth century, and the Covered Standing Cup reflects
both of them. The first involved the combination of
abstract, lathe-turned forms with robustly modeled
figural elements, and the second introduced an element
of asymmetry and a shifting or zigzagging vertical
axis to heighten the sense of precarious balance. The
Standing Cup, which is signed and dated 1631 under
its base, represents one of the fullest realizations of this
new Baroque style in turned ivory vessels.

FRANÇOIS GIRARDON

French, 1628 – 1715
Pluto Abducting Proserpine,
cast circa 1693 – 1710
Bronze
H: 105 cm (41⅓ in.)
88.SB.73

Girardon's signed abduction group forms a pair with Gaspard Marsy's *Boreas Abducting Orithyia*, also in the Museum's collection (88.SB.74). Both bronzes are based on models for monumental marble groups commissioned by King Louis XIV to decorate the Parterre d'Eau in the gardens at Versailles. In executing their models, the sculptors faced the artistic challenge of achieving a complex composition viewable from all angles and depicting violent action, all within the boundaries of decorum dictated by the French classicizing style. Their success must have been apparent to contemporary collectors, for bronze reductions of the famous Parterre groups already were in widespread demand by the end of the seventeenth century. Girardon's *Pluto Abducting Proserpine* is the finest and most beautifully patinated of the surviving large casts of his original model.

FERDINANDO TACCA

Italian, 1619 – 1686
Putto Holding a Shield,
1650 – 55
Bronze
65 × 53.3 × 46.7 cm
(25⅝ × 21 × 18 in.)
85.SB.70.1

This bronze putto or angel is one of a pair commissioned in 1650 to adorn the high altar of the church of Santo Stefano al Ponte in Florence. It testifies to Ferdinando's importance in the transition of the Florentine sculptural style from the late Mannerism of Giambologna (see p. 243) to the Baroque. The putto's elegant gesture and the sway of his hips are the last remnants of Giambologna's legacy, which Ferdinando inherited along with that master's workshop in the Borgo Pinti. However, the infant's realistic anatomy, the dramatic play of light across the complex surfaces of his hair and drapery, and the resulting sense of animation underscore Tacca's mastery of the Baroque idiom.

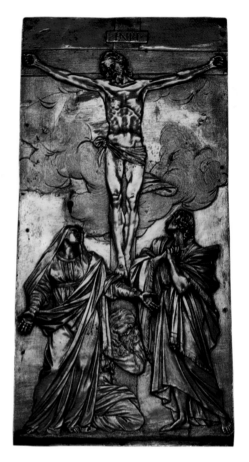

FRANCESCO MOCHI

Italian, 1580–1654
Tabernacle Door with *The Crucifixion*, circa 1635–40
Gilt bronze
54.3 × 28.8 cm (21¼ × 11⅜ in.)
95.SB.2

The elongated, rectangular shape and large size of this relief—as well as the presence of a keyhole and the remains of a hinge—identify it as the door of a sacrament tabernacle, called a *ciborium*, destined for the high altar of a church. *Ciboria* were used to house the sanctified Eucharist and were often grand in scale, towering as much as fifteen feet above the floor. Mochi has taken the exigencies of this placement into consideration in planning the organization and treatment of the relief. The sharp undercutting of the bold, simple figures makes them readable from the distance between the transept, where worshipers would be gathered, and the altar. In addition, the perspective of the clouds and the

foreshortening of the figures achieve illusionistic resolution only when viewed from below.

Mochi has organized the composition hieratically rather than naturalistically, in keeping with the Eucharistic theme and function of the relief. Although the crucified Christ and the kneeling Magdalene presumably occupy the same spatial plane, Christ is depicted in higher relief to underscore his importance and the iconic nature of the portrayal. Another unusual feature of this relief is the extension of the arms of the cross beyond the borders of the image, suggesting an infinite and timeless space for the enactment of this sacred scene.

LUISA ROLDÁN

Spanish (Seville),
circa 1654 – circa 1704
San Ginés de la Jara, 169(2?)
Polychromed wood (pine
and cedar) with glass eyes
H: 176 cm (69½ in.)
85.SD.161

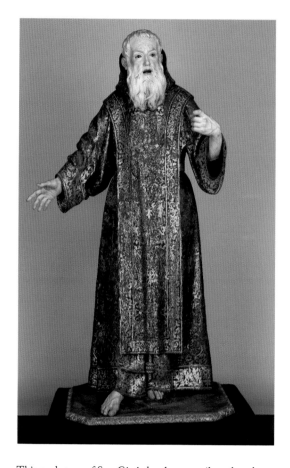

This sculpture of San Ginés has been attributed to the
Seville artist Luisa Roldán, known as La Roldana. She
was primarily active in Madrid, where she was named
Sculptor of the Bedchamber (*Escultura de Camara*)
by King Charles II. Indeed, this work displays not only
her exceptionally beautiful and expressive sculptural
style but also an inscription that can be read [LUIS]A
RO[LD]AN, ESC[U]L[TU]RA DE CAMARA AÑO
169[2?]. The rich decoration of the saint's robes is
executed in *estofado*, a technique that simulates the
brocade of ecclesiastic vestments by stamping patterns
of foliage and fleurs-de-lis over brown pigment and
burnished water gilding to mimic the texture and
brilliance of the gold cloth. This sumptuous display,
together with the heightened realism of the San Ginés,
are typical of the emotionally expressive devotional
practices of Catholic Spain.

MASSIMILIANO
SOLDANI BENZI

Italian, 1656–1740
Venus and Adonis,
circa 1715–16
Bronze
46.4 × 49 × 34.2 cm
(18¼ × 19¼ × 13½ in.)
93.SB.4

Massimiliano Soldani Benzi was the
finest bronze caster in late seventeenth-
century Europe and a leading figure
in the evolution of a Florentine Baroque
aesthetic in sculpture. This bronze
group illustrates an episode from Ovid's
Metamorphoses (10:495–739) in which
Adonis, despite the protests of his im-
mortal lover Venus, sets out in pursuit
of a wild boar and is gored to death.
Soldani's interpretation of the narra-
tive emphasizes the poignant tragedy of
the lovers and their final emotional

exchange. Venus, having just arrived on
a cloud, cradles the head of her dying
paramour as she gazes into his eyes. The
figures enact their drama as if on a stage,
in a frontal composition oriented toward
a stationary viewer. This arrangement
recalls contemporary productions of
theater and opera, the latter having been
invented in Florence a century earlier.

Landscape details such as the rocky
ground, flowers, and clouds enhance
the scenographic quality of the bronze.
Other details serve to demonstrate the
artist's superlative skills as a bronze cas-
ter. For instance, the leash of Adonis's
hunting dog, which is pulled by a stand-
ing cupid, seems to stretch tautly in a
way that defies the rigidity and stasis
inherent to bronze sculpture. By means
of such features in the *Venus and Adonis,*
Soldani proves himself to be a master
of both technique and illusion.

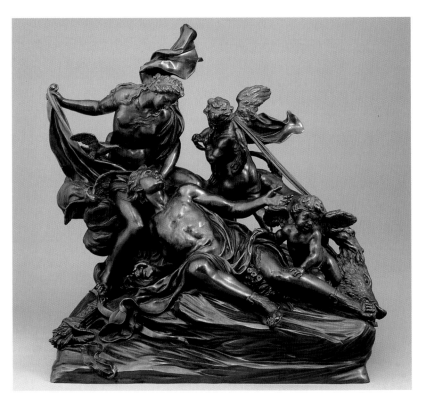

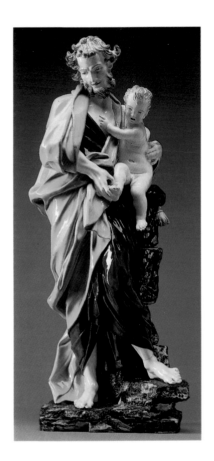

SAINT JOSEPH WITH THE INFANT JESUS

Probably modeled by Gennaro Laudato (Italian, active 1790s) after a model by Giuseppe Sanmartino (Italian, active in the 1790s), 1790s
White-bodied earthenware (terraglia), glazed and polychromed
H: 53.8 cm (21⅛ in.)
91.SE.74

This work is one of the few examples of eighteenth-century ceramic figures from southern Europe of comparatively large scale, sculptural conception, and brilliant execution. The composition is virtually identical to a life-size marble of the same subject by the Neapolitan sculptor Giuseppe Sanmartino that adorns a niche in the vestibule of the San Cataldo Chapel in the Cathedral of Taranto, Italy. Presumably, the Getty *Saint Joseph with the Infant Jesus* copies the same terracotta model (now lost) that was used by Sanmartino for his marble figure group in Taranto. The ceramic group is attributed to Gennaro Laudato, a Neopolitan artist who appears to have been active in the circle of Sanmartino. Laudato signed several of his works, including a ceramic *Tobias and the Angel* based on a drawing by Sanmartino for a silver group in the chapel of the Treasury of San Gennaro, Naples. The stylistic similarities between Laudato's signed works and the Getty piece further support attribution of this work to him.

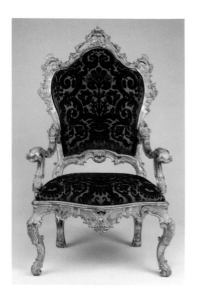

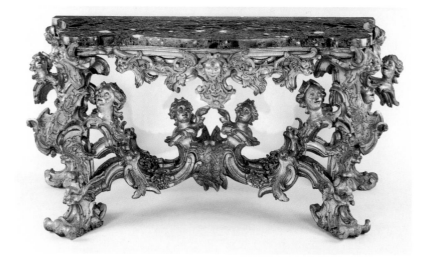

SIDE TABLE

Italian (Rome), circa 1720–30
Gessoed and gilded lime-
wood; modern marble top
93.9 × 190.5 × 96.5 cm
(47 × 75 × 38 in.)
82.DA.8

This table is carved with masks, deep scrolls, and female
heads in keeping with the exuberant, curvaceous forms
of the early eighteenth-century Baroque. It is one of
a pair of tables, the other of which is in the Palazzo
Barberini, Rome. Although it is not known whether the
Barberini table is in its original setting, both pieces un-
doubtedly were made for one of the grander eighteenth-
century palaces in Rome. They probably would have
supported works of art—such as bronze sculptures or
Chinese porcelains—for display.

ONE OF FOUR
ARMCHAIRS

Italian (Venice),
circa 1730–40
Carved, gessoed, and gilt
walnut; upholstered in
modern Genoese velvet
137.8 × 85.1 × 88.3 cm
(55¼ × 33½ × 34¼ in.)
87.DA.2.1

This is one of a set of four armchairs in the Museum's
collection which, given their opulence and elaborate
carving, would have been used for decoration rather
than for seating in the *salone* of a grand eighteenth-
century Venetian *palazzo*. They share stylistic similari-
ties with the work of the most famous sculptor active in
Venice at the time, Antonio Corradini (circa 1700–
1752). Like works attributed to Corradini, these chairs
combine a rather Baroque, sculptural form with the
graceful and voluptuous elements—such as scrolls,
garlands, and foliage—more typical of the mid-
century Rococo style. Comparable examples include a
suite of carved and gilt furniture attributed to Cor-
radini produced for Paolo Renier (1710–1789), penulti-
mate Doge of Venice, in the Ca' Rezzonico, Venice.

FRANCESCO NATALE
JUVARA

Italian, 1673–1759
Wall Plaque, 1730–40
Silver, gilt bronze, and lapis
lazuli; wood backing
70 × 52 cm (27⁷⁄₁₆ × 20½ in.)
85.SE.127

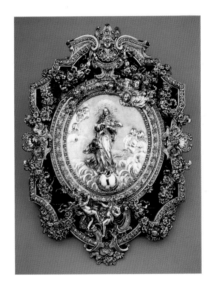

Juvara, son of the Messinese goldsmith Pietro and
brother of the architect Filippo, established a reputation
as a maker of fine liturgical metalwork. His wall
plaques, altar frontals, monstrances, and chalices once
graced the interiors of many Roman and Sicilian
churches. This plaque represents the Virgin of the
Immaculate Conception as she tramples a snake, a
symbol of sin.

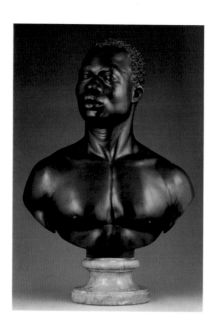

FRANCIS HARWOOD

British, active in Florence
1748 – 1783
*Bust of a Man (Possibly
a Boxer or Athlete)*, 1758
Black stone (*pietra da
paragone*) on a yellow Siena
marble socle
Bust (with socle):
69.9 × 50.2 × 26.7 cm
(27½ × 19¾ × 10½ in.)
Socle: 12 × 22.2 cm
(4¾ × 8¾ in.)
88.SA.114

In contrast to the stereotypical "black-
amoor" busts produced in the eighteenth
century, this work portrays a specific
individual and therefore ranks as one of
the earliest European sculpted portraits
of a black man. Very little is known of
the artist's training. By 1748 he had
moved from England to Florence, where
he became one of the major sculptors for
English aristocrats visiting that city on
the Grand Tour. Harwood's classicizing
style is rather undistinguished, except
for this beautiful and powerful portrait.

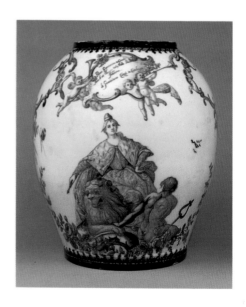

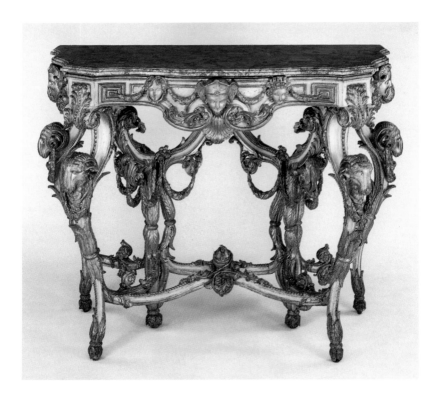

SIDE TABLE

Italian, circa 1760–70
Carved and gilt wood;
marble top
105 × 153 × 74 cm
(41⁵⁄₁₆ × 60¼ × 29⅛ in.)
87.DA.135

The maker of this rare six-legged table was influenced
by the furniture designs of Giovanni Battista Pira-
nesi, one of the principal forces behind the birth and
development of the Neoclassical style in Europe. As
in Piranesi's designs, this table combines antique orna-
ments with flamboyant, complex, and curvilinear ele-
ments. Against a wall in an eighteenth-century palazzo,
this table would have served to display decorative
objects or sculpture.

WORKSHOP OF
GEMINIANO COZZI

Italian, active 1764–1812
One of a Pair of Vases, 1769
Hybrid soft-paste porcelain
H: 29.8 cm (11¼ in.); DIAM
(max.): 27.3 cm (10¼ in.)
88.DE.9.1 –.2

Produced in one of the leading Italian porcelain factories
of the eighteenth century, these vases are remarkable
for their large size, unusual shape, elaborate markings,
and delicately painted, sophisticated pictorial scheme.
The painted decoration on the pair, which copies con-
temporary print sources, celebrates the beauty and
sovereignty of the Venetian republic. One vase displays
the sea god Neptune on one side and an invented
riverside town on the other; the second vase shows the
allegorical figure of Venice and, on the other side, a
panorama of the Piazzetta San Marco.

CLODION

(Claude Michel)
French, 1738 – 1814
*Vestal Presenting a Young
Woman at the Altar of Pan,*
circa 1775
Terracotta
H: 45 cm (17¼ in.)
85.SC.166

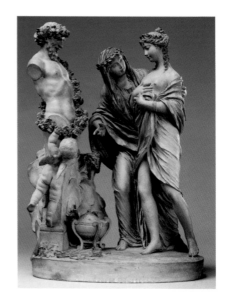

Through his technical brilliance and virtuoso handling
of wet clay, Clodion raised to new heights the aesthetic
quality of the terracotta as an independent work
of art rather than a preparatory sketch or model for a
sculpture in a more permanent material. The Museum's
terracotta depicts the enactment of a ritual before
a herm of Pan, the god of the fields, who is associated
with lust. The object's playful, romantic attitude toward
the classical world is typical of the work of Clodion,
who preferred genre scenes involving marginal mytho-
logical figures to the epic dramas of the principal
Olympian gods.

JOSEPH NOLLEKENS

English, 1737 – 1823
Venus, 1773
Marble
H: 124 cm (48¹³/₁₆ in.)
87.SA.106

Nollekens studied in Rome from 1762 to 1770, and his
style, a mannered classicism inflected by coy charm,
exhibits the influence of ancient and sixteenth-century
Italian sculpture. *Venus* is one of a group of female
deities by Nollekens in the Museum's collection. With
the other figures of Juno and Minerva, the *Venus*
formed part of a series sculpted for Lord Rockingham
to accompany a marble *Paris,* which Rockingham al-
ready owned and believed to be antique. The four stat-
ues together illustrate the story of the shepherd king
who was empowered to judge which goddess was the
fairest. Nollekens chose to depict each of the goddesses
in a different state of undress. Venus, the winner, is
nude except for the single sandal she is removing.

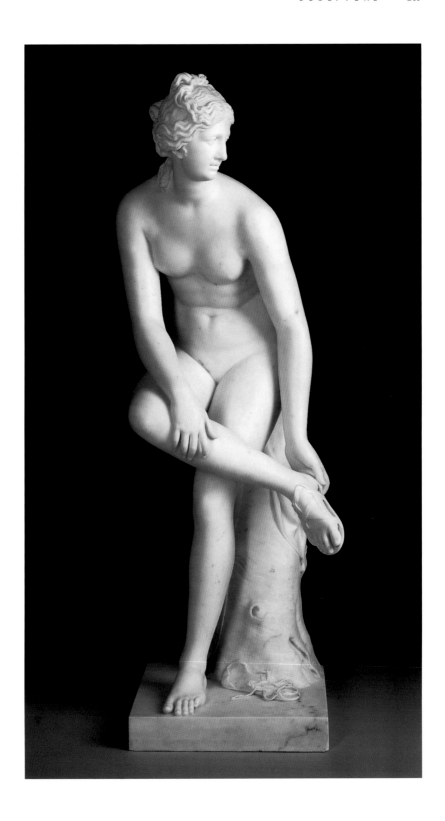

FRANCESCO
ANTONIO
FRANZONI

Italian, 1734–1818
Table with Supports in
the Form of Winged Rams,
circa 1780
Marble
100 × 200 × 81 cm
(39½ × 79 × 32 in.)
93.DA.18

The artist of this table is best known for his work in the
Museo Pio-Clementino, Rome, the Vatican museum of
antiquities, in which Franzoni, under Pius VI, restored
ancient sculptures and decorative objects as well as
created works of his own design. It is in the *Sala degli
Animali* of this museum that Franzoni produced a pair
of tables nearly identical to the Getty Museum's ex-
ample. These tables, whose supports include winged
rams and swags of laurel leaves, were undoubtedly
influenced by the works of Giovanni Battista Piranesi
(1720–1778). Franzoni was employed in Piranesi's
workshop upon his arrival in Rome around 1765 from
his native Carrara. The pier supports of the Museum's
example hold up a single slab of *Breccia Medicea*, a
massive and spectacular stone specimen from the Apu-
ane Alps, a quarry operated by the Medici from the
early seventeenth century.

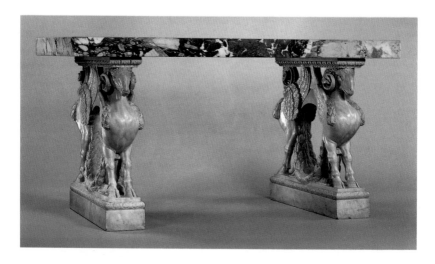

ANTONIO CANOVA

Italian, 1757–1822
Apollo, 1780–81
Marble
84.7 × 41.9 × 26.4
(33⅜ × 16½ × 10⅜ in.)
95.SA.71

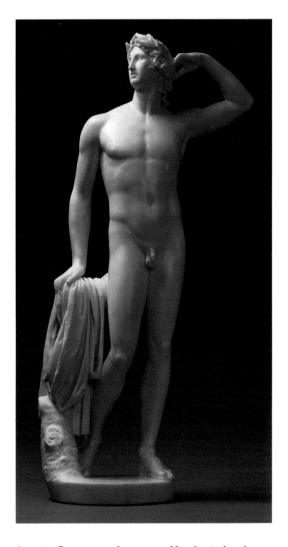

Antonio Canova was the greatest Neoclassical sculptor from the 1790s until his death in 1822 and the most famous artist of his time. This marble of the nude god Apollo crowning himself with a laurel wreath was a pivotal work in the young sculptor's transition from a more naturalistic, Venetian style toward a Neoclassical aesthetic. *Apollo*'s pose conforms to a canonical *contrapposto*, in which the tensed limbs are opposite the relaxed limbs and the body reposes in harmonious equilibrium. Canova intended the figure to be a study in classical proportion that would emulate and rival antique statues.

His subject, derived from Ovid's *Metamorphoses*, is a poignant and seldom-represented moment in the story of Apollo and Daphne showing Apollo's grief after the nymph has been transformed into a laurel tree.

JEAN-BAPTISTE
CARPEAUX

French, 1827–1875
Bust of Jean-Léon Gérôme,
1872–73
Marble
H (with socle): 61 cm (24 in.)
88.SA.8

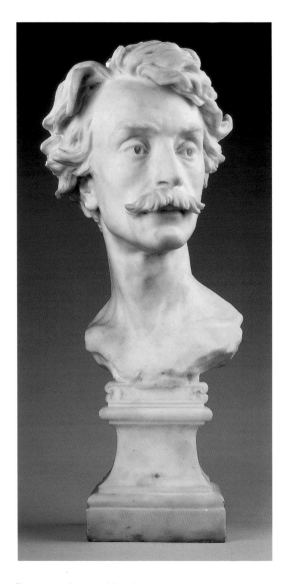

Portrait sculptor to Napoleon III (r. 1852–1871) and
a key figure in the history of nineteenth-century sculp-
ture, Carpeaux first modeled a bust of his friend
Gérôme, a prominent painter, in 1871, when the two
were exiles in London during the Paris Commune.
The Museum's bust is the only known marble example
of this portrait. In it Carpeaux achieved a romantic
image of the alienated, creative spirit in turmoil by ac-
centuating the sunken eyes and cheeks and giving full
play to the unruly mass of hair. The bust ends below
the neck with a jagged line that suggests a fragment or
a disembodied head.

VINCENZO GEMITO

Italian, 1852 – 1929
Medusa, 1911
Parcel-gilt silver
DIAM: 24.1 cm (9¼ in.)
86.SE.528

Vincenzo Gemito's gilt-silver *Medusa* is a sculpture in a category of its own, falling somewhere between a flat, two-sided medal and a fully sculpted object meant to be viewed from several angles. On the concave side the head of the Gorgon Medusa, one of three terrible, mythological sisters whose appearance was so hideous that their beholders were turned to stone, is modeled in relief, and the skin of a snake is rendered over the entire convex side. Gemito based his *Medusa* on an ancient cameo called the *Tazza Farnese*, which he could have studied in the National Archaeological Museum of his native city of Naples. The famous Hellenistic hardstone object, a shallow bowl carved of agate, is decorated with the head of Medusa on its bottom. Although known primarily for his depictions of genre subjects— such as fisher boys, water-carriers, and gypsies— Gemito approached the theme of the Medusa head several times in his career, perhaps because its legendary power as a talisman attracted him, or because its long abundant hair afforded him the opportunity to exploit his facility for sensuous, undulating lines.

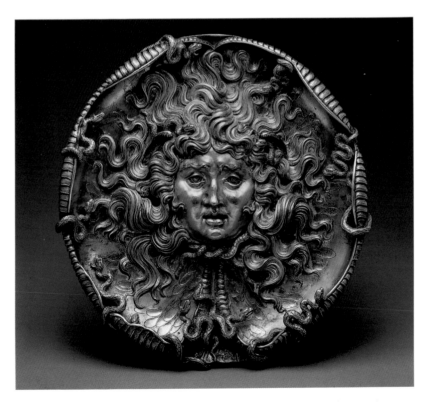

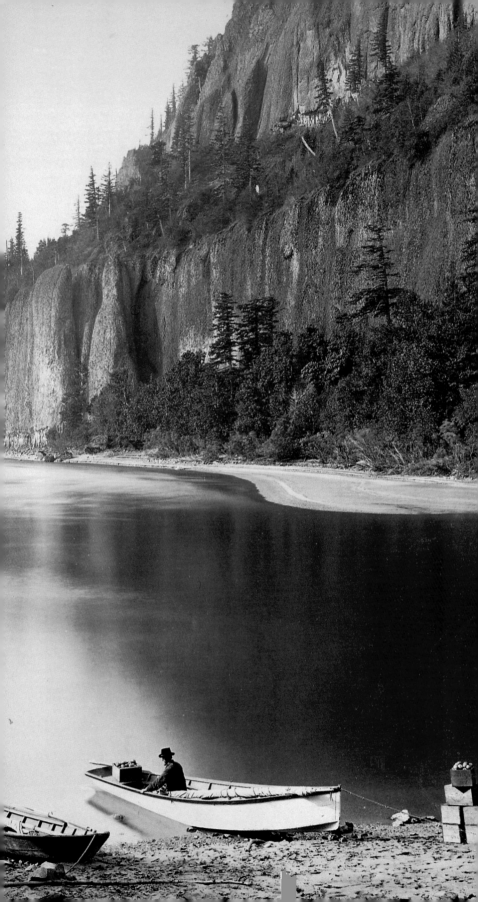

Photographs

In mid-1984 the Museum established a new curatorial department dedicated to the art of photography. The opportunity to acquire several of the most important private collections of photographs in the world may be compared to the establishment of the Department of Manuscripts through the acquisition of the finest gathering of illuminated manuscripts then in private hands. The Museum decided to form a photography collection for reasons similar to those advanced in favor of collecting manuscripts and drawings: photography is an art fundamental to its time in which individual works of great rarity, beauty, and historical importance have been made.

Among the collections acquired in their entireties were those of Samuel Wagstaff, Arnold Crane, Bruno Bischofberger, and Volker Kahmen / George Heusch. The gathering of these collections, along with other block acquisitions made at the same time, including a substantial proportion of the collection of André Jammes, and a continuing program of individual acquisitions, has brought to Los Angeles the most comprehensive corpus of photographs on the West Coast.

The photographs reproduced in the *Handbook* represent a survey of some of the strengths of the collection, which is particularly rich in examples dating from the early 1840s and which includes major holdings by William Henry Fox Talbot, David Octavius Hill and Robert Adamson, Hippolyte Bayard, and other early practitioners in England who worked around Talbot, and in France. The collection also includes significant works by some of the most important photographers of the first half of the twentieth century. International in scope, its guiding principle is the belief in the supremacy of certain individual master photographers and in the timeless importance of individual master photographs.

For conservation reasons, photographs, like manuscripts and drawings, cannot be kept on permanent display. The collection is available to the public by appointment, and rotating exhibitions from the collection are shown in the photographs galleries at the Museum.

CHARLES R. MEADE

American, 1827–1858
*Portrait of Louis-Jacques-
Mandé Daguerre*, 1848
Half-plate daguerreotype
16 × 12 cm (6⁵⁄₁₆ × 4¹³⁄₁₆ in.)
84.XT.953.1

One of the unresolved mysteries in the history of pho-
tography is why Daguerre, who was a painter, became
interested in light-sensitive materials about 1824. By
1829 he had formed a partnership with Nicéphore
Niépce, who had successfully worked with sensitized
metal plates. By New Year's Day, 1840, just four months
after the first daguerreotype was exhibited in Paris,
Daguerre's instruction manual had been translated into
at least four languages and printed in at least twenty-
one editions.

The daguerreotype was enthusiastically accepted in
the United States. Charles R. Meade was the proprietor
of a prominent New York photographic portrait studio.
He made a pilgrimage to France in 1848 to meet the
founder of his profession, and while there, he became
one of the few people to photograph Daguerre.

UNKNOWN
AMERICAN
PHOTOGRAPHER

Edgar Allan Poe, late
May – early June 1849
Quarter-plate daguerreotype
12.2 × 8.9 cm (4¹³/₁₆ × 3½ in.)
84.XT.957

For reasons that are unclear, few daguerreotypes
of notable poets, novelists, or painters have survived
from the 1840s, and some of the best we have are
by unknown makers, as is the case with the Getty *Poe*.

Four of the eight times that Poe is known to have
been photographed occurred within the last year of
his life. This portrait was presented by him to Annie
Richmond, one of two women to whom he made roman-
tic declarations in the months following the death
of his wife. Poe, who has been described as a libertine,
a drug addict, and an alcoholic, is represented here
as a man whose haunted eyes and disheveled hair reveal
the potential for mercurial emotions.

WILLIAM HENRY
FOX TALBOT

British, 1800 – 1877
Oak Tree, mid-1840s
Salt print from paper negative
22.5 × 18.9 cm (8⅞ × 7⁷⁄₁₆ in.)
84.XM.893.1

Talbot's most important invention was one that is easily taken for granted today: the negative from which faithful replicas can be produced. He patented his procedure, which came to be known as the calotype process. He intended his invention to be clearly distinguished from the daguerreotype. Daguerre's procedure resulted in pictures on metal plates that could not be multiplied easily. Daguerreotypes were used almost exclusively for studio portraiture as sitters generally required but a single example, while calotypes required less fussy procedures and therefore were favored when a particular subject had an audience of more than one. There is no known early daguerreotype of a single tree. Yet trees were a favorite subject for photographers who were influenced by the aesthetic of picturesque romanticism evident in Talbot's treatment of this image.

HIPPOLYTE BAYARD

French, 1801 – 1887
Arrangement of Specimens
(from Bayard Album),
circa 1841
Cyanotype
27.7 × 21.6 cm (10¹⁵⁄₁₆ × 8½ in.)
84.XO.968.5

Bayard occupies a position in the shadow of his fellow countryman Daguerre, and also of Talbot, from whom he learned some important techniques. Neither an inventor nor a follower, he was a satellite in the sphere of invention. Bayard was introduced to the work of Sir John Herschel and Talbot and soon abandoned his own direct-positive-on-paper prints in favor of Herschel's cyanotype and Talbot's calotype processes. Talbot was fascinated with nature's power to give form, while Bayard's arrangement of specimens seems to say that nature's design is elevated to a higher power by an organizing human intelligence. Both men proved that the choice of subject is fundamental to the art of photography.

ANNA ATKINS

British, 1799–1871
*Pink Lady's Slipper,
Collected in Portland
(Cipripedium)*, 1854
Cyanotype
25.8 × 20.2 cm
(10 3/16 × 7 15/16 in.)
84.XP.463.3

Atkins was the first woman to create an extensive
body of work. She came to the new medium through
her father, John George Children, who presided over a
February 1840 meeting of the Royal Society at which
Talbot disclosed the workings of the positive-negative
process. Children's friend Sir John Herschel instructed
Atkins in the production of cyanotypes. Atkins com-
bined Herschel's and Talbot's methods to create a visual
lexicon of British ferns, algae, and plants, arranging
her specimens in contact with light-sensitive paper
and exposing the sheets to achieve cameraless negatives.
From these negatives editions of positive cyanotype
prints were made.

DAVID OCTAVIUS
HILL AND ROBERT
ADAMSON

Scottish, 1802–1870;
1821–1848
Newhaven Fisherman, 1845
Calotype
20.7 × 15 cm (8⅛ × 5¹⁵⁄₁₆ in.)
84.XM.445.1

Hill brought his abilities as a portrait painter to the
partnership in photography he formed with Adamson
in 1844. Adamson brought his skills in the manipula-
tion of the calotype process, which he had learned indi-
rectly from its inventor, William Henry Fox Talbot. In
the four years before Adamson's death the partners pro-
duced the first corpus of photographs made as art rather
than experiment. Their prints are characterized by a
Rembrandtesque chiaroscuro in tonalities enhanced by
gold chloride, which also gave the prints permanence.

SAMUEL BEMIS

American, 1789–1881
View of a Barn, 1840–41
Whole-plate daguerreotype
15.8 × 21.3 cm (6³⁄₁₆ × 8³⁄₈ in.)
84.XT.180.2

Samuel Bemis, a prosperous Boston dentist, summered in the early 1840s in the White Mountains region of New Hampshire, where he made some of the earliest American photographs of outdoor scenes. Bemis concentrated his attention on a small wooden barn, seemingly newly built, situated in an unidentified valley surrounded by a range of small mountains. The barn's construction is somewhat unusual in that its surface consists of vertical running planks butted edge to edge, but the most commanding aspect of this picture is less the design of the structure than the remarkable way in which its cubic essence is defined by light and shade. Bemis's selection of a homely barn and its surroundings as a subject contrasts with the choices made by his European contemporaries when they took their daguerrean equipment outdoors; they were more likely to focus on structures of great antiquity or historical importance.

JOHN PLUMBE, JR.

American (b. Wales),
1809–1857
The United States Capitol,
1846
Half-plate daguerreotype
10.8 × 13.9 cm
(4½ × 5½ in.)
96.XT.62

Plumbe's 1846 view of the east front of the United States Capitol is one of three he made of the building as part of a pioneering series documenting the principal buildings of Washington, which were then few in number. Although the building he shows is comparatively simple in contrast with the present day behemoth on the site, it had already had four architects: William Thornton, Benjamin Henry Latrobe, Charles Bulfinch, and Robert Mills. The dome is the work of Bulfinch, whose commission was the result of his earlier success with the Boston statehouse. The wings at the end of the building, which then housed the House of Representatives and the Senate, now serve as antechambers that connect the present chambers with the central rotunda and its dome. This is the only view Plumbe made of the building in which the White House is visible in the distance and is the only picture of any kind before 1900 that includes both monuments.

NADAR

(Gaspard-Félix Tournachon)
French, 1820–1910
Self-Portrait, circa 1854–55
Salt print
20.5 × 16.9 cm (8¹¹⁄₁₆ × 6⅝ in.)
84.XM.436.2

Before he dedicated himself to photography in the early 1850s, Nadar was—as he tells us in his autobiography—a poacher, a smuggler, a bureaucratic functionary, and a fighter for the cause of Polish liberation. *Nadar* was the nickname Gaspard-Félix Tournachon used in the 1840s to sign his stinging lithographic caricatures. While his drawings depended on bold exaggeration for their success, his photographs are marked by a spontaneous naturalism. Here, gentle light falls from above, leaving the right side of his face in partial darkness. His deeply shadowed eyes gaze at the observer, as though the camera did not exist. Equally expressive are his hands.

JULIA MARGARET
CAMERON

British, 1815–1879
Ellen Terry at Age Sixteen,
negative, 1864; print,
circa 1875
carbon print
DIAM.: 24.1 cm (9½ in.)
86.XM.636.1

Cameron is renowned for her portraits of famous men such as Carlyle, Tennyson, and Herschel. This image of Ellen Terry, however, is one of her few known photographs of a female celebrity. Terry, the popular child actress of the British stage who later became Dame Ellen Terry, was sixteen years old when Cameron photographed her. She had just married the eccentric painter George Frederic Watts, who was thirty years her senior and an artistic mentor to Cameron. The ill-fated union lasted less than a year.

Cameron's portrait echoes Watts's study of Terry entitled *Choosing* (1864). Here, as in the painting, Terry is shown in profile with her eyes closed, an ultrafeminine, ethereal beauty in a melancholic dream state. In this guise she embodies the Pre-Raphaelite ideal of womanhood rather than the wild, boisterous teenager she was known to be. Terry's enchanting good looks, if not her personality, suited this ideal perfectly. The round format of the photograph, referred to as a tondo in painting, was popular among Pre-Raphaelite artists.

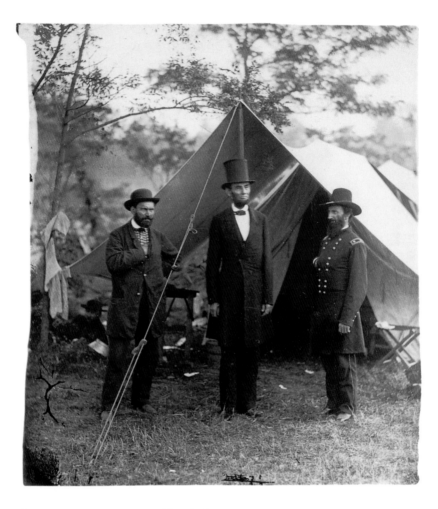

ALEXANDER
GARDNER

American, 1821–1882
*Lincoln on the Battlefield of
Antietam, Maryland,* 1862
Albumen print
22 × 19.6 cm (8⅝ × 7¾ in.)
84.XM.482.1

After the Second Battle of Bull Run, Robert E. Lee
crossed the Potomac River in early September 1862 to
occupy positions in Maryland and Virginia. The inva-
sion was checked at Antietam by the forces of General
George McClellan, whose failure to pursue Lee back
across the river after the battle cost him his job.

Lincoln was the first American president to make
time in his schedule to be photographed. Here we see
him conferring with Major General John McClernand
and Major Allan Pinkerton, who organized an espi-
onage system behind Confederate lines. The genius of
this photograph lies in Gardner's skillful composition
built around the visual details of camp life. The tent and
tent lines dominate. The eye is thus drawn equally to
the fastenings on the lines and the faces of the princi-
pals. Despite compositional interruptions, the imposing
figure of Lincoln remains the center of interest.

GUSTAVE LE GRAY

French, 1820–1882
Cavalry Maneuvers,
Camp at Châlons, 1857
Albumen print
31 × 36.7 cm (12⅕₆ × 14⁷⁄₁₆ in.)
84.XO.377.12

Le Gray was a seasoned landscape and portrait photographer. In 1857 Napoleon III commissioned Le Gray to commemorate the inauguration of, and chronicle life in, the vast military camp established that year on the plain at Châlons-sur-Marne. Designed to accommodate twenty-five thousand imperial guards and staff, the camp sprawled over thirty thousand acres of mostly flat terrain. Le Gray's photographs are comprised of images of cavalry exercises on a grand scale and include genre studies of troops in bivouac, formal portraits of officers, records of ceremonies (including High Mass), and multipart overall panoramas of the camp as seen from the emperor's central pavilion. In this photograph, lines of cavalry behind a field bulwark are cloaked in an atmospheric mist new to photography. They occupy a narrow band across the center of the picture, leaving a great empty swath of pale sky and a dark, nearly vacant foreground. This photograph romanticizes the scene by miniaturizing the figures—a practical necessity to mitigate the blurring effect caused by men and horses in action.

HENRI-VICTOR
REGNAULT

French, 1810 – 1878
Sèvres, the Seine at Meudon,
circa 1853
Carbon print by Louis-
Alphonse Poitevin
(French, 1819 – 1882)
31.1 × 42.5 cm
(12¼ × 16¹³⁄₁₆ in.)
92.XM.52

Regnault, a professor of physics at the Collège de
France, where he performed classic experiments in
thermodynamics and the properties of gases, obtained
samples of Talbot's calotype printing papers from Jean-
Baptiste Biot. Biot was the chief advocate of Talbot's
method in France, and Regnault's good luck may have
resulted from the meeting between Talbot and Biot in
Paris in 1843. By 1852, the year before this negative was
made, Regnault had become director of the porcelain
factory at Sèvres and was hopeful that photographs
could be as permanent as painted porcelain. This print
was made with highly durable carbon ink using
Alphonse Poitevin's carbon ink process, which was
related to lithography.

This is an important complement to Silvy's *River
Scene — La Vallée de l'Huisne* (see p. 289), where a
similar interest in idyllic landscape composition related
to the Barbizon School and early Impressionist painting
is evident. Regnault experimented with different print-
making processes. Using a waxed-paper negative, he
created a print of great clarity. This unusual collabora-
tion between Regnault and Poitevin is a carbon print
made by that process's inventor. It is a benchmark in the
history of the photomechanical printing of photographs.

CAMILLE SILVY

French, 1834–1910
*River Scene — La Vallée de
l'Huisne*, negative, 1858;
print, 1860s
Albumen print
25.7 × 35.6 cm (10⅛ × 14 in.)
90.XM.63

Silvy, who lived and worked in France and England in
the 1850s and 1860s, is best known to the twentieth cen-
tury through his *River Scene*. Inspired by painters of the
Barbizon School, Silvy's four versions of this subject
each show a different treatment of sky and atmosphere,
changes that were achieved by utilizing multiple nega-
tives and different toning methods. Silvy appears to
have created two master negatives, one for the clouds
and the other for the landscape. Some prints, including
this one, may have been copied from the originals
using skillfully made paper negatives that introduced a
grainy image structure. This print was perhaps made
in the 1860s, when the Barbizon School was giving way
to Impressionism.

ROGER FENTON

British, 1819–1869
Pasha and Bayadère, 1858
Albumen print
45 × 36.3 cm (17¹¹/₁₆ × 14¼ in.)
84.XP.219.32

Even though his career as a photographer lasted only ten years, Roger Fenton had a strong impact on the history of the medium. A founder of what became the Royal Photographic Society, Fenton is best known for his images of the Crimean War, which were among the earliest photographic war reportage. He also made photographs that represent fictional situations. He often drew inspiration from painting, which he studied before turning to photography. In creating this image Fenton looked to the Orientalist works of, among others, Eugène Delacroix. These European depictions of the Islamic world were romanticized inventions rather than accurate representations of Middle Eastern life. Fenton's imaginary harem scene was staged in his London studio with his friends as models. The dancer's graceful pose was achieved with the aid of wires.

OSCAR GUSTAVE
REJLANDER

British (b. Sweden),
1813 – 1875
*The Infant Photography
Giving the Painter
an Additional Brush,*
circa 1856
Albumen print
6 × 7.1 cm (2⅜ × 2¹³⁄₁₆ in.)
84.XP.458.34

Oscar Gustave Rejlander's allegory of painting is one
of the most direct treatments by a photographer in the
1850s of the interaction between painting and photog-
raphy. Rejlander's title for this image refers to the idea
that an artist could use photographs of posed models
as preparatory studies for paintings. The photograph is
also a clever self-portrait, with the artist's own silhou-
ette reflected in a parabolic mirror. Like Fenton, Rejlan-
der had been trained as a painter, and both his allegory
and Fenton's tableau on the facing page reflect the
efforts of British photographers of the period to make
the new art of photography more closely resemble the
traditional art of painting by adopting similar kinds
of subject material and pictorial tactics that both media
would share for the rest of the century. For artists the
camera miraculously enabled them to shorten the time
between having a perception and recording it in enor-
mous detail.

CARLETON E. WATKINS

American, 1829–1916
*Cape Horn, Columbia River,
Oregon*, negative, 1867;
print, circa 1875
Albumen print by
Isaiah West Taber
40.5 × 52.3 cm
(16⅛ × 20¹¹⁄₁₆ in.)
85.XM.11.2

While Watkins's Eastern contemporaries—Gardner and O'Sullivan—photographed the Civil War, Watkins, who ranks among the greatest American photographers, had the leisure in the tranquil West to ripen his style to full maturity between 1861 and 1868. Watkins had the gift to create complex compositions from very simple motifs and the power of perception to apprehend ephemeral forces in nature that form a seamless web of formal relationships. The three key elements of this picture are the massive rock formations, the transient quality of the boat loaded with a box of enormous fruit, and the delicacy of the light reflected from the water's surface.

Watkins designed photographs brilliantly to achieve a painterly interplay between surface pattern and spatial dimensions. The network of intricately connected compositional elements is chiefly responsible for this picture's palpable sense of space and is typical of this concern. Watkins's photographs were used as references by painters such as Thomas Hill and Albert Bierstadt.

Watkins was an excellent technician in a variety of materials. He frequently made stereographs, a type of miniature photograph that functioned for him as a sketching medium. After visualizing his subject, he would proceed to make mammoth plate negatives that yielded his celebrated presentation prints.

TIMOTHY
O'SULLIVAN

American, 1840–1882
*Desert Sand Hills near Sink
of Carson, Nevada*, 1867
84.XM.484.42

While employed by Alexander Gardner beginning in
1862, Timothy O'Sullivan was present at most of the
chief military engagements of the Civil War, from the
Second Battle of Bull Run to Appomattox. When
Gardner published his *Photographic Sketch Book of the
War* in 1865, forty-four of the one hundred photographs
were by O'Sullivan—many of them simultaneously
social documents and landscape compositions.

O'Sullivan left Gardner in 1867 to join the newly
formed Fortieth Parallel Survey, the first federal
exploring party in the West after the Civil War. O'Sul-
livan was allowed to roam the wilderness apart from the
main party in order to prospect for motifs that would
fulfill the Survey's scientific needs. We see here a
kind of self-portrait showing the wagon that served as
his rolling darkroom, pulled by four mules positioned
on a hill of windblown sand near the Carson Sink, a
shallow marshy region in western Nevada. The wagon
has just made a U-turn, and the viewer sees the foot-
prints leading from the vehicle to the spot where
O'Sullivan erected his camera to compose this heroic
image of exploration and discovery.

P. H. EMERSON

British, 1856–1936
Gathering Water Lilies, 1886
Platinum print
19.8 × 29.4 cm (7¹³/₁₆ × 11⁹/₁₆ in.)
84.XO.1268.10

"Wherever the artist has been true to nature, art has been good. Whenever the artist has neglected nature and followed his imagination, there has resulted bad art," P. H. Emerson wrote. Emerson called his aesthetic position Naturalism, and his preferred mode of presentation was the album or book, in which texts could accompany the photographs. One of his most important albums, *Life and Landscape of the Norfolk Broads*, was issued as a limited edition of carefully printed platinum photographs, mounted by hand onto pages, where *Gathering Water Lilies* was first seen. Emerson achieved compositional unity out of a great variety of competing elements that range from distracting reflections of light off the water, to the foreground branches, to the randomness of the lily pads and the river grasses. The composition is highly intuitive and yet admits to analysis. The structure of the photograph is built upon the diagonal axes that move corner to corner, from the bow through the stern of the wherry, and toward the opposite corners through the oars intersecting at the man's left hand, which is the center of the image. The point of sharpest focus is the surface of the woman's hat; its concentric circles of braided straw echo the circular field of focus established by the physics of lenses. "The image which we receive by the eye is like a picture minutely and elaborately finished in the center, but only roughly sketched in at the borders," Emerson wrote. This composition binds tender emotion to aesthetic form with poetic simplicity.

THOMAS EAKINS

American, 1844–1916
*Eakins's Students at the Site
for "The Swimming Hole,"*
circa 1883
Albumen print
16.5 × 12.2 cm (6½ × 4¾ in.)
84.XM.811.1

Photography was invented just when painters seemed
to require a new way of seeing the world. Although
many nineteenth-century painters dabbled in photog-
raphy, very few carried their experiments far enough
to produce a significant corpus of work. Two painters
who did, and who are still universally respected, were
Thomas Eakins and Edgar Degas (see p. 296).

Eakins began to photograph in the late 1870s. Inter-
ested in the poses and gestures of static nude figures,
he made this study of seven young men at a swimming
hole around 1883. Male nudes were then very uncom-
mon in photography, and Eakins was among the first
to experiment with this subject. His models were
students at the Pennsylvania Academy of the Fine Arts,
which censored him for this practice. Eakins's paint-
ing *The Swimming Hole*, now in the Amon Carter
Museum, Fort Worth, was created from sketches based
on these photographs; it is probably the most famous
nineteenth-century painting known to have been based
on a photograph.

EDGAR DEGAS

French, 1834–1917
*After the Bath, Woman
Drying Her Back*, 1896
Gelatin silver print
16.5 × 12 cm (6¹¹/₁₆ × 4¾ in.)
84.XM.495.2

Degas was an inveterate experimenter in the graphic
arts, creating major works in monotype, drawing,
etching, and lithography, before turning his talents to
photography between 1894 and 1896. However, twenty-
five years before, at about the time he first met Nadar,
Degas used carte-de-visite photographs as the sources
for several portraits. In 1874 he drew a pastel of a
dancer posing in a photographer's studio, which led to
his 1896 study of a model drying herself after her bath.
The movement shown here is complex and contorted,
almost acrobatic. The photograph is related to a star-
tling, almost voyeuristic series of drawings devoted
to the motions of women dressing, bathing, and twisting
their bodies while drying themselves.

FREDERICK H.
EVANS

British, 1853 – 1943
*Kelmscott Manor: In the Attics
(No. 1)*, 1896
Platinum print
15.5 × 20.2 cm (6⅛ × 7¹⁵⁄₁₆ in.)
84.XM.444.89

Evans found poetic and artistic inspiration in the archi-
tecture of the past. He was inspired by the nearness
of the designer-craftsmen of the Middle Ages to their
product and by the essential equality of the craftsmen to
each other. In 1896 Evans visited the home of William
Morris, the proselytizing medievalist. Kelmscott Manor
dates from 1280 and is highly representative of the
medieval manor house, an institution in which the role
of the craftsman was central to all of everyday life.
Evans methodically photographed the exterior and inte-
rior and selected decorations, including the attics.

Evans photographed architecture and its ornaments
using a vocabulary of light, volume, and texture. In this
photograph he isolates the intersecting network of posts
and beams, choosing his point of view carefully so as
to make clear that they were carved by hand out of the
trunks and branches of trees. Almost a decade later,
Evans wrote that he hoped people would exclaim upon
seeing his photographs, "What a noble, beautiful, fasci-
nating building that must be, and how priceless an art
is that sort of photography that can so record one's
emotional rapprochement to it!" In focusing his atten-
tion on the details of architecture, Evans proved that a
photographer could join in a single artistic tempera-
ment the classic and the romantic, the linear and the
painterly, the objective and the abstract.

ALFRED STIEGLITZ

American, 1864–1946
Georgia O'Keeffe: A Portrait,
June 4, 1917
Platinum print
24.4 × 19.5 cm (9⅝ × 7¹¹⁄₁₆ in.)
91.XM.63.3

A catalyst for Stieglitz was Georgia O'Keeffe, a young painter whose art and personal style influenced him and his circle enormously. She was living in New York during the first half of 1916 and was included in a group exhibition at Stieglitz's gallery. Toward the end of the exhibition she visited the gallery for the first time, appearing "thin, in a simple black dress with a little white collar [and with] a sort of Mona Lisa smile," as Stieglitz recalled. This study was among the first of a series that eventually amounted to more than 325 photographs of O'Keeffe that probed different aspects of her persona. Hands are an important motif in the series. Stieglitz shows us hands that shape art, and he challenges us to imagine how they could also stroke and caress, grasp and hold, or scratch and claw. In visual language they stand for everything in nature that is subject to change.

CHARLES SHEELER

American, 1883–1965
Doylestown House—
The Stove, 1917
Gelatin silver print
22.9 × 16.2 cm (9 × 6⅜ in.)
88.XM.22.1

This photograph displays a concern for the symbolic value of pure light, along with the status of the found object in the spirit of Duchamp. The interior is photographed at night, with a single source of artificial light blasting from the belly of the stove via the electric bulbs that had recently come into use by photographers. Sheeler reconciles the perennially opposing forces of light and dark, of mass and line, and of nostalgia and modernity. "[The photographs are] probably more akin to drawings than to my photographs of paintings and sculptures," wrote Sheeler to Stieglitz.

PAUL STRAND

American, 1890–1976
Portrait—New York, 1916
Platinum print
34.3 × 25.1 cm (13½ × 9⅞ in.)
89.XM.1.1

When Strand first visited Stieglitz in 1910, he had been listening to the advice of Lewis Hine, who was one of the most socially concerned photographers of the twentieth century. One of Strand's contributions to a new aesthetic was to bring together Hine's humanism with Stieglitz's formalism (see p. 299). This photograph made in New York's Washington Square Park is less a portrait than an archetype of old age and urban survival. The woman has been photographed without her knowledge. The composition is off-center, with hard-edged light and an oblique viewpoint that establishes a sense of sculptural immobility. Strand turned to socially conscious themes in the 1930s and never returned to complete abstraction.

DORIS ULMANN

American, 1882–1934
Portrait Study, South Carolina,
circa 1929–1930
Platinum print
20.6 × 15.4 cm (8⅛ × 6⁄₁₆ in.)
87.XM.89.81

Ulmann, a small, frail woman from Manhattan, began
her lifelong project of photographing American "types"
with portraits of the Dunkards, Shakers, and Men-
nonites in rural Pennsylvania and other Eastern states.
Through her circle of literary friends in New York,
she met the South Carolina writer Julia Peterkin,
who persuaded her to produce illustrations for *Roll,
Jordan, Roll* (1933), Peterkin's book documenting the
customs and inhabitants of Lang Syne Plantation.
This portrait of an adolescent girl probably was made
as part of that project. It displays both the influence
of the Pictorialist Clarence White and Ulmann's tech-
nique of photographing in natural light with a view
camera and soft-focus lens.

ANDRÉ KERTÉSZ

American (b. Hungary),
1894–1985
Chez Mondrian, 1926
Gelatin silver print
10.9 × 7.9 cm (4⁵⁄₁₆ × 3⅛ in.)
86.XM.706.10

The Hungarian-born Kertész once described himself as a "Naturalist-Surrealist." In his most characteristic photographs, an abiding interest in the prosaic aspects of life blends with a surrealistic perspective. His work is marked by an ability to surprise us by addressing familiar subjects in unusual ways. If the subject was a still life, Kertész chose his viewpoint deftly and occasionally made a subtle alteration to gain his desired effect. He described for a friend the shaping of this particular composition: "The door to [Mondrian's] staircase was always shut, but as I opened it in my mind's eye the two sights started to present themselves as two halves of an interesting image that I thought should be unified. I left the door open, but to get what I wanted I had to move a sofa."

AUGUST SANDER

German, 1876–1964
Frau Peter Abelen,
Cologne, 1926
Gelatin silver print
23 × 16.3 cm (9¹⁄₁₆ × 6⁷⁄₁₆ in.)
84.XM.498.9

Enigmatically, Sander's photographs are simultaneously
traditional and modern. He used a tripod-mounted
plate camera when handheld cameras were attracting
many photographers, and he usually posed his figures in
an environment that revealed something about their
life, a strategy appropriated from painting and profes-
sional portraiture. Sander was skilled at causing his sub-
jects to project a sense of expectation and then arresting
that moment. Dressed in stylish culottes, Frau Peter
Abelen stands in a gallery surrounded by her husband's
paintings. She is about to light the cigarette between
her teeth with the match and striker she holds. We have
a powerful sense of tense psychological reality. The
woman is androgynous, and her expression falls some-
where between anticipation and anger. We do not know
whether Sander accuses or praises her.

EDWARD WESTON

American (1886–1958)
Two Shells, May 1927
Gelatin silver print
24 × 18.4 cm (9½ × 7¼ in.)
88.XM.56

Tabletop still-life arrangements were a favorite subject for amateur photographers, but very few achieved the powerful form and masterful control of technique that Weston did. Bored with portraiture, he experimented with the symbolic and formal potential of found objects. By nesting one chambered nautilus shell inside another, he created a powerful form not seen in nature. Viewing his subject close-up from below, with a camera designed for eight-by-ten-inch sheets of film, Weston was challenged to keep all the visual elements in sharp focus. He wrote: "It is this very combination of the physical and spiritual in a shell . . . which makes it such an important abstract of life."